Art without Boundaries
1950–70

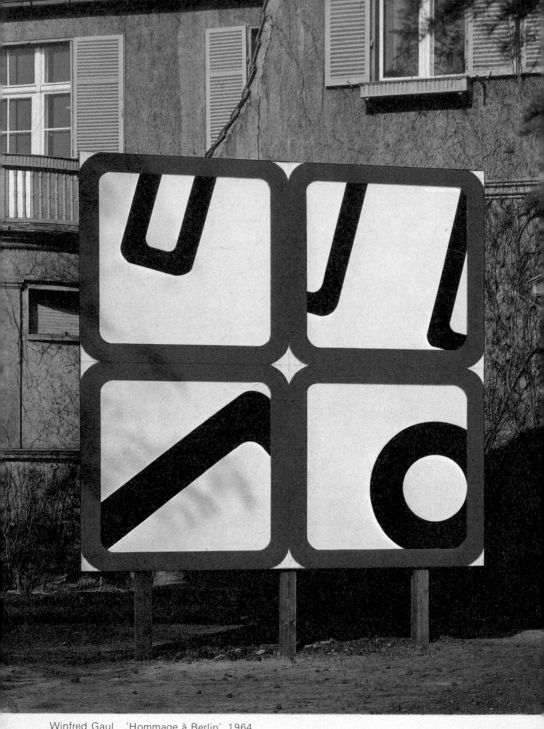

Winfred Gaul 'Hommage à Berlin', 1964

Art without Boundaries
1950–70

Edited by
Gerald Woods
Philip Thompson
John Williams

with 333 illustrations, 15 in colour

Thames and Hudson · London

Printed in Great Britain by Jarrold and Sons Ltd, Norwich
ISBN 0 500 18135 7 Clothbound
ISBN 0 500 20129 3 Paperbound

Contents

Raymond Moore

Josef Müller-
Brockmann

Siegfried Odermatt
and Rosemarie Tissi

Claes Oldenburg

Giovanni Pintori

Michelangelo
Pistoletto

Paul Rand

Robert Rauschenberg

Roger Raveel

Alain Robbe-Grillet

Diter Rot

Hans Schleger

Peter Schmidt

Richard Smith

Stefan and
Franciszka Themerson

Jan Tschichold

Stan Vanderbeek

Tom Wesselmann

Kurt Wirth

Henry Wolf

Edward Wright

Preface

The idea for this book took shape at some time in 1968. While teaching at two London art colleges, I was disturbed by the fact that new work in any particular field of the visual arts was documented and considered in isolation. I felt that it was desirable to correlate many apparently disparate activities. I was aware that the student of graphic design, for instance, might have little knowledge of 'conceptual' or 'minimal' art, and that, on the other hand, the fine-art student could be equally ignorant of developments in 'autonomous typography' or 'ideative design'. By the same token, innovation in audio-visual techniques might elude both groups of students.

My purpose, in planning this book, was to meet this need by presenting illustrations of a wide range of recent work in the visual arts, accompanied by texts in which the artists' aims are discussed, in many cases in their own words. When I discovered that several of my friends agreed that such a book would be useful, I decided that the selection of material would be both more objective and more interesting if I invited two other people to collaborate with me on the project.

The process of compiling and collating the material has been long and arduous. Inevitably, the selection of artists for our survey has been personal and prejudiced, though we have tried to be as impartial as possible. We have often disagreed about the inclusion or the exclusion of certain artists, and the first, provisional list was notably different from the final one.

We have tried to approach our task without preconceived ideas. We are aware, of course, of the relationships which exist between different fields of the visual arts, but we have attempted to discover them by a process of writing and of selection which is, perhaps, analogous to the methods which have often been employed by the artists represented in these pages. We have tried, in fact, in producing this book, to parallel the fluidity of the situation we are describing, and also to see new relationships —

usually implicit rather than permanently forged. To avoid loading the argument in any way, we have presented the artists in alphabetical order.

We have been fortunate in the assistance given to us by the staff of Thames and Hudson, particularly the encouragement given to the project by Constance Kaine, the help of Madeline Haes and the editing of Mr Michael Graham-Dixon. The book was designed by Philip Thompson. Finally, we would like to record our thanks to all the people who have willingly sent us examples of their work and, in some cases, statements about their work. We hope that the book may contribute towards a wider appreciation of all those artistic activities which are at present isolated by their labels.

G.W. 1971

At one time it was easy to distinguish between the 'fine' artist and the commercial artist. It is now less easy. The qualities which differentiated the one from the other are now often common to both. The painter, who once saw the commercial designer as a toady to the financial pressures of industry, may now find that the dealer can impose a tyranny worse than that of any client. During the last twenty years or so, barriers have been broken down; and they are still being broken down.

The painting and sculpture of the 1950s was largely dominated by abstract expressionism and social realism. There were a few interesting exceptions to the general trend. Fontana, in developing his spatialist theories, was using neon light in large-scale murals. And, in most countries, individual artists were encroaching on the areas which divide one field of activity from another.

A number of key exhibitions in Europe and the United States helped to disseminate new ideas and techniques. The Venice Biennale made, and continues to make, a particularly valuable contribution, as did the Documenta series in Kassel. Certain galleries and organizations, such as the Tate Gallery, the Whitechapel Gallery and the Institute of Contemporary Arts in London, the Stedelijk Museum in Amsterdam and the Museums of Modern Art in New York and Turin, also mounted useful exhibitions. In the late 1950s, the influence of John Cage's theories and personality was critical in a new movement towards the combination of media. Cage acted as a catalyst: dance, concrete poetry, happenings, painting, sculpture, music — all things were possible for him. During the 1960s the interaction of media became more lucid. Warhol and Rauschenberg began to silkscreen photographic half-tones directly on to canvas. A movement concerned with 'concrete poetry' was established, continuing the experiments in autonomous typography which Arp, the Futurists and the De Stijl group had undertaken in the 1920s, and which had been anticipated by Mallarmé in 1897.

Cover of sheet music, *4'33"*, by John Cage, a work for piano consisting of total silence for four minutes and thirty-three seconds. The work, however, may be performed by any instrumentalist or combination of instrumentalists

Richard Hamilton 'Kent State'. Pring (see footnote on page 129)

Juan Genoves 'The Victims', 1969

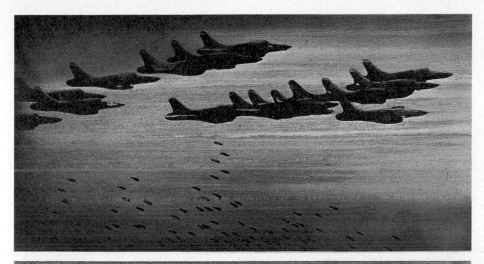

nt,

to
is
o

all
the

udget
r cent.
ensat-
65 per
cases
ed to
e re-
d be
ents.
men
ded
ent,
our-
the

Electrically transmitted image. Immediate, ominous, irrational. See Genoves and Hamilton (pages 122 and 128)

Godard interspliced verbal messages with film sequences. Antonioni 'painted' with film. Genoves produced paintings in series that emulated the sequences of images which one sees in newsreel films. Gaul and Carmi made their own signs and signals for the imagination. The ideas of Duchamp, Schwitters, the Surrealists and the Dadaists were examined afresh and revived. And, in a sense, the world was rediscovered through the common object.

During the last two decades, artists have been increasingly concerned with what art can be 'about'. Among the things which it has been about are attitudes, concepts, boredom, danger, chance, decomposition, the process of seeing, violence, the possibilities of 'bad' art, the polarity of one's own nature and even the total uninvolvement of the artist in his own creation.

The activity of art today is less concerned with the possibility of a finite solution than with the possibility

of making discoveries in a diversity of media. The process is analogous to that of keeping a diary. Thoughts, jottings and essays – the form itself often spills over into life. The range of media is infinite: film, typography, dance, collage. The work-in-progress nature of the activity seems to render the art gallery system more and more archaic.

Artists move freely between media and the edges between these media have become blurred. Labels, however, proliferate, and, in the attempt to grasp the situation we are apt to falsify it. Labelling seems to be part of a human need to classify, systematize and tabulate; to give life a meaning and order. But artists have gone mad in trying to identify and reconcile the extremes of their own personalities and obsessions. Logical/intuitive, cool/passionate, drip/hard-edge, fine/commercial – increasingly, this very ambivalence is being explored by such artists as Rot, Godard and Hamilton. 'All things', said Hegel, 'are in themselves

A designer's designer, Charles Eames has, with his chairs, modular storage systems, films on communication and toys, revolutionized our world and our thinking as well as solving most of the technical problems of designers working in other fields. His house in Venice, California, designed in the late 1940s and made from components listed in factory catalogues, reveals an attitude of mind that has gradually seeped into all other areas of design, including graphics. The drawing (right) from the catalogue of the Truscon Steel Company shows Eames' own markings

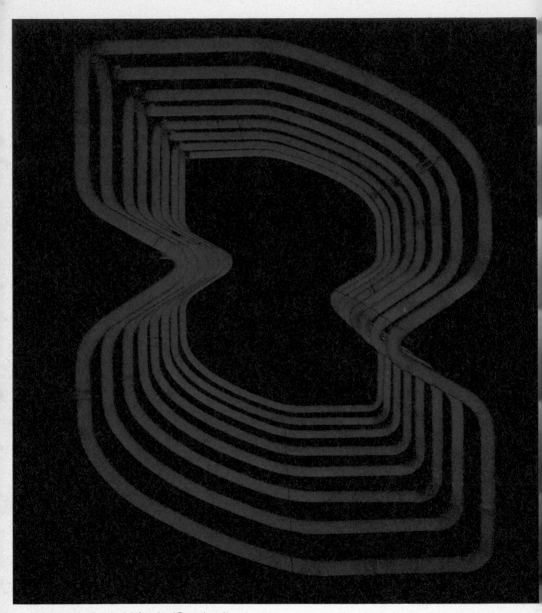

Chryssa Study 14 for the 'Gates' series

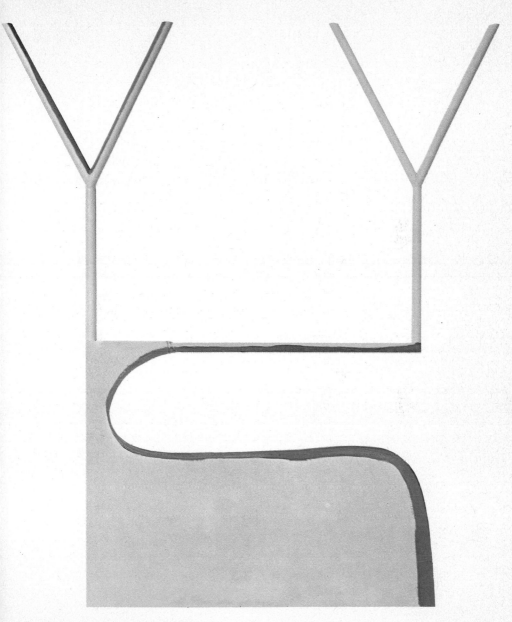

John Kaine 'Let the Wall in', 1964

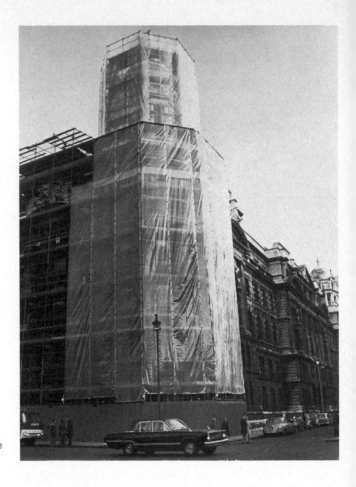

Cleaning the old War Office
building, London, 1969

contradictory, and it is this principle, more than any
other, which expresses the truth, the very essence of
things.' Movements and labels are often invented by
journalists and critics who, for purposes of con-
venient classification, attempt to impose a pattern
on what is largely a fluid situation.

Many of the artists represented in this book use the
word 'communication', in statements and in con-
versation, to describe their ideas and what they see as
their function. Each brings a different meaning to the
word. Some people, on the other hand, prefer not to

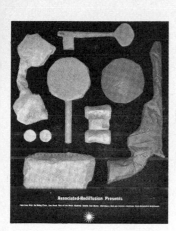

Television wraps up its wares. An advertisement, designed by Robert Brownjohn, for Associated-Rediffusion Television

Crime copies art

use the word at all. Mark Boyle has said that he is not consciously concerned with communication. The most he felt was that his work was a constant communication or dialogue with himself. When we asked Wesselmann to contribute to our survey, he said that he was not sure what *we* meant by 'visual communication', and went on to say, 'All that I have done is to make my paintings and collages within the context of painting and art.' Oldenburg, however, does call himself a 'visual communicator'.

Confusion has probably arisen from the familiar use of the word 'communication' in the sense of imparting unequivocal information — particularly when this is allied to the insistent conspicuousness of the techniques, processes and imagery of the 'communication industry'. It might be more helpful if we were to use the word to mean the sharing of feelings and emotions.

Tolstoy took the view that art was a human activity consisting in one man consciously, by means of external signs, handing on to others feelings which he himself had lived through, and that others were affected by these feelings and also experienced them. Herbert Read thought that Tolstoy's idea of 'communication' was true only of the crudest forms of art, such as melodrama and sentimental fiction. He

David Hockney 'California Seascape', 1968

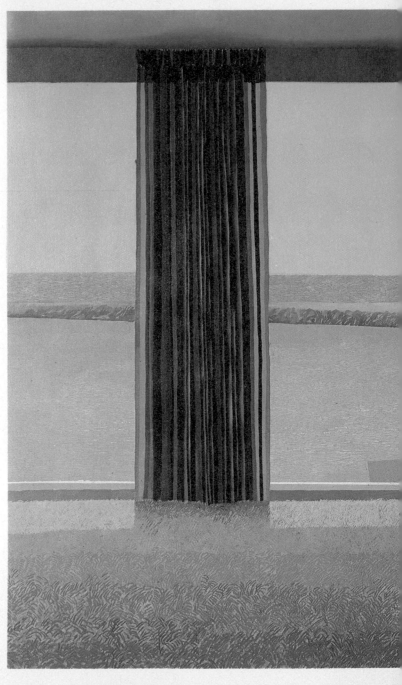

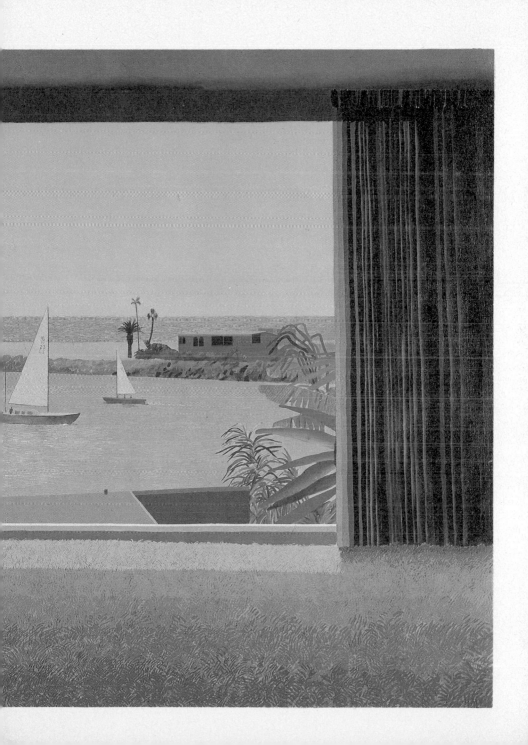

A great many buildings designed during the 1950s and 1960s, which at the time were considered 'good', are now seen to be wanting technically, functionally and socially. Applying no criteria of any kind, Diter Rot (see page 174) nominated Cox's, on the Watford by-pass, as his favourite British building

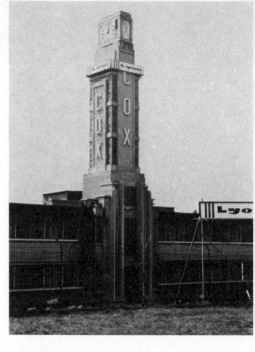

'Bad taste' cinema architecture of the 1930s became a revered model in the 1960s

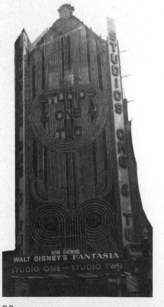

thought that the proper function of art was to express feelings and to transmit understanding, but that the emotion experienced by the spectator was totally different in kind from the emotion experienced by the artist. It was more a state of recognition, he believed, than a direct reception of feelings transmitted to him. A work of art can, of course, communicate on more than one level at the same time. The paintings of Giotto, Cimabue and Simone Martini, for instance, were, in their day, infinitely more effective in communicating the Christian message than were the dogmatic writings of contemporary theologians. However, the transmission of distinct messages in a symbolic form in no way interferes with the aesthetic value of their work.

For the purpose of this book we say that 'visual communication' is that area of painting, drawing, print-making, photography, film-making, typography and so on, in which some sort of dialectic has been

Claes Oldenburg's proposed colossal monument for the Thames Estuary, 'Knee' (1966), had been foreshadowed by many years by Teesside industry

established — where there is a continuing enquiry into the nature of things — and, perhaps, where there is a concern for the problems of coming to terms with a culture which is dominated by technology.

The term 'visual communication' is also, sometimes, used as a euphemism for 'graphic design' (which, in turn, was coined as a euphemism for 'commercial art'); it is also used in an attempt to redefine the scope of the graphic designer, as well as to elevate his status. Today, both painters and designers have become non-specialists; indeed, one man may well engage in both activities. We are not saying that designers and painters are doing the same thing. First, there is a difference in motivation, and secondly, the designer must work within the network of the various 'channels of communication'. He has a problem to solve and a message to transmit through the medium of television or of posters or of the press or whatever it may be. Though the designer bears in mind his own

Edward Wright 'Dialectal D', 1969. Collage

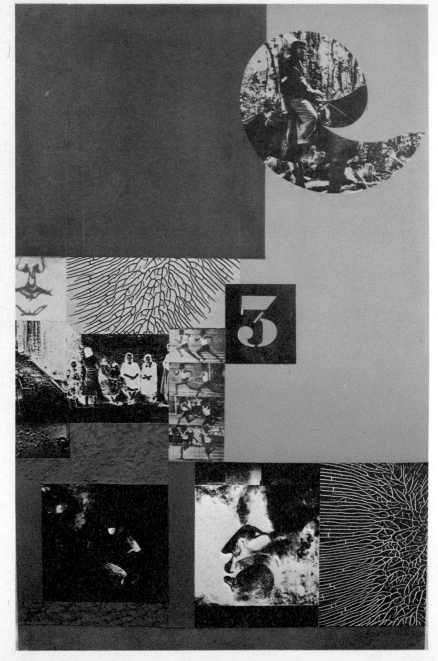

Cable drum

'Undulating Form', by Mario
Ceroli

aesthetic aims, he must also consider his client —
something that the painter need never do. And yet
the designer's environment may be the same as the
painter's; they may share the same interests, obses-
sions, ideas and attitudes, and the designer also may
be concerned to express them, quite apart from the
requirements of his brief.

The Bauhaus ideal of a total integration of the arts,
with architects, designers, and engineers training
together, still seemed possible twenty years ago.
Since then, the unimaginable advance of technology
has totally outstripped art education theory, and the
art school has been faced with a chronic dilemma as
to its precise function. In England, the best in art
education seems to happen of its own volition,
independently of an administration, either benign or
despotic. It happens when certain events, attitudes,
indefinable moods, staff and students all come
together at a particular time. It is a nebulous pheno-
menon which eludes all attempts to pin it down, to
identify it, to systematize it and to incorporate it into
the syllabus. In West Germany, the now defunct
Hochschule für Gestaltung in Ulm tried to instigate a
methodical approach to education in design. Under

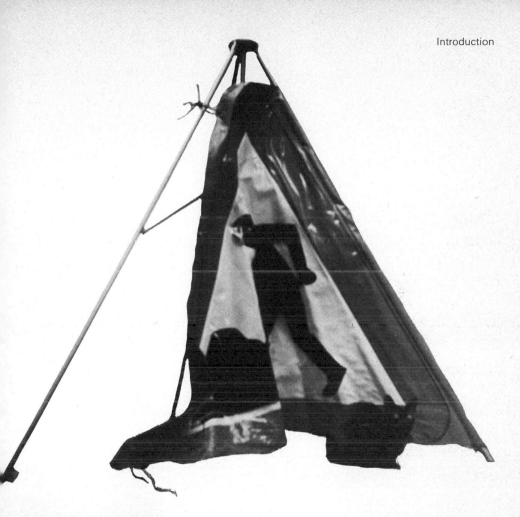

A four-foot plastic motorway sign used by the GPO. 'Everyone who wants to be loved desires a pliable world.' Claes Oldenburg

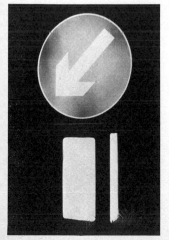

Road sign

Overleaf: Christo Wrapped coast, Little Bay, Australia, 1969

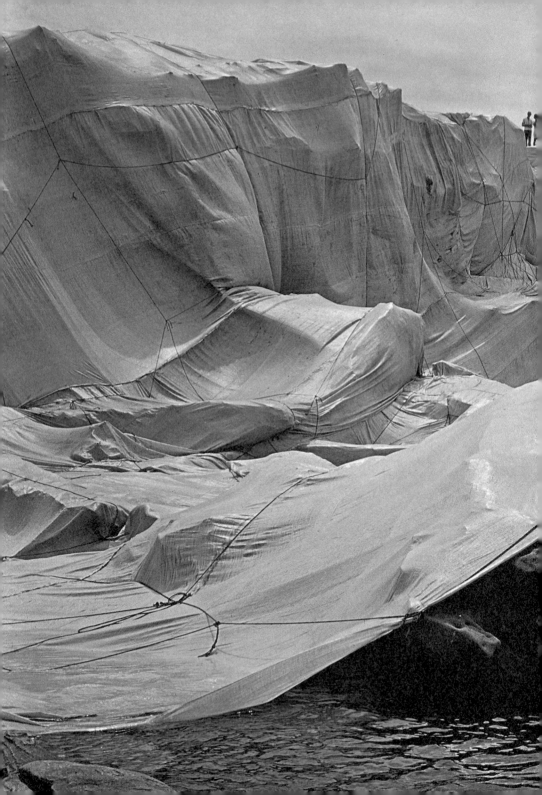

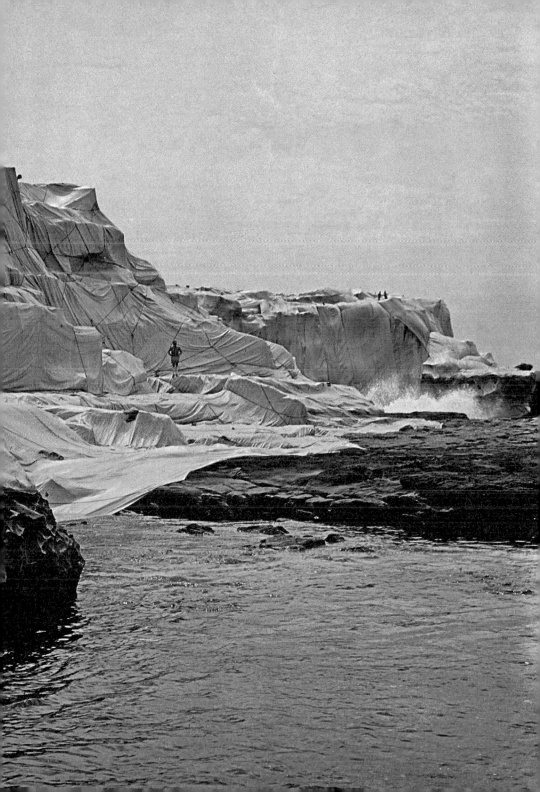

the direction of Max Bill, it established a reasonably satisfactory system for the training of designers for industry. It is not enough, however, merely to use designers to 'clean up' our environment. What is necessary is that society should feel the influence of all the skills, attitudes and ideas of all 'specializations'.

One of the editors, Gerald Woods, with a two-dimensional friend

We have placed the artists alphabetically. We have used no other system of classification, since we believe that the conventional categories are irrelevant. That is not to say that there are no relationships between the work of different artists, but, rather, that the relationships are likely to be transitory. Artists may form temporary groups in order to achieve some special purpose.

Many of our contributors appear to be obsessed by recurring themes. Hockney and Adami are both fascinated by the impersonal nature of hotel rooms, showers and the like. The designers Müller-Brockmann and Odermatt have both made use of phonetic spacing. Christo communicates by innuendo, hinting at the forms contained within his packages. By making the sound-track, in certain sequences of his films, almost inaudible, Antonioni

Modern materials such as fibre-glass, from which these commercial shop dummies were made, enable artists such as Bob Graham and Frank Gallo (page 118) to create their disturbing super-reality

makes us concentrate on the dialogue. He facilitates our understanding by deliberately making perception difficult. This apparent paradox is also seen in half-concealed letters in the work of Wolf and Godard. The space created by Fontana's *atesse* paintings, Burri's stitched 'wounds' and Pistoletto's 'mirror paintings' indicate something greater which is beyond our immediate comprehension.

A number of artists working in different media and independently of each other have expressed their interest in working in the area 'between art and reality'. They are concerned with the distance between images, between the real and the illusory. Pistoletto has said that the purpose and result of his 'mirror paintings' was to carry art to the edges of life, in order to verify the entire system in which both of them function. There has been a preoccupation with the simulation of real objects and with the transcription of familiar imagery, using new materials and adjusting the scale.

One of the interesting aspects of compiling and editing work for this book has been the way in which we have noticed in our surroundings examples of the

Federico Fellini Still from *Fellini Satyricon*, 1969

William Klein Poster for the film *Mr Freedom*, with graffiti, 1969

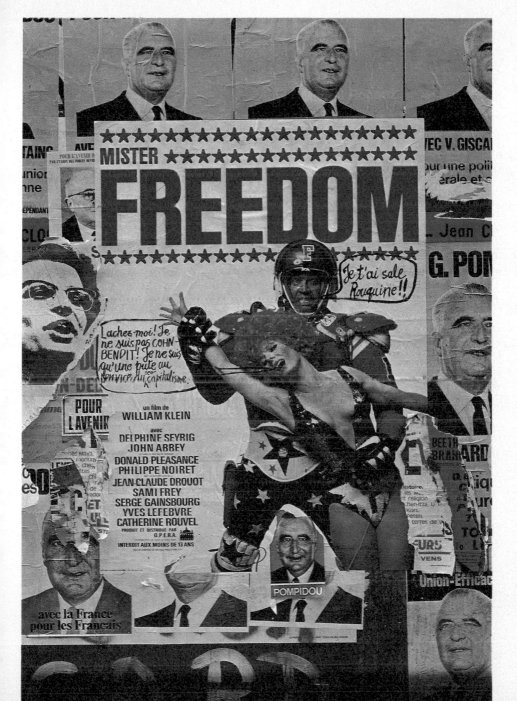

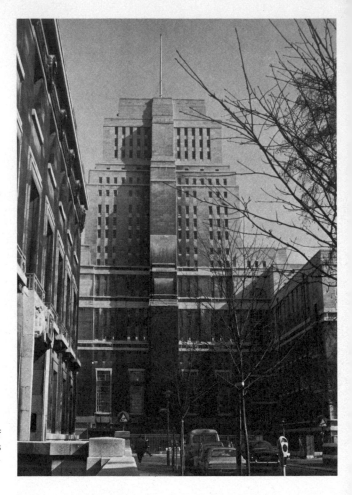

Senate House, University of London. This building seems to evoke the type of architecture which Folon draws.

source material from which many of the contributors have drawn their imagery. The kind of building which haunts Folon suddenly becomes noticeable in the familiar townscape of London. The Senate House of the University of London, particularly, seems to evoke the nightmarish architecture which he draws. The long-standing 'Sissons Paint' sign anticipates the work of Raveel, Gallina and Ceroli. The rough-cut breakers of an English seaside resort recall the technique of Ceroli's sculpture. As we watch buildings being wrapped for stone-cleaning, the work of

Drawing (1954) by Saul Steinberg, from *The Passport*. One of a series of drawings exploring stylistic divergence, an obsessive theme in the painting of the 1960s. Steinberg says, 'From way back it [his work] reads like a diary. It reflects what I've read, my entanglements with people, places, moods; various forms of schizophrenia that we all have and it's stupid to conceal.'

Christo inevitably comes to mind. Large motorway signs made from plastic sheeting appear to be derived from Oldenburg's 'soft' puns. The South London street which a motor dealer bought and painted bright red was a lucky find for Antonioni when he was making his film *Blow-up*. Adami has photographed the underground toilets at Victoria Station, London, and in almost any city one can see the sort of shop-fronts and hotel rooms which he uses as source material.

With the coming of the Renaissance, Western man re-awoke to the vast body of knowledge which had accumulated, and conceived a desire to enquire into his own nature and into that of the world. Leonardo would not allow himself to be contained by the strictures of 'art'. He was, at the same time, a musician, an architect and an inventor, as well as an artist. His science and his art complemented each other. The ensuing period of the Cinquecento, however, was analogous to our own time. We also, like our sixteenth-century ancestors, are taking a lateral view of our situation in an effort to relate a bewildering mass of information and techniques to our own needs.

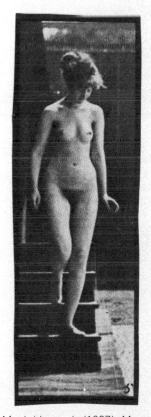

Muybridge nude (1887). Muybridge's thesaurus of humans and animals in motion has been plundered by painters continuously for a century. His obsessive image of a nude descending a staircase has been used by Duchamp, Richter, Jean-Luc Godard and others

Richard Smith 'The Amazone', 1969

Antonio Carena 'Captured Sky', 1967

The Artists

Valerio Adami

'"It is not enough to have a key to open a door," asserts Wittgenstein, and this is as true of the creative process as it is of the process undergone by the beholder when faced with a work of art.'

'I would like people to see my pictures in the same way as, according to McLuhan, a television picture is formed on the screen, by receiving three million stimuli a second. I believe that the viewer must re-experience in his own way the same creative process as the picture itself underwent. He should not find himself confronted with an object that is sealed, static. He should find himself involved in something that is actually coming into being. A picture is a complex offering in which previous visual sensations evoke unforeseeable combinations, the imagination ceaselessly forging new associations of ideas, with one image merging into another and with the original shape undergoing constant transformation.

'A work of art is, therefore, the expression of a perpetual dialectical game, which, via the picture, reaches out to the mind of the viewer and then, by recoiling on to the picture once more, brings about a real broadening of the viewer's experience.

'I have always strongly refused the pop label. Fortunately, today, it's a term fallen into disuse, almost. If we take a bottle of Coca Cola, even if it has never appeared in a picture of mine but serves here in an apt comparison with pop, if, then, I introduce a bottle of Coca Cola in a picture of mine, it would be that very bottle that occurred in connection with the precise moment of my life, the one before me the day a girl picked it up. It does not at all reflect, in the pop sense, its symbolism of society.'

'Suburban Rooms', 196⬛

36

'Cinema', 1969

Source photographs taken by the artist

Michelangelo Antonioni

'Of course the moment always comes when, having collected one's ideas, certain images, an intuition of a certain kind of development — whether psychological or material — one must pass on to the actual realization. In the cinema, as in other arts, this is the most delicate moment — the moment when the poet or writer makes his first mark on the page, the painter on his canvas, when the director arranges his characters in their setting, makes them speak and move, establishes, through the composition of his various images, a reciprocal relationship between persons and things, between the rhythm of the dialogue and that of the whole sequence, makes the movement of the camera fit in with the psychological situation. But the most crucial moment of all comes when the director gathers from all the people and from everything around him every possible suggestion, in order that his work may acquire a more spontaneous cast, may become more personal and we might even say — in the broadest sense — more autobiographical.' Michelangelo Antonioni, 'Entretien', *Cahiers du Cinéma*, October 1960.

Working from behind the camera, Antonioni frames a landscape, a building, or a room and its occupants, with painterly precision. In the film *The Red Desert*, the horizontal complexity of a grey industrial landscape is broken by a thin vertical flare stack which emits an orange flame; in another sequence, a whole street was painted grey to emphasize the isolation of the two main characters. In *Zabriskie Point* consumer goods are carefully arranged, shortly before a building and its contents are blown up.

In 1952 Antonioni collaborated with Fellini on a short film called *Lo Sceicco Bianco*. Like Fellini he has discarded the conventions of film-making. He avoids narrative, dramatic progression and development of character, making instead an intense analysis of circumstantial situations. He employs 'real' time, rather than the aggregation of cinematic time; his whole approach is essentially visual and autonomous.

Michelangelo Antonioni Still from *Zabriskie Point*, 1969

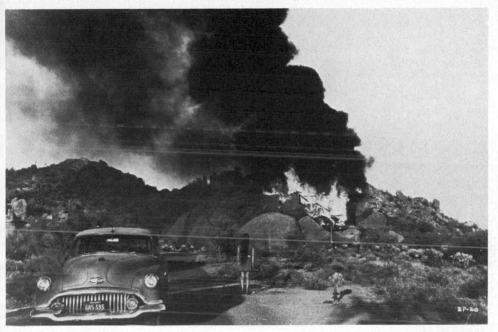

Still from *Zabriskie Point*

Antonioni arranging consumer goods on the set of *Zabriskie Point*, before the sequence during which an explosion takes place

Dennis Bailey

The peculiar form of schizophrenia that sometimes afflicts the designer, who is also an illustrator, is the desire, on the one hand, to organize the environment: to signpost, to rationalize, to codify (the designer's function), and, on the other hand, the desire to leave the subject-matter as it is (the illustrator's function). This dichotomy is usually side-stepped by administrative expediency in art schools and by the need of the average art-director to pigeon-hole everything. The pressures to develop one activity at the expense of the other are sometimes overwhelming, and it is unusual that in Bailey the two have equal status and co-exist on the same level. Bailey has achieved this partly by being his own art-director at various times.

But the contradictions outlined above have sometimes helped to create the necessary tensions in Bailey's work. For instance, the use of a free illustrative treatment in the four stamps designed for the G.P.O., instead of the more usual 'designed' (that is, formalized) approach, gives them their peculiar distinction. Similarly, a drawn illustration is given a sudden change of pace by the introduction of typographical elements. For Bailey treats typography as a structure and does not use it arbitrarily for a decorative purpose. In his design work, it is the essential problem which defines the solution. A freshness is thereby maintained, and a quality of surprise (which he probably experiences himself); he does not present a collection of

professional preconceptions.
His work as art director of
Town magazine was marked by
exquisite visual judgment and
imaginative detailing in
typography.

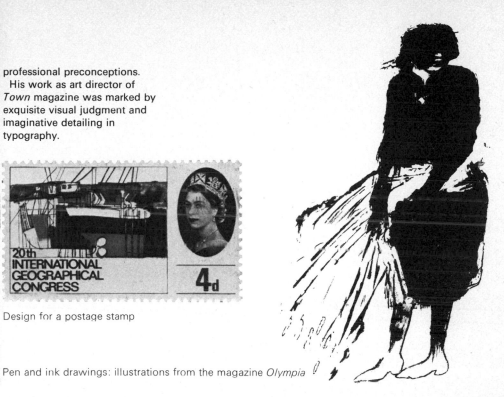

Design for a postage stamp

Pen and ink drawings: illustrations from the magazine *Olympia*

Double-page spread from the magazine *Town*

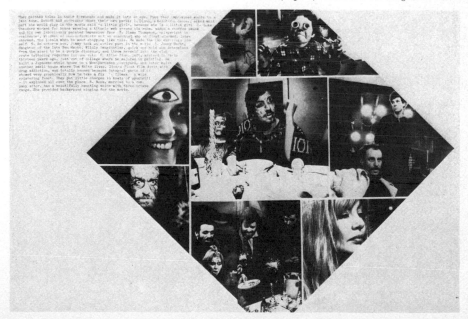

Saul Bass

Bass's design was the characteristic design of the 1950s. He combined the classically cool style of Rand with the robustness of the American urban landscape. And with his use of fragmented typography and photographs he created a new pictorial syntax. This use of pictorial images had been intimated at the Bauhaus, but Bass was one of the first to see its relevance to the design problems of the 1950s, and has been one of its most exuberant manipulators. His influence on graphic designers in England was overwhelming, for they felt that a viable vocabulary of design was at last being created. Although Bass has worked in almost every sphere of graphic and three-dimensional design, his work is now almost exclusively in film, particularly credit titles: a genre he almost invented. Graphic symbols take so long to develop, and take so many forms in gestation, that it sometimes seems illogical to stop the growth of one of them at one point and say that it is now fixed for ever. In Bass's film work, this organic process is enabled to continue, allowing the elements to reform, disintegrate and be regenerated.

Why Man Creates. The film is a series of explorations, episodes and comments on creativity. Each section of the film makes its own statement in its own style and technique:

 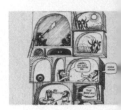

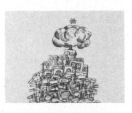

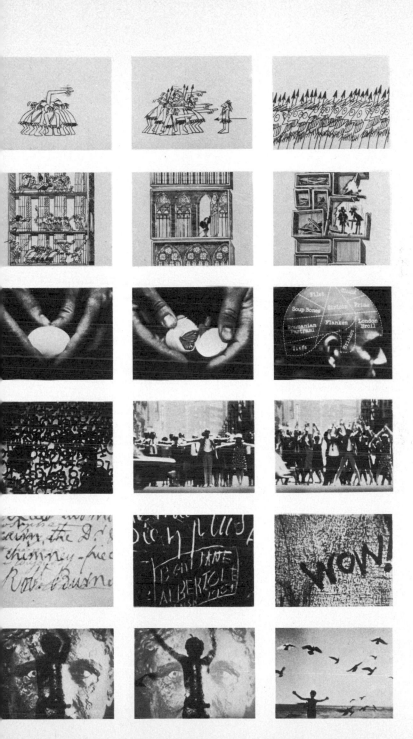

Lester Beall

The designer Lester Beall died in 1969, and any attempt to survey his life's work would to some extent involve tracing the history of contemporary American graphic design.

One of the most significant phases of his career was during the 1930s, when his typographical experiments clearly paralleled the work of the Constructivists. He was one of the first designers to recognize the validity of the Bauhaus philosophy, which became known in the United States through Moholy-Nagy and other *emigré* artists.

By using simple, contrasting elements, he gave the printed page a new dynamic form, juxtaposing black type with other elements printed in primary colours, X-ray photographs and montage techniques, heavy rules and directional arrows. In a lecture given in 1939 he said, 'We are not content to present a page of printed matter that, because of its weakness, goes unread. We want a living, dynamic entity that is both an expression of today and a working machine.'

Throughout the years of the Depression in America Beall continued to work as a freelance designer, resisting offers of permanent employment from various advertising agencies. The photographic experiments and paintings that he produced at that time are equally interesting. A series of posters designed for the Rural Electrification Administration in the late 1930s provided him with the opportunity of applying his principles of design to a larger format. He was the first designer to be honoured with

an exhibition at the Museum of Modern Art, New York.

In 1951 Beall established a design studio in the outbuildings of his farm in Connecticut. Here he was concerned with creating what he described as 'an organization, an environment and a system of thinking for the creation of organic design in the applied arts'. Within this concept of an integrated life-style, he paid great attention to detail, designing drawing desks and studio furniture; even the farm fencing appears to be placed in the landscape with the same precision that he would apply to a page layout. His extensive library was a central feature of his background as a designer. In a lecture given to the Art

Directors Club in Chicago he put forward his view that the dedicated designer should receive stimulation from music, painting, sculpture, architecture, the theatre, books, ballet and *life around him*, rather than be overtly concerned with the work of contemporaries, an attitude which could only result in unconscious imitation.

The full significance of Beall's pioneer work in the field of establishing a working method for designing corporate identity systems, is now widely recognized. The best known of his design programmes include those for the Caterpillar Company, Martin Marietta, Connecticut General Life Insurance, Rohm and Haas and the International Paper Company.

Symbol for the International Paper Company

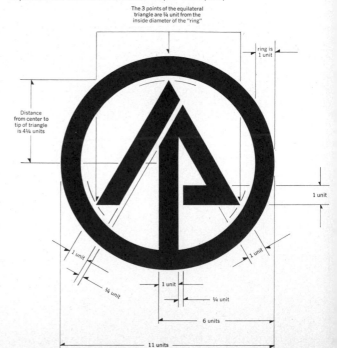

page 44

The International Paper Company is the largest paper manufacturer in the world. Beall was briefed to design a strong trademark which could readily be adapted to a wide variety of applications, ranging from the stencilled mark painted on the tree shown here to designs for cartons, labels or trucks.

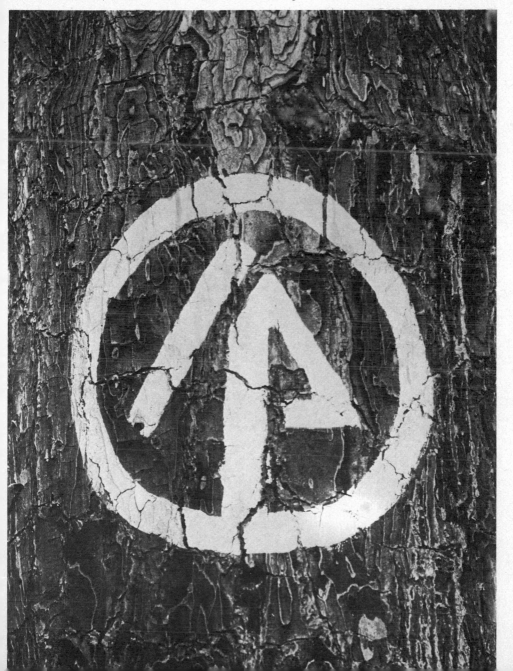

Max Bill

For forty years Max Bill has been active in architecture, sculpture, painting, design and publicity. His simple forms and geometric figures bear no relationship to the 'natural' world. He is always seeking simplicity and purity, and likes to arrive at a solution which has apparently no alternative. He has said that his subject-matter in painting is colour, and that the generation of fields of energy with the aid of colour is one of the new possibilities. He has himself no colour preferences. It is immaterial whether one likes or dislikes a colour, which he sees simply as a value in its own right. In his paintings he manipulates colour without preconceptions, and without reference to conventional colour relationships.

Bill has always shown an interest in education and from 1951 until 1956 he was director of the architectural section of the Hochschule für Gestaltung at Ulm, West Germany.

In this advertisement for a block-making company, designed in 1936, Bill achieved the perfect synthesis of meaning and structure in graphic terms — a concept which should lie at the root of every graphic designer's thinking. The half-tone screens are angled at forty-five degrees, and there is a continuous tension between the 'wrong' angle of the large eye and the 'correct' angle of the small eye. The pull between word (meaning) and image, the contrast in scale and texture, the ambiguity of line and half-tone, and the continually activated surface contain the seeds of subsequent thought in graphic design up to the present time.

Translation of the text shown in the illustration:

Generally the eye does not see the small dots which constitute a photographic reproduction in a newspaper. When highly magnified, the screen becomes distinct and one can recognize that the size of the dot determines the tonal values of the picture. In order to apply this principle in such a way that the block is made correctly, experience and careful work are necessary. We have the experience and are accustomed to do careful work.

Das Auge sieht im allgemeinen die kleinen Punkte nicht aus welchen eine fotografische Reproduktion in der Zeitung besteht. Stark vergrößert wird der Raster deutlich und man erkennt, daß die Größe der Punkte die Tonstufung des Bildes bestimmt. Um für seine Verwendungsart das richtige Cliché herzustellen, braucht es Erfahrung und sorgfältige Arbeit.

Wir besitzen diese Erfahrung und sind sorgfältiges Arbeiten gewöhnt: **Wetter & Co., Cliché-Anstalt, Zürich 6, Tel. 26 17 37**

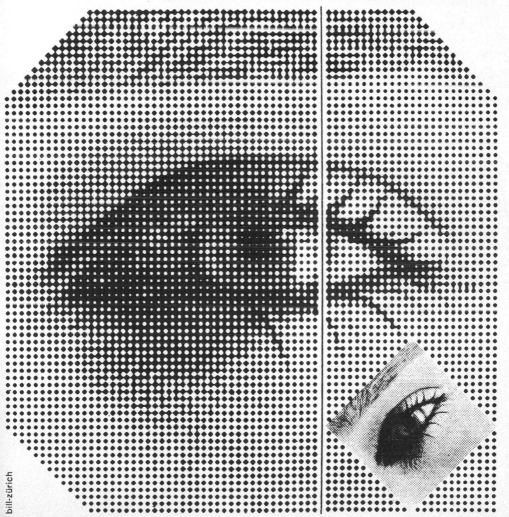

Derek Birdsall

In a sign and information saturated environment, the 1960s produced a new need and a new attitude. The need to stop designing and start relating. A 'taking stock' period was required. It was not necessary to invent any more new forms, but to relate, and make appropriate, things that already existed. The main material of the graphic designer had always been 'found objects' (of any culture) and prefabricated elements. But the characteristic trend in the 1960s was for the designer to manipulate his raw material less and less. The edict 'Don't design it, let it just happen' was in sympathy with the attitudes of artists working in other media. This is not to say that the torrent of freshly 'designed' symbols and monograms in any way abated; but the most interesting design was that which saw the rich possibilities in the mundane and in the problems of co-relation. The world of common objects was rediscovered by designers and painters at about the same time, the designer using his new awareness to create a language based on the common currency of objects.

The power of the word was also rediscovered, as was the awful presence of the unadorned text. Paradoxically, as the 'content' became more mundane, the actual costs for reproducing it soared.

Birdsall understands the nature of designing as an evolving process and seems to be able to turn the forces and tensions to work for him instead of against him, like a judo expert using his opponent's strength.

Above: design for the cover, and a double-page spread, from *Script*, a magazine published for members of the Script Writers' Guild of Great Britain. *Script* is financed by an extremely low budget, and each issue is limited to two thousand copies, one colour throughout. Below: cover of a prospectus for Mobil. The budget is high, yet the cover is restricted to one colour. A real stamp provides second colour.

the 'X' category. Some of the language would not, of course, be permitted in a normal feature film but in this context it seemed wholly acceptable.

Enter David Attenborough

The film was then submitted to BBC 2. And in June, David Attenborough wrote to King saying: 'The spoken obscenities, we decided, could be accepted. Nor were we worried as to how widely this particular kind of therapy is recognised or accepted in this country. We would not, after all, be showing the film in order to try and convince our audience on that point one way or another.

'But unhappily we have come to the conclusion that it is simply too harrowing to be broadcast to a general audience. I remember you saying in conversation that the effect of the film was devastating if one did not stay on until the end. You were indeed right, as I myself discovered, for I did not see the end on my first viewing.

'Very, many people would, I am sure, find it so painful that

they would turn away, as I did, before the end and be deeply distressed as a result. We do not feel we can properly treat our audience in this way.

'I am truly sorry to have reached this decision, for I greatly admire the film as a film. It more than merits the plaudits it received in Cannes. They must, I fear, sound rather hollow in view of this decision on our part – and for that I am very sorry.'

The Director replies

When Allan King replied he described Attenborough's decision as 'a mistake in itself and an unfortunate assessment both of your audience and of your obligations to it'.

King continued: 'Warrendale is a disturbing film but we should ask as Dr Winnicott does, "Do such children exist?" If so, why do we wish to deny it? What is involved in the denial, how do we justify it? That is a question to do with the children. In deciding not to show the film you are quite literally

involved in the basic social response which precipitates the problem and perpetuates it. Again quoting Winnicott, any clinical definition of sanity really means, "These people whom we cannot bear to be with". Why do we continue to collude in this state of affairs?

It is hard to accept the validity of censorship or refusal to show the film to protect an audience. Do you really think that is a valid point of view in a free and open society? It is characteristic of paternalistic orientation which I certainly would not associate with you, your audience is adult, so is ours here. They have the option to switch, they can be told in advance what to expect. Surely choice in the matter of a film whose merits you entirely accept can be left to your audience. They are far more mature than we like to think.

We have had a heartening experience with our theatre audiences were in Canada. They are young, perceptive, serious, and they come in droves. Virtually every performance was sold out in the first two weeks. And they come out for recreation, or

providing new and important insights. Certainly they are quickened when they emerge, unquestionably they have been profoundly moved. But that the experience was valuable has not been in doubt...

The unique virtue of television is its capacity to involve an entire nation in a shared moment of deep involvement. It is the experience of such moments which engage national insight. Warrendale has this capacity to enlarge attention profoundly. It treats alienation at a level which is both inescapable and ultimately promising. That is why it is so deplorable that it be denied a television audience.'

The ironical postscript to King's reply came when the BBC wanted to commemorate the closing of Warrendale by the Toronto authorities with a special programme. They asked King if he would allow them to use a few clips from his film. Understandably, King refused. He still hopes that the BBC will show the entire film. The film remains seen...

Symbol for the United Overseas Bank, Singapore. Part of a large corporate design programme involving the redesign of all the company's branch offices and forms, this symbol was designed to be as effective as possible on a large scale, as an external illuminated sign, and as a three-dimensional object for use as a badge or as an external sign mounted on a wall at eye-level. The illuminated version counts to five; the upright strokes are illuminated one at a time, the symbol being completed by the horizontal stroke. The apparatus is then switched off and the cycle begins again, one complete cycle lasting for about three seconds. The symbol was derived from the 'five-barred gate' system of counting to five, and in this formalized version is intended to represent security and to be manifestly oriental in origin. A more or less abstract symbol is particularly appropriate for use in a region where Chinese and English names for companies are not always translations of each other, and where few of the Chinese or English people can read each others' languages.

Jan Bons

Notes on communication

'Visual communication is to be used in case of emergency. Why send each other puzzle pictures when we can write or talk, perhaps using our hands?

'The visual language, though it may reach a high grade of perfection in itself, is much more primitive, more direct, nearer to smelling and touching than audible language.

'A picture of a telephone on a door tells me visually that I will be able to communicate there audibly. Is it really always the quickest way to indicate the place? I wonder if any test was ever made. I can imagine people looking for the word and overlooking the picture. Not only intellectuals. Also the village woman visiting her son in town, might more readily notice the enamelled plaque with the familiar blue type. This also became a picture. We can even 'read' it when illegibly battered. It is a matter of codes. One has to translate the picture as well as the word into the actual thing.

'We adapt our means of communication to the occasion, to the purpose. *A* wants to tell *B*. It's my work to find out how.'

Notes on experiments

'I made very few typographical experiments. I stick to traditions and disciplines. I like to read what has been written unhindered by typographical humbug. There are a few exceptions where the expressiveness of type adds to the word, the idea, or the poetry — as with some Dadaists — or rather adds to the atmosphere, for a bad text never became better by good typography. I agree that spoken or thought language never quits the laboratorium state, so we have to accommodate its printed form. Even relatively small alterations of the general code — f.i. a change in interpunction — is a revolution to some people.

'Unlike the ABC, colours and forms are vague codes of understanding. We have to mix again and again these reds to find the particular one that will do. Here experiments are very useful. I like to see what happens at the printers. Things may go wrong in your favour. It keeps your conscience awake by not relying on your own or someone else's knowledge. With colours and forms I like to do things as if they have never been done before.'

Sections from programmes for the Amsterdam Studio Theatre Group

toneelstukken:
oraison
les deux bourreaux
fando et lis
le cimetière des voitures
guernica
le labyrinthe
le tricycle
pique-nique en campagno
la bicyclette du condamné
le couronnement
le grand cérémonial
concert dans un oeuf
cérémonie pour un noir assassiné
la communion solennelle
les amours impossibles
une chèvre sur un nuage
la jeunesse illustrée
dieu est-il devenu fou?
strip-tease de la jalousie
les quatre cubes

romans:
baal babylone
l'enterrement de la sardine
la pierre de la folie, livre panique
fêtes et rites de la confusion

arrabal in 1932 in melilla, marocco geboren,
woont in parijs
thans op bogtocht
mij in spanje
beschuldigd van
godslastering en
belediging van
het vaderland

De architekt en de keizer van Assyrië is een obsessie. Het stuk gaat over liefde en angst. Het
laat zien hoe onvermogen tot liefde kan leiden tot panische situaties. De keizer en de
architekt zijn prooi van de VERWARRING. De keizer droomt; de architekt is zijn alter ego, of
althans een poging tot zijn beeld en gelijkenis. In zijn opstand tegen de moeder en de
maatschappij vlucht de keizer in het theater en het spel
We zien hoe doorzichtig en wanhopig het spel soms is, hoe akteurs dan weer komisch, dan weer
tragisch zijn en hoe tenslotte iedereen die komisch of tragisch tracht te zijn vaak niet meer dan
grotesk wordt. De keizer is het slachtoffer van zijn spel en een man in strijd met zijn masker.
De ceremonie laat hem alleen.
Arrabal confronteert zijn publiek met een geraffineerd samenspel van trucs, extremen,
banaliteiten, diepzinnigheden en onzin. Het zijn de trucs die voor velen middel zijn om te leven,
de extremen die logische konsekwenties zijn van het normale, de banaliteiten die bij het kinderspel
horen en het is de onzin die in staat stelt de zin te ontdekken.

ontwerp jan bons / druk w c den ouden

Walerian Borowczyk

'The fantasies of Borowczyk began in Poland. No official biography points out that his country was invaded when he was sixteen — he is first recorded demurely studying art at the Cracow Academy in 1946 at the age of twenty-three — but too much of the Polish chaos has been analysed and restaged for us to avoid the supposition that the ministries of fear in Borowczyk's films originated with the events of his late adolescence. From such a background would emerge quite plausibly the themes in his work of casual brutality, malignant direction by superior forces, the fragile, elegant past represented by faded snapshots and piecemeal lithographs, and a ritualism in which military and religious paraphernalia are closely intermingled.' Philip Strick, in *Sight and Sound*, Autumn 1969, vol. 38, no. 4.

Borowczyk has moved from posters to collage/drawn animation (with Lenica in *Once upon a time*), drawn film (*Les Jeux des Anges*), drawn film with live action (*Le Théâtre de Monsieur et Madame Kabal*), and 'conventional film' (*Goto, l'Ile d'Amour*).

'A moment always comes when one cannot help applying aesthetic criteria.'

'One can only copy one's dreams by an act of memory. It is therefore inevitable that one changes and organizes the elements. The final form taken by a work of art depends on the degree and direction of this operation.'

'In the domain of creation, everything which exists without belonging to a school, runs the risk of being considered useless.'

Still from the film *Dom*, 1958 'In *Dom* ('The House') I gave a hank of hair some milk to drink because it was thirsty.'

Still from the film *Encyclopédie de Grand 'Maman'*, 1963

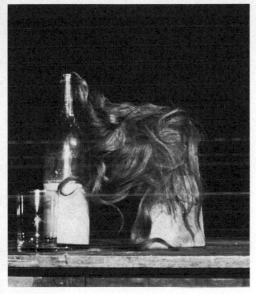

Still from the film *Theatre de Monsieur et Madame Kabal*, 1967. In this film Borowczyk is himself manipulated by one of his own drawn characters. Madame Kabal, dissatisfied with her creator's choice of head (ranging from a bomb to Mona Lisa), calls him to the screen and attempts seduction. Narrowly escaping this, he substitutes Madame Kabal for himself.

Still from the film *Goto, l'Ile d'Amour*, 1968

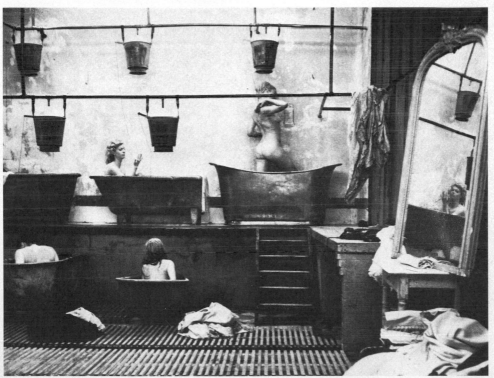

Mark Boyle

T. S. Eliot said, 'Human kind cannot bear very much reality'. Unfiltered reality is a preoccupation of many artists. And, in their different ways, people such as Birdsall, Godard and Pistoletto have blurred the edges of art and reality — art as life. The difficulty is in giving it formal expression without the form itself becoming self-conscious and 'arty'.

Throughout the history of art, there have been painters and sculptors obsessed with absolute objectivity and with a scientific approach to nature. Photography and moving film, which was developed at the turn of the century, could also be seen as an attempt to grasp total reality. But whereas, in the past, Romantics such as Constable, Ruskin, Monet, Seurat and the Impressionists chose what attracted them in nature, Boyle, whose 'ultimate object is to include everything', uses random selection to determine the scope of his activity. Everything, to him, is of equal value.

Boyle invites us to experience reality for its own sake. It is the formal means by which this is possible that Boyle finds suspect. He says, 'In the end the only medium in which it will be possible to say everything will be reality itself. I mean that each thing, each view, each smell, each experience is material I want to work with. Even the phoney is real. I approve completely of the girl in Lyons who insists that it's real artificial cream.'

One of nine sequences from *Suddenly Last Supper* (Mark Boyle's Queensgate event, 1964). After a meal the audience went into an empty studio where random films and burning slides were projected on to a variety of screens and surfaces, among them a slide of Botticelli's 'The Birth of Venus' (deliberately burned in the projector) projected on to this nude girl. During the piece all the pictures, furniture and fittings were silently taken from the house. The performers left, and the audience eventually emerged unsuspecting into a dark empty flat. Mark Boyle and his family had moved, all trace of their occupancy having been taken with them. As a member of the audience ('the audience must be regarded as performers') recounts, 'We were left alone, a group of self-conscious strangers, without anybody left to say good-bye to, or to thank for an extraordinary evening.'

A map from *A Journey to the Surface of the Earth*. A literally global project, this was launched at the Institute of Contemporary Arts in 1969 and was likely to take at least twenty-five years to complete. The purpose of this journey is to make 'multi-sensual' presentations of a thousand sites selected at random from the surface of the earth. These sites were selected by blindfolded members of the public throwing darts at an enormous map of the world. A map (on a larger scale) of each area in which a dart fell was then obtained and a second series of darts was thrown in order to locate each site exactly. Mark Boyle and his assistants travel to each site, selecting at random an area six feet square. A multi-sensual presentation is then made, which includes digging, collecting live specimens, taking surface casts in Epikote resin, making records by photography and film, collecting plants and seeds and making random physical checks on Mark Boyle and his assistants. In the event of the location being in the sea, surface studies will be made with film and perhaps surface coatings of the sea bed will be taken; also holograms of the water, and underwater films showing turbulence, will be made.

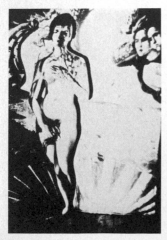 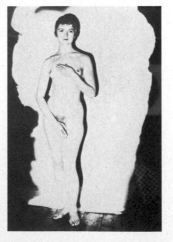

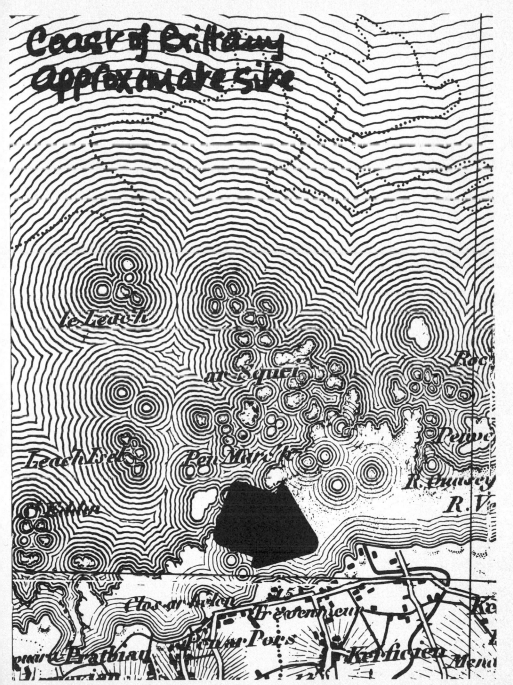

Coast of Brittany
approximate site

le Leac'h

ar Squel

Roc

Petite

Leach Isek

Pen Mar Ro

R Guasey

R. V

Clos ar

Frevenn

Kr

ar Pors

Kerficien Men

Prathian

Bill Brandt

'I had the good fortune to start my career in Paris in 1929. For any young photographer at that time, Paris was the centre of the world. Those were the exciting early days when the French poets and Surrealists recognized the possibilities of photography. One could say that it was now that modern photography was born. Atget's work was at last being published, he had died almost unrecognized, two years before; Brassaï, Kertesz and Cartier-Bresson were working in Paris, as well as Man Ray. Man Ray, the most original photographer of them all, had just invented the new techniques of rayographs and solarization. I was a pupil in his studio, and learned much from his experiments. There were the surrealist publications, *Bifur*, *Variétés*, *Minotaure* and others, the first magazines to choose photographs for their poetic quality; there were the surrealist films such as Buñuel's notorious *Le Chien Andalou* and *l'Age d'Or* which had a strong effect on photography.

'Looking back now, one can see that already two trends were emerging: the poetic school, of which Man Ray and Edward Weston were the leaders, and the documentary moment-of-truth school. I was attracted by both, but when I returned to England in 1931, and for over ten years thereafter, I concentrated entirely on documentary work. The extreme social contrast, during those years before the war, was, visually, very inspiring for me. I started by photographing London: the West End, the suburbs, the slums. I photographed everything that went on inside the large houses of wealthy families, the servants in the kitchen, formidable parlourmaids laying elaborate dinner-tables, and preparing baths for the family; cocktail-parties in the garden and guests talking and playing bridge in the drawing rooms; a working-class family's home, with several children asleep in one bed, and the mother knitting in a corner of the room. I photographed pubs, common lodging-houses at night, theatres, Turkish baths, prisons and people in their bedrooms. London has changed so much that some of these pictures have now the period charm almost of another century. After several years of working in London, I went to the north of England and photographed the coal-miners during the industrial depression. . . .

'In 1939 at the beginning of the war, I was back in London photographing the black-out. The darkened town, lit only by moonlight, looked more beautiful than before or since. It was fascinating to walk through the deserted streets and to photograph houses which I knew well, and which no longer looked three-dimensional, but flat like painted stage scenery. When the bombing started I was commissioned to take pictures of Londoners in their improvised air-raid shelters in unused Tube tunnels, East-end wine-cellars, church crypts and the basements of large houses. These pictures were taken for the Ministry of Information, and kept for the Home Office records. A selection of them was later published in *Lilliput* magazine, opposite Henry Moore's shelter drawings.

'Towards the end of the war, my style changed completely. I have often been asked why this happened. I think I gradually lost my enthusiasm for reportage. Documentary photography had become fashionable. Everybody was doing it. Besides, my main theme of the past few years had disappeared; England was no longer a country of marked social contrast. Whatever the reason, the poetic trend of photography, which had already excited me in my early Paris days, began to fascinate me again. It seemed to me that there were wide fields still unexplored. I began to photograph nudes, portraits and landscape.

'To be able to take pictures of a landscape, I have to become obsessed with a particular scene. Sometimes I feel that I have been to a place long ago, and must try to recapture what I remember. When I have found a landscape which I want to photograph, I wait for the right season, the right weather, and right time of day or night, to get the picture which I know to be there. . . .

'I always take portraits in my sitter's own surroundings. I concentrate very much on the picture as a whole and leave the sitter rather to himself. I hardly talk, and barely look at him. This often seems to make people forget what is going on and any affected or self-conscious expression usually disappears. I try to avoid the fleeting expression and vivacity of a snapshot. A composed expression seems to have a more profound likeness. I think a good portrait ought to tell something of the subject's

Photograph of Norman Douglas

past and suggest something of his future. Most frequently reproduced of all my photographs, is the portrait of a young girl resting on the floor of her London room. Perhaps it is not really a portrait. Her face fills the foreground and beyond the profile stand a chair and a chest of drawers; seen through two windows are houses on the other side of the street. This picture may have been subconsciously inspired by Orson Welles' film *Citizen Kane*. The technique of this film had a definite influence on my work at the time when I was starting to photograph nudes. Feeling frustrated by modern cameras and lenses which seemed designed to imitate human vision and conventional sight, I was looking everywhere for a camera with a very wide angle. One day in a second-hand shop, near Covent Garden, I found a seventy-year-old wooden Kodak. I was delighted. Like nineteenth-century cameras it had no shutter, and the wide-angle lens, with an aperture as minute as a pin-hole, was focused on infinity. In 1926, Edward Weston wrote in his diary, "The camera sees more than the eye, so why not make use of it?" My new camera saw more and it saw differently. It created a great illusion of space, and unrealistically steep perspective, and it distorted. When I began to photograph nudes, I let myself be guided by this camera, and instead of photographing what I saw, I photographed what the camera was seeing. I interfered very little, and the lens produced anatomical images and shapes which my eyes had never

observed. I felt that I understood what Orson Welles meant when he said, "The camera is much more than a recording apparatus. It is a medium via which messages reach us from another world."

'For over fifteen years I was now preoccupied with photographing nudes. I learned very much from my old Kodak. It taught me how to use acute distortion to convey the weight of a body or the lightness of a movement. In the end, it had also taught me how to use modern cameras in an unorthodox way, and for the last chapter of my book *Perspective of Nudes*, which was published in 1961, I discarded the Kodak altogether. These last pictures are close-ups of parts of the body, photographed in the open air. I saw knees and elbows, legs and fists as rocks and pebbles which blended with cliffs and became an imaginary landscape.

'When young photographers come to show me their work, they often tell me proudly that they follow all the fashionable rules. They never use electric lamps or flash-light; they never crop a picture in the darkroom, but print from an untrimmed negative; they snap their model while walking about the room. I am not interested in rules and conventions. Photography is not a sport. If I think a picture will look better brilliantly lit, I use lights, or even flash. It is the result that counts, no matter how it was achieved. I find the darkroom work most important, as I can finish the composition of a picture only under the enlarger. I do not understand why this is supposed to interfere with the

truth. Photographers should follow their own judgment, and not the fads and dictates of others. Photography is still a very new medium and everything is allowed and everything should be tried. And there are certainly no rules about the printing of a picture. Before 1955, I liked my prints dark and muddy. Now I prefer the very contrasting black and white effect. It looks crisper, more dramatic and very different from colour photographs.

'It is essential for the photographer to know the effect of his lenses. The lens is his eye, and it makes or ruins his pictures. A feeling for composition is a great asset. I think it is very much a matter of instinct. It can perhaps be developed, but I doubt if it can be learned. To achieve his best work, the young photographer must discover what really excites him visually. He must discover his own world.'

From an article in 'Album'.

58

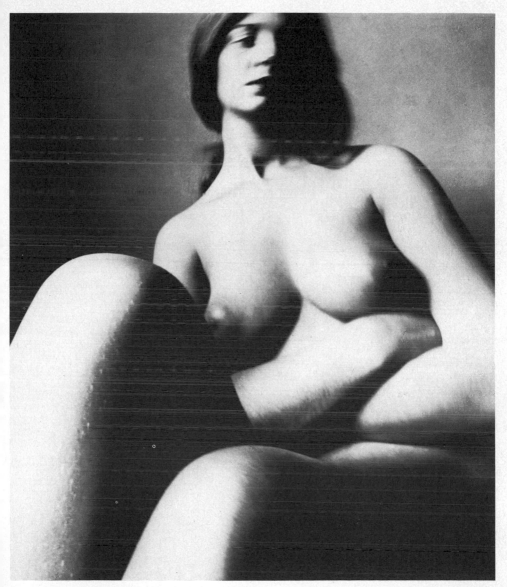

Photograph from the series 'Perspective of Nudes'

Robert Brownjohn

Robert Brownjohn died in
London during the summer of
1970. He was forty-four years
of age. We felt that it was not
possible for his life's work to be
adequately represented on a
double-page spread in this
book and we have therefore
reproduced only his last piece
of work.

Brownjohn studied
architecture and also (with
Moholy-Nagy) painting and
graphic design. During the
1950s and 1960s he worked as
a designer on both sides of the
Atlantic: as a partner with
Chermayeff and Geismar (see
pages 76–77) in New York,
and later in London, where his
ideas and experiments served
to foment a new conception
of what is possible in terms of
visual semantics.

Peace poster. Brownjohn pro-
duced this design shortly before
his death in 1970

PE ?

Love — Bj.

Alberto Burri

Burri studied medicine and surgery before serving in the Italian army as a doctor during the Second World War. He was taken prisoner and sent to a prison camp in Texas. The accumulation of his experience in treating the wounded, and performing surgery in the squalid theatre of war, disturbed him greatly, and in 1944 he began painting in an attempt to find a means of formulating the mental record of his anxieties. On his return to Rome at the end of the war these feelings persisted, and he gave up medicine and devoted himself entirely to painting.

He uses fragments of sackcloth and rags sewn together with twine like the wound of an emergency operation, but red paint seeps through the wound, and it does not heal. His visual surgery becomes a valid metaphor for the wounds of mankind which we try to conceal. First-degree burns are represented by holes made in plastic and metal with a blowlamp. His work serves as a constant reminder of our terror of the void.

Alberto Burri 'Red', 1956

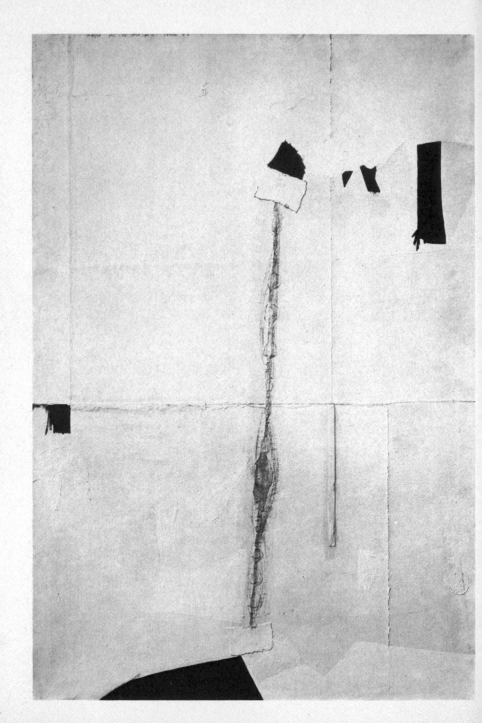

'Bag', 1959

Study for 'The Rent', 1952

Pol Bury

Pol Bury was an active participant in the surrealist movement in Paris until 1945, when he exhibited at the International Exhibition of Surrealism in Brussels. From then on his painting moved slowly towards abstraction and his forms became more organized. He abandoned painting completely in 1953 and began to experiment with mobile constructions that were motivated by concealed electrical impulses. He became obsessed with the slowness of motion and the time that exists between immobility and mobility, between the perceptible and the imperceptible. The eye cannot perceive the movement of spheres; a minute mechanism continually upsets any regularity that tries to establish itself. The constructions (beautifully made from stained and painted wood) demand a definite confrontation with the spectator. By concentrating on the slow moving object, Bury ensures that the factors of weight and gravity become evident, and that the volume of the object assumes its full significance. In 1968 he became interested in the use of magnets. Set in motion from within the base, they draw into their opposing fields balls which appear still freer.

The time element is present also in his 'cinematizations': photographs of images at hand (the Eiffel Tower, the Mona Lisa, the Pan Am building, bridges) are motivated by the cutting of concentric and separate circles in the photograph itself, and by the re-alignment of the internal shapes, to create the sensation

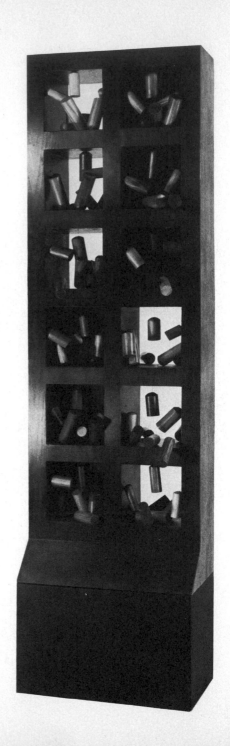

of a slow breaking-up
movement, like the tremor of
an earthquake.

'Every day, science makes a
discovery: the laser already
permits an impalpable reality.
We can start to be delirious.
The magnet and neon light are
only a small beginning.'

'112 cylinders in 12 apertures',
1966

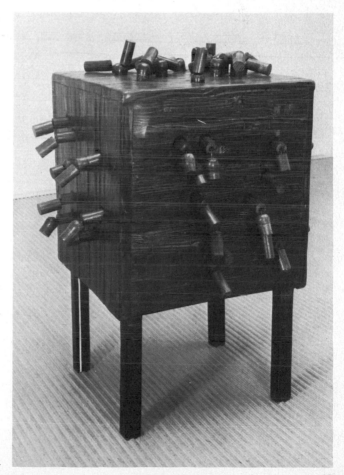

'Petit Meuble', 1964

Mel Calman

'I am continually drawing and doodling around the theme of identity. Men with labels, men with blank faces, men with masks keep recurring.'

'I find the idea of public and private personas fascinating: the image we present to the world and the image we have of ourselves often conflict.'

'These private obsessions sometimes reappear in drawing that I do for magazines and newspapers. *Fortune* magazine wanted some drawings about the business world and I started drawing a series of business men in masks.'

'Probably the best work any cartoonist/artist does is his most personal, and where his personal obsessions can relate to the outside world, then he can connect and other people can respond to them.'

Antonio Carena

A Sky for Everybody

'At the moment in which art will become nonsense, a computer will decide for us. In this expectation, I offer my meteorological information: *Cielo Sereno*.'

Carena says that he is a specialist in producing paintings of the sky. The fragments of sky that he paints on panels or circular plastic shapes can be placed anywhere in the home at the owner's discretion: on the floor, on top of furniture, or even hanging from the ceiling. He is prepared to risk the obvious in an attempt to clarify his intentions, and to make himself easily understood. Carena works for the mass of the people and not for an élite of art collectors; he prefers to exhibit in department stores, rather than in art galleries or museums.

He says that he has chosen the sky as his theme because of its universality. Like many painters before him, he is fascinated by the atmospheric qualities of light and space, and the movement of clouds across the sky. The clear blue sky, and the passing clouds, are rendered by him in a style which is anonymous and impersonal.

Carena says that when he thinks about the world he does not think about the dramatic or the fantastic, but about the world's very existence. By concentrating on the reality of his subject-matter, he feels that he is verifying his own knowledge and experience, and for this reason he rejects any romantic stylization and evasive formulas. He prefers to make a straightforward transcription of his subject, without any suggestion of indeterminacy.

Although his work consists of an objective record, there is nevertheless a calming consistency in all his paintings.

(See also page 34.)

'Film', 1962

'On Sham Poetry: Sky', 1968

'Sky Object', 1966

71

Eugenio Carmi

During the period 1950–58, Carmi worked primarily as a graphic designer. He became art consultant to the Italian steel group Italsider, carrying out the research and development of corporate identity systems. While he was working for Italsider, he and Carlo Fedeli edited a book called *The Colours of Iron*, in which various weathered states of steel and iron stock were documented by photographers and painters (including Alberto Burri). Carmi extended his studio work at Italsider by exploring the metal workshops, and, in 1962, produced a series of heavy iron and steel sculptures which were exhibited at the Festival of the Two Worlds in Spoleto. He also discovered 'ready made' prints in a lithographic printing factory which specializes in printing on tin, where he retrieved printed sheets of tin before they were moulded into containers for soup or polish. To some extent the printed sheets were analogous to the work being done at that time by American pop artists; the brash, repetitive, coloured designs on the tin sheeting were like continuous targets, or like Warhol's stacks of canned soup.

In an old warehouse near his home in Genoa, Carmi established an artists' workshop co-operative, where sculpture, painting and prints could be sold in editions at low cost by mail order.

In 1965 he became interested in signs and symbols released from their function of directing and anticipating the actions of motorists. He re-arranged the basic shapes, letter-forms and numerals. By inventing his own signs Carmi presents us with an imaginary system of non-verbal communication.

'Walking down the streets I saw those forbidding signals and I have made my own signals for the imagination. They are made out of Perspex, using the same shape in common use for traffic signals. The difference: you can keep them at home, look at them or not, emotionally or not, but certainly not anxiously.'

The idea of low-cost unsigned multiples has always appealed to Carmi; he has even designed fabrics which are made up into dresses. 'These are my best multiples as, not lying on a table, they surround a living body. And then you can meet them in the street, which is the right place for art.'

Carmi has also experimented with computers, devising an automatic system of presenting images whereby seventy-two fragments of the images are silkscreened on to Melinex tapes which are then wound and unwound mechanically. The electronic controls are activated by sound stimuli from the spectator; these are picked up by a series of microphones and converted into an electronic signal.

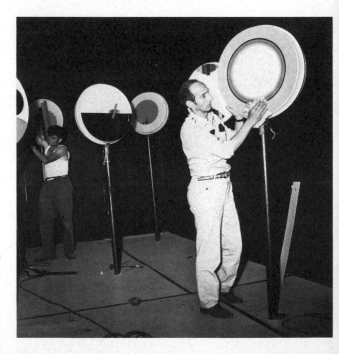

Caorle, Venice, 1969. Carmi during the setting-up of his environment of electric imaginary signals

Exhibition of multiple paintings in a department store at Taranto

Carmi dressing a girl in a fabric called 'Signal', which he designed

Mario Ceroli

Ceroli's sculpture has the appearance of being rapidly 'knocked together'. His silhouettes and related structures are made from roughly cut planks of unplaned wood, which are nailed, bolted and joined together to make up, say, a row of marching soldiers, a butterfly, or the Sistine Chapel.

The apparent incompatibility of the material with the subject dictates the simplicity of the sculpture and prevents Ceroli from making a too literal interpretation of his source imagery. Each work seems to be a sophisticated pun on the serious issues of today; alternatively, Ceroli makes a transcription from familiar 'art history' figures: Botticelli, Michelangelo and Leonardo. The sensitive details of frescoes, translated into splintered plankwood shapes, yet retain their identity to a certain degree.

'Small Square Club'

'Farfalla', 1968

'Detail of Sistine Chapel', 1966

Chermayeff and Geismar

Originally this partnership consisted of three members (Brownjohn, Geismar and Chermayeff) until Brownjohn left the United States for England in 1960. (For Brownjohn, see pages 60–61.) Their work included designs for record sleeves, trademarks, advertisements, stationery, posters. They were also responsible for *Streetscape*, an abstraction of American urban typography and demotic signs created for the 1958 Brussels World Fair. As Chermayeff and Geismar, they have since carried out similar murals for the New York underground. Recent work includes a complete house-styling programme for Mobil. (Significantly, the trademark is now the name; if you have a memorable name why load it with superfluous graphics?)

The fact that Chermayeff and Geismar are superbly gifted and professional need not be stressed. What is more important, and what lifts their work out of the realms of mere effective graphic design, is the fact that it is informed by a sense of history and by widely

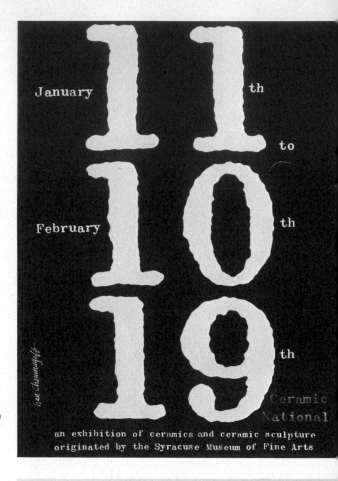

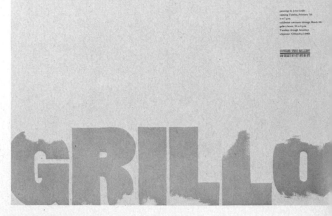

Poster for the Nineteenth National Ceramic Exhibition, Syracuse Museum of Fine Arts

Poster for an exhibition of the work of John Grillo at the Howard Wise Gallery, New York

Cover design for *The Journal of Commercial Art*

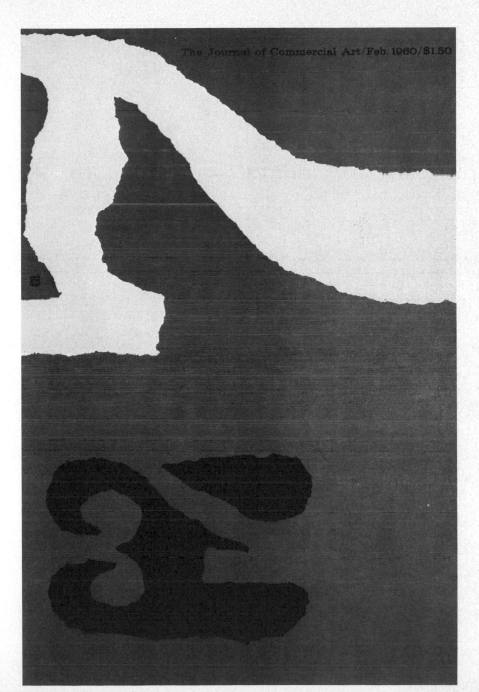

The Journal of Commercial Art/Feb. 1980/$1.50

Double-page spreads from *About U.S.*, an experimental booklet produced under the sponsorship of 'The Composing Room Inc.'

ranging cultural interests. Chermayeff is the son of Serge Chermayeff, a pioneer of the modern movement in architecture.

Gene Federico, writing of their work, commented, 'The aware designer's intuitive and acquired knowledge invests in him a more reliable sense of his times and of the needs of the people. Sensing these, he is able to "talk" directly. He *knows* intuitively the language of his day and, whereas research groups may possibly note the effectiveness of his work of yesterday, they cannot even indicate the imperceptible changes from yesterday's ''language'' to today's, let alone the language of tomorrow.'

It is significant that those graphic designers whose contribution to our times and our understanding is greatest are invariably those who have benefited from a peculiarly liberal educational system in which all manner of unlimited possibilities are admitted. Their work has the tension that hovering between such possibilities brings.

+dd

−tract

xultiply

div÷de

spe-cif'i-cal-ly

r e g i m e n t e d

f1rst

EXPEN$IVE

e¢onomical

Christo

As a member of Yves Klein's 'new realist' group in Paris, the Bulgarian-born artist Christo produced his first packaged objects in 1958. His early packages were small in scale; then he began to work on a progressively larger scale, moving from the small still-life to a pushchair, a motor-cycle, or a Volkswagen. In all his packaged works the scale is that of the wrapped object itself. The act of packaging is for Christo a temporary transformative act. The original object or structure is modified by the wrapping which conceals it. The act of concealment does not completely destroy the identity of the object, but demands our further recognition of the forms which lie beneath the wrapping. In 1961 Christo formed the idea of packaging on an architectural scale. To do this he prepares careful working drawings, three-dimensional models and photo-montages. Permission is not always granted for the carrying out of such projects. In these circumstances the work is documented simply by the initial photo-montage visualization, although Christo prefers to see the project through to its completion as a 'live' event. When he packaged the theatre and several other old buildings in the Umbrian hill town of Spoleto, the local people were perturbed to see the buildings which they had known for a lifetime concealed by polythene and canvas. But perhaps they now became more aware of the baroque forms, which previously may have passed unnoticed. By concealment and obstruction we learn to appreciate.

There are other aspects of Christo's work which are equally important: in particular, the series of aluminium store fronts which he produced for the Documenta exhibition at Kassel, 1968. In this work Christo shows the same interest in faceless windows and emptiness that has for long been noticeable in the films of Antonioni and Fellini.

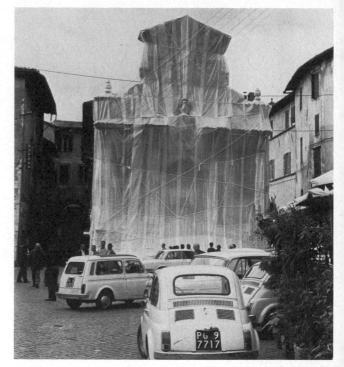

Wrapped fountain at Spoleto, 1968

Packed tree, 1966. Length, 33 feet

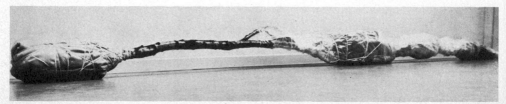

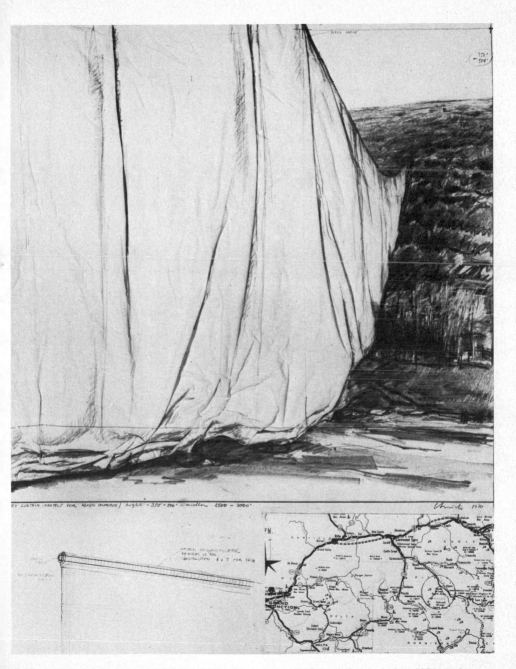

Preliminary drawing and plan for the 'Valley Curtain' project, carried out during 1971 at Aspen, Colorado

Chryssa

During the 1950s Chryssa used fragmentary letter-forms, broken messages, building plaques, and newspaper tabloids as her main source material for paintings and sculpture. The newspaper paintings consist of repeated columns of blurred type identified only by the overall tonal pattern broken by precise column spacing. Her plaques and tablets are partially literal transcriptions, proposing a general notion of the sign, rather than relating to a specific sign.

While a number of her contemporaries were using neon light as part of their paintings and constructions, Chryssa first used neon in 1962 as part of a sculpture called 'Times Square Sky'. The word 'air' was formed in neon surmounting larger metal letter shapes. The direct associations with the commercial sign became more obscure as Chryssa perfected the manipulation of neon techniques. The letter-forms become more abstract as the neon forms free-flowing shapes enclosed in grey or near-black Perspex boxes, which soften the bright neon colours and simulate the effect of coloured neon at dusk. Coloured neon is 'equalized', so that no single colour dominates the whole structure; the intervals between darkness and illumination are carefully programmed and controlled by an electronic timer.

(See also page 14.)

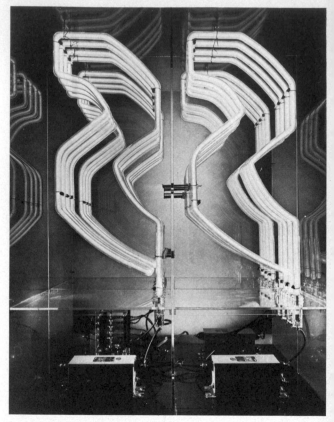

Study for the 'Gates' series. Fragment No. 5 (Tate Gallery)

Study for the 'Gates' series ▶

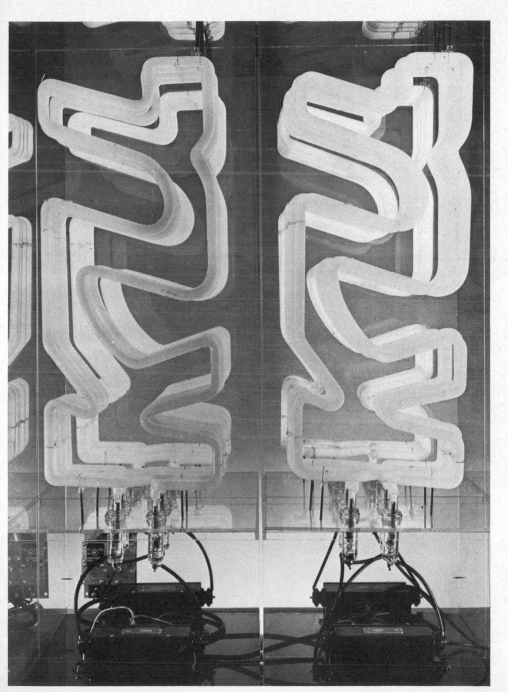

Roman Cieslewicz

As a student in Cracow, Cieslewicz trained in the tradition of Polish graphic design. Later, in Warsaw, he produced over two hundred posters for the theatre and cinema. The posters provided an ideal vehicle for extended experiment with photo-mechanical techniques. By juxtaposing photographs of enlarged nineteenth-century line-engravings with freely drawn shapes, images out-of-focus with sharp line-photographs, and baroque cut-out letter-forms with enlarged half-tone screens, Cieslewicz created haunting compositions, mainly in black and white, that were reminiscent of the surrealist movement. Settling in Paris in 1963, he found it necessary to reconcile his method of work to the

demands of publicity design. He became art editor of the magazine *Elle* and was able to give the page layouts new emphasis by adding graphic comments to fashion shots. More recently he became interested in the pop art movement and designed a series of covers for the magazine *Opus International*, using bright primary colours registered with black line drawings and revived typefaces.

In all his work he retains his personal identity within the context of the problems of a particular publicity campaign. He manages to be fully committed to the demands of society and yet to remain aloof as an experimental designer. The unifying link in

his work lies in his ability to use fragmentary elements, colour and type, in a way that is dramatic and concise. His interest in pop art has perhaps made his recent work less serious in content and more open to amusing visual themes.

Cover design for the magazine *Opus International*, 1968

Cover design for *Opus International*, 1969

Poster for Kafka's play, *The Trial*

Design for 'Paris la Nuit de Jacques-Louis Delpal', 1968

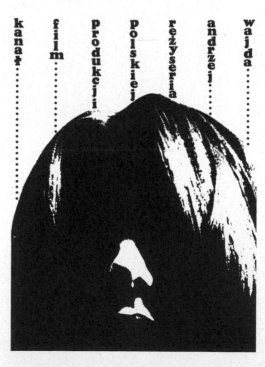

Poster for the film *Kanal*

Giulio Cittato

'I consider myself a visual communicator. Art should be the culminating of earlier graphic communications, after these communications have lost their initial utilitarianism. If it was art to begin with, when it loses its functions it will remain art. I also consider my work precise yet emotional; geometric, yet spiritual; mathematical but feeling. I believe that the environment should be an expression of a higher, well-ordered and complete dedication to the well-designed. And by environment I mean all that surrounds us. Trains and roads, packages and toys, buildings, doorways, clothing and refrigerators.'

Chicago is the biggest printing centre in the world. Every day millions of American popular magazines, mail-order catalogues and brochures are printed there. Giulio Cittato was born in Venice and now lives and works in Chicago. However, he has clients on both sides of the Atlantic: in Italy and in the United States. His work includes industrial design and packaging, and he has received commissions from such diverse organizations as Rinascento, the Milan department store, and the Container Corporation of America.

There is a marked clarity in his visual diagnosis of linguistic problems. He employs symbols and signets to illustrate the meaning and function of an object or of a service. His choice of colour and the legibility of the letter-forms give a distinctive quality to his work.

Package design for Resistol hats, 1966

Pages from corporate identity programme for Varian, Palo Alto, California, manufacturers of scientific and technical equipment

Bob Cobbing

'It seems to me that almost all the valid experimental work going on at present in British poetry can conveniently be considered under the heading "concrete" though I am aware that this is stretching the word concrete further than ever intended by the originators of the term "concrete poetry".

'Concrete poetry, for me, is a return to an emphasis on the physical substance of language — the sign made by the voice, and the symbol for that sign made on paper or in other material and visual form. Leonardo da Vinci asked the poet to give him something he might see and touch and not just something he could hear. Sound poetry seems to me to be achieving this aim.

'Partly it is a recapturing of a more primitive form of language, before communication by expressive sounds became stereotyped into words, and the voice was richer in vibrations, more mightily physical. The tape-recorder, by its ability to amplify and superimpose, and to slow down the vibrations, has enabled us to rediscover the possibilities of the human voice, until it becomes again something we can almost see and touch. Poetry has gone beyond the word, beyond the letter, both aurally and visually. Visual poetry can be heard, smelt, has colours, vibrations. Sound poetry dances, tastes, has shape.

'My use of "vocal-micro-particles" as Henri Chopin calls the elements with which we now compose sound poetry, retains, indeed emphasizes, the natural quality of the human voice, more perhaps than does Chopin's poetry. But both he and I are attempting to use new means of communication which I believe is an old method re-established, which is more natural, more direct and more honest than, for example, the present-day voice of politics and religion.

'Parallel to this total use of sound, is picture poetry which extends communication by utilizing primitive sign which is also direct, expressive and universal.

'Poetry in these forms is closer to physical being, at least one step nearer to bodily movement. Gone is the word as word, though the word may still be used as sound or shape. Poetry now resides in other elements.'

From 'The Wild Game of Sight' (1970).

Collage

Poem 1 (top left)

```
        lo                    so
     so  so                 solos
       sol                   los
    solo  o                oso  os
     o slo                  solo
   os  oso                o  oslo
      los                   sol
     solos                 so  so
      so                    lo

    oslo                   solo
```

Poem 2 (top right)

```
              grin
              grin
              grin
              grin
              grim
          gay green
          grey green
          gangrene
          ganglia
              grin
              grin
              grin
```

Poem 3 (bottom left)

```
tan tandinanan tandinane
 tanan tandita tandinane
  tanare tandita tandinane
 tantarata tandine tandita

tan tandinanan tandina
 tanan tanare tandita
tantarata tanrotu tankrina
tan tandinanan tankrina

 tanan tanare tankrina
 tanrotu tanrita tantarane
tanrotu tantarata tantarane
tantarane tanrita tanrita

tan tandinanan tandinane
tan tandinanan tandina
 tanan tanare tankrina
 tanan tandina tandinane

 tanan tanare tandita
tanrotu tanrita tantarane
 tanare tandita tandinane
tantarata tanrotu tankrina

tanrotu tantarata tantarane
 tantarata tandine tandita
tan tandinanan tankrina
 tantarane tanrita tanrita
```

Poem 4 (bottom right)

```
    'm
    'n
   h'm
   h'n
   m'm
```

Four concrete poems, 1967

Crosby, Fletcher, Forbes

In the 1950s there was often a disparity between the words, the image, and the idea, and much design at the time was an uncomfortable mixture of 'fine art' design and 'literary' copy. During the 1960s the attitude towards graphics became more robust. Words and ideas became important. In fact, the best design during the 1960s was carried out with wit, humour and irony, and the designer maintained his integrity while still serving the interests of his clients. The best work carried echoes and ramifications over and above the mere acceptance and completion of a brief.

Crosby, Fletcher, Forbes is the combination of the architect Theo Crosby and the designers Alan Fletcher and Colin Forbes. Originally, Fletcher and Forbes were allied with Bob Gill in Fletcher, Forbes, Gill. And it was probably Bob Gill who gave the group its initial impetus. The partners defined and crystallized the feelings, attitudes and aspirations of many designers, at a time when there was an understandable uncertainty about the character of British design, hemmed in as it was by the 'cool' Swiss style on the one hand, and by transatlantic exuberance on the other. They gave it a new identity at a time when the Beatles were doing the same for English pop music. In fact, there is an interesting analogy between pop music and the design groups of the 1960s.

Design for letter heading for the Flora Boutique

Logotype for the Fifth International Pressure Die Casting Conference

Trademark for Holman Paper Sales

Design for the symbol of the Liverpool Metallizing Company

Bus advertisement for Pirelli Slippers

Logotype for Reuters News Agency

Trademark for the Lead Development Association, 'Lead Power Year'

Double-page spreads from the pamphlet *Objects Count*

Cover design for the magazine *Typographica*

Wim Crouwel

'A proposal for a new type that is suited for the composing system with the cathode-ray tube'

'The use of alphabets, of which the letters are individually designed with meticulous care, involves the same meticulous care in the setting of type. It is the individual designer's sense of form that determines the proportions of the letters and human imperfections, although often imparting an attractiveness and distinctive character, require corrective alignments and spacing when the type is being set. This operation cannot, of course, be performed with complete effectiveness by a machine, not even with the assistance of an elaborate computer. The precision of the human eye coupled with an aesthetic feeling can never be equalled by any mechanical device. Nevertheless, the machine has to be accepted as essential if we are to cope with the demands of our age. The quantity of information which must, of necessity, be printed daily has increased to such an extent that mechanization is indispensable.'

'The inconsistency now becomes more apparent.'

'The letters have never evolved with the machines.'

'The proposed unconventional alphabet shown here is intended merely as an initial step in a direction which could possibly be followed for further research. The reproduction method by means of the cathode ray, the same principle as used for television, is taken as a starting point. The letter symbols will be introduced into the memorizing mechanism of a computer. Because circular and diagonal lines are least suitable for this technique of screen reproduction, the proposed basic alphabet consists entirely of vertical and horizontal lines.

'It will be possible for the typographer, by adding appropriate directives, to arrive at the final form of the text. Other signs can be used to specify italics, Roman, bold or light, wide or condensed, as well as differences between typeface and spacing, or any other wanted detail.'

'Capitals are denoted by a line above the letter.'

An evident comparison, very much enlarged, between a 'scanned' Garamond-a and a 'scanned' newly proposed form of the a.

Een voor zichzelf sprekende vergelijking, in sterk vergrote vorm, tussen een 'afgetaste' Garamond-a en een 'afgetaste' voorgestelde nieuwe vorm voor de a.

Une comparaison évidente, dans une forme très enlargie, entre un Garamond-a 'balayé' et une nouvelle forme proposée pour un a 'balayé'.

Ein für sich selbst sprechender Vergleich, in stark vergrösserter Form, zwischen einem 'abgetasteten' Garamond-a und einer 'abgetasteten' vorgeschlagenen neuen Form für das a.

Extracts from *New Alphabet*, a
booklet outlining a proposed
plan for the development of
programmed typography

Allan D'Archangelo

Allan d'Archangelo is one of the most significant landscape painters working in America at the present time. His main work has been concerned with the way in which man is transforming the surface of the earth by roads. Giant multi-lane freeways link the east coast to the west, and state to state; in European countries, motorways form networks which contain every town and city. The hill towns of Tuscany and Umbria are scarred by the Autostrada as it moves south to Rome and Naples. This man-made spectacle has an international uniformity. The soft green shoulder, the tarmac divided by crash barriers, the white centre markings which lead the eye to the horizon, the bridges of a standard pre-stressed concrete design, the anticipatory signs: all these elements radiate in perspective towards infinity.

Like Gaul and Carmi, D'Archangelo rearranges the constituents of this landscape to create anonymous iconic pictograms. In his recent paintings he has taken single elements from his earlier works in order to develop an interaction between sign aggregates.

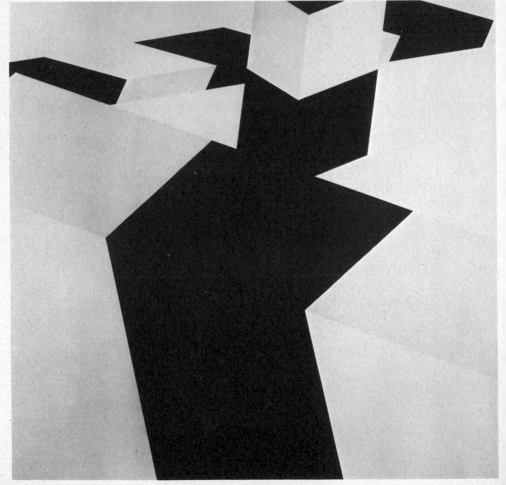

'Landscape', 1969

'Constellation No. 4', 1970

Rudolph De Harak

De Harak's work as a designer goes beyond the mere organization of elements in space. Like Paul Rand, he seems to be able to apply his intuition to the problems of functional design. He has a personal philosophy which sees design in its relationship with all other aspects of civilized life. And from this comes an individual style which, at times, exhibits the sort of nuances that one associates with surrealist painting. This is particularly noticeable in the small drawings or ideograms which he produced as spot illustrations for *Esquire*.

His recent work, executed since he became a partner in the Corchia-De Harak graphic and industrial design group, has been in three-dimensional design and departs quite radically from his earlier illustrative work as an art director for the magazine *Seventeen*. His designs for a series of clocks, for instance, are impersonal and rigidly functional, but the imaginative substance of his graphic work has an enduring quality which is almost extinct in contemporary design.

Gallaghers 33 Corchia/De Harak exhibition design

Cover design for the magazine *Graphis '70*

Magazine illustration

Cover design for the record
Sounds from the Alps

Sounds from the Alps

WESTMINSTER

Design: Rudolph de Harak

Eric De Maré

'For better or worse buildings deeply affect our lives. Why then do most people take so little interest in them? Architecture remains a branch of archaeology to be enjoyed only on holidays abroad; at home eyes are closed to the urbanoid mish-mash, as Lewis Mumford has called the chaos. The main causes of the degradation are social-economic, but one cause must lie in a serious gap in general education. Architects and planners, who are not really responsible for the subtopian mess of the industrialized world, talk only to each other in an esoteric language no one else understands. Who then is to teach the teachers?

'The camera can help for it can open the eyes far wider than words. The photographer is perhaps the best architectural critic, for by felicitous framing and selection he can communicate direct and powerful comments both in praise and in protest. He can also discover and reveal architecture where none was intended by creating abstract compositions of an architectonic quality – perhaps from a ruined wall, an old motor car or a pile of box lids. This exploratory nature of architectural photography, as opposed to mere recording, can provide the greatest pleasure and, through subtle intimations, it can teach a few architectural lessons.

'The meaning of architecture is barely explained by the trinity of Commodity, Firmness and Delight. Its aesthetic can be further divided into three overlapping categories. The first is two-dimensional, that is façade, where the third

dimension is concerned only with modelling and texture. Here, in a way, architecture is like painting or graphic art. The second category is three-dimensional, that is external form, where light and shade are all-important. Here architecture is like sculpture whose effects vary as you take different stands *outside* the composition. The third category is four-dimensional in that time is involved. Changes in spatial relationships are appreciated as you move around *inside* a building. This is pure architecture which cannot be likened to any other visual art. As Lao Tse said a long time ago, "the reality of building does not consist of walls and roof but of the space within to be lived in." Here townscape becomes pure "internal" architecture with streets as corridors, open spaces as rooms, and sky as roof, while trees, serving as organic foils to the structural geometry, create baroque decoration.

'Photography cannot express this spatial aspect of architecture, except inadequately by suggestion or by a series of shots. Space control can only be appreciated directly by the body moving legs, waist, neck and eyes at will; hearing may also be involved and sometimes smell. Even cinema cannot realize such physical actuality with its dramatic contrasts and sudden surprises. The limitation must be accepted. Some have tried by bold experiments to overcome it but all have inevitably failed owing to the nature of the process.

'In spite of that, photography can admirably express and

make personal comments upon the man-made environment as façade and as sculpture. There it can communicate the poetry of structure – that is, the clear articulation of the dynamic forces that keep a building stable. A good photograph can make you feel a great edifice ceaselessly at work to maintain its equilibrium, for example through the flying buttresses of a medieval cathedral where the outward pressures of the nave vaulting are transferred in a rhythm of daring leaps to sturdy stone piers and thence to the ground. Here engineering and architecture are one. Within its limitations the camera, whether used by professional or amateur, can do an immense service in many ways in helping to reinstate the Mistress in her rightful throne among the arts.'

Warehouses, Rye, Sussex. This photograph was used for a Gordon Fraser postcard

Walter De Maria

De Maria might be designated 'ultra-conceptualist' or 'purist', but it is only when one realizes that almost any label can fit him that one sees that he defies any single label. He simply uses the appropriate form to express his singular sensibility. What is necessary to De Maria is the involvement of the spectator. One work, produced in 1961, consists of two identical unpainted wooden boxes, mounted on a platform inscribed with the legend: 'Box for meaningless work – move pieces back and forth'. The boxes contain untreated blocks of wood, which can be moved by the spectator as the mood takes him. Another work, consisting of a narrow box with eight sections and one ball, is inscribed: 'Move the ball slowly down the row'. De Maria says of this work, 'It can be your conception of slowness of any duration. One's choice enters in. You might move it in a minute, or every day or every four months. It could be spread out over a year or ten years. Time can be stretched more than most people think.'

The concepts of time and mutability are also used in the 'Silver Picture of Dorian Grey'. This consists of a cornice and draperies which reveal an increasingly corroding mirror. Unblemished when new, this silver plaque gradually turns black and is lovingly documented (photographically) in time by its owner, as requested by the artist in a caption on the back of the work.

In the same way that the Catholic Church believes in collective prayer as a cosmic force, De Maria believes in the 'collector-energy' of his High Energy Bars. These are solid stainless-steel rods, 14 inches long and $1\frac{1}{2}$ inches square in section. Engraved 'High Energy Bar, to be made in infinite numbers', they are sold with 'certificates' to their owners ('a terrific network of High Energy Agents'), who are exhorted to display them and to carry them. De Maria believes that people would be overcome by their beauty.

In 1959 De Maria met John Cage, whose theories have since strongly influenced him.

'Bed of Spikes', 1969. Progression of spikes across stainless steel

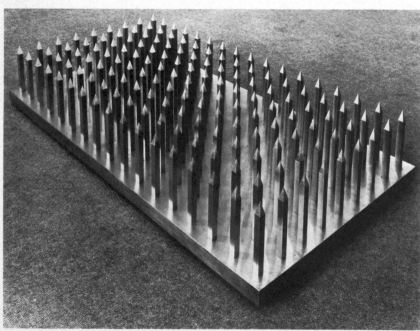

'50 M3 (1600 cubic feet) level dirt 1968.' Photograph taken at a one-man exhibition at the Heiner Friedrich Gallery, Munich, 1968

Federico Fellini

As a scriptwriter for the radio in post-war Rome, Fellini ventured into the world of film-making at the invitation of Roberto Rossellini. They co-operated in the production of a number of films, including *Rome, Open City* and *Paisa*, which were in the category of the neo-realist school. It was from Rossellini that Fellini learned the fundamental techniques of film-making, techniques which he was later to abandon in order to work intuitively. The process of film-making itself is important to Fellini. While retaining an overall control over the central structure of the film, he creates an atmosphere which facilitates improvised experiments. He has sometimes referred to his belief that a resemblance exists between the circus and the cinema; both are dependent on a combination of technique, precision and improvisation. His characters often disguise their proper identities, using costumes and make-up to give emphasis to a departure from normality. He is interested in baroque architecture, circus trappings and the juxtaposition of antagonistic images (in one scene, a helicopter carries a statue of Christ). All his works are closely related to his own world of fantasy, and to his childhood memories. He is ready to incorporate into a film any situation that may arise, and he is sometimes stimulated by a particular mannerism, face, or gesture. A film by Fellini usually originates in an idea about which he feels a sense of urgency; from that point he works in collaboration with his co-writers.

In his film *Fellini Satyricon* he enlarged on a fragment of a story by Petronius about decadent, pre-Christian Rome. He interviewed three thousand people before production began, giving leading roles to unknown actors and non-actors, and employing porters and abattoir workers as extras.

'I have often been urged to make a film on ancient Rome and decided to make one that differs from previous films on the subject. What interests me is the pagan attitude to life before the coming of the Christian conscience. I shot *Fellini Satyricon* very quickly (in twenty-five weeks). As long as I am healthy, I must take advantage of the situation. I cannot afford to lose even one hour.'

Stills from the film *Fellini Satyricon. (See also page 30.)*

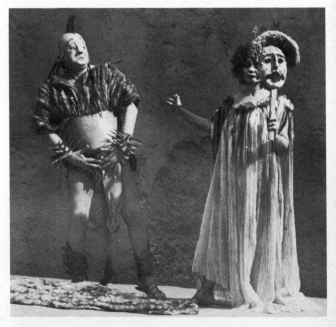

104

Jean-Michel Folon

Some of the most poignant comments on our consumer-durable junk culture can be made through the apparently artless form of the simple line drawing.

Folon studied architecture before taking up drawing. His concern is for the individual trying to survive in the technological nightmare that he has somehow allowed to grow up around him. One of Folon's most important works to date is the large mural which he created for the fourteenth Milan Triennale exhibition. This took the form of a city environment, complete with five hundred electronically programmed lights. In some of his drawings Folon has literally described McLuhan's concept of the tools of technology as physical extensions of man.

Full-page illustration for the magazine *Réalités*

Full-page illustration for the magazine *Fortune*

Lucio Fontana

'When shall we make a hole in the sky, Lucio Fontana?' Otto Piene.

'As a painter, while working on one of my perforated canvases, I do not want to make a painting: I want to open up space, create a new dimension for art, tie in with the cosmos as it endlessly expands beyond the confining plane of the picture. With my innovation of the hole pierced through the canvas in repetitive formations, I have not attempted to decorate a surface, but, on the contrary, I have tried to break its dimensional limitations. Beyond the perforations a newly gained freedom of interpretation awaits us, but also, and just as inevitably, the end of art.'

Fontana issued the first spatialist manifesto in 1948, together with Tullier, Kaisserlain and Joppolo. In 1951 he created a vast spatial arabesque of nine hundred feet of fluorescent tube in the grand staircase of the fine arts palace at the ninth Milan Triennale exhibition.

The works of Lucio Fontana cannot be defined or categorized in terms of 'painting or sculpture'. All his works, he has said, are 'spatial concepts'. He did not recognize the existence of a hierarchy in art, with the fine arts occupying a higher position than the more commonplace applied arts. Nor did he recognize the formal divisions of art in terms of painting, sculpture, graphics and so on. Aware of the problems involved in working on equal terms with scientists and technologists, Fontana considered his works to be the result of continuing research, rather than as objects worthy of permanent places in a gallery. He was interested in the seventeenth-century baroque artists and architects who were concerned with spatialist concepts, and he also identified his aims with those of the Italian Futurists, though his own work transcends the limitations of their theories. Space, light and movement have all formed integral parts of his works. His ideas anticipated the work of many conceptual artists and he had considerable influence on the younger generation of painters working in Europe.

Fontana made the first of his scar-like incisions in canvas in 1958. For him, the cutting of a slit in the canvas was not an arbitrary gesture, but an emotional and precise act of sudden finality. The space that he created was not the space of mathematics, measurable in inches, but rather the space that is beyond total comprehension.

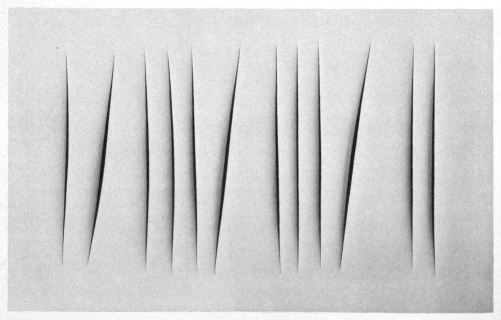

'Spatial Concept—Attese', 1958

'Spatial Concept—Attese', 1962

André François

'I studied drawing and painting,
turned first to advertising, later
to cartoons and book
illustration. I kept, however,
painting over these periods,
and this provided me with raw
material for graphic work. I
took up sculpture, metal first
and polychrome wood later in
the recent years, and spend
now most of my time doing
sculpture, painting and
etching. This gives me more
freedom for the limited amount
of commercial or graphic work
I do nowadays. I am always
trying to do my best.'

Illustrations from an edition of
Alfred Jarry's play *Ubu Roi*.
'Le Complot' and (right) 'La
Machine à Decerveler'

'La Belle Journée', 1968

Anthony Froshaug

The statement by Anthony Froshaug is contained in his biography (see page 204)

Bach: *Mass in B Minor*. Gloria. MS. 1948
Verbal partition derived from full musical score. Prototype for printed libretti of recorded music (unaccepted)

Type list AF. Single letter and numeral specimens of typefaces with 8 pt Gill 262 and 275. Red and black on white board. $5\frac{7}{8} \times 4\frac{1}{8}$ in. 1947
List of minimal equipment soon after inception of workshop. Black now, red later

Invitation card Eleonore Schjelderup. 8 and 10 pt Gill 262 and 275 with 18 pt Gill 275 and 24 pt Minster Black. Black on green board. $5\frac{7}{8} \times 4\frac{1}{8}$ in. 1947
Fatness of face of 1832 black letter permits mixture with 1927–29 humanistic sans

Opposite, centre:

$Ἐν\ ἀρχῇ\ ἦν\ ὁ\ λογος$.John 1, 1.
Christmas card AF. Linocut with 6 pt Gill 262 and 8 pt Gill 275. Red and black on white board. $5\frac{7}{8} \times 4\frac{1}{8}$ in. 1949
Freely cut essay towards a Gill Greek Isomorph. Some twelve years later Monotype Corporation cut Greek Gill Sans Inclined 571 and Greek Gill Sans Upright 572

Change of address card AF. 8 pt Gill 262 and 275. Red and black on white board. $5\frac{7}{8} \times 4\frac{1}{8}$ in. 1952
Crossing-out the old red heading with typographically dominant black

Opposite, bottom row:

Initium sancti evangelii secundum Joannem. John 1, 1–14. Altar card. 8 and 10 pt Gill 262. Black on grey board. $5\frac{5}{8} \times 8\frac{3}{4}$ in. 1950
Roman caps with italic lowercase, in tribute to Aldus Manutius, 1501. All major problems of orthography, punctuation and layout of orthodox texts were solved in the first 100 years of typography. Note escalated indents from left and right and punctuation spaced by phrase

Prospectus Stefan Themerson: *Semantic Sonata No. 2* (book unpublished in this form). 10 pt Bodoni 135 with 24 pt Bodoni 260. Red and black on white laid. 4 pp. $5\frac{5}{8} \times 8\frac{3}{4}$ in. 1951
Exploration of meaning of words demands new typographical arrangement to accord with new syntactical structure

Type list Experimental Printing Workshop, School of Art, Watford College of Technology. 10D/11 pt Univers 689. Black on white wove. $5\frac{7}{8} \times 4\frac{1}{8}$ in. 1965
Maximum information on face, body and set sizes tabulated in open-ended layout, to allow later inclusion of additions to initial minimal equipment

Gloria in excelsis Deo et in terra pax hominibus bonae voluntatis. Bach: *Mass in B Minor.* Christmas scroll AF. 8 pt Gill 262 with 8 pt Minster Black. Black on red

board. $5\frac{7}{8} \times 19\frac{7}{8}$ in. 1948 Condensed version of text derived from score analysis: the four lines of the verbal partition combined into a single phrase,

each new syllable taking over further formation of each 'word' eg. 'hominibus bonae' / 'hominibus' / 'bonae' concatenated into 'homihominibobus'

please note change of address

Geoffrey Gale

'The car is a recurring and obsessive image of mine. The power, destructiveness, grotesque human simulation and junked end make it as appropriate an image as the steam locomotive to a previous generation.'

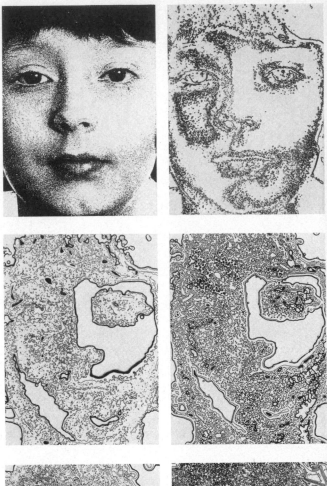

Metamorphosis of a head. These six photographs have been extracted from a series of over thirty negatives, each of which records the different stages of change and the variations that occur during a process which is not completely controllable or predictable.

An old couple of interlocked radiator grills from a north London car dump.

114

Pietro Gallina

Gallina worked for twelve years as a graphic designer in an Italian advertising agency before turning to more personal experiment and development. He believes that the language of the mass media is now in common usage among artists, and this is apparent in his work. Gallina makes full use of the range of techniques that had once been his stock-in-trade as a designer in the service of advertising. The first stage of his work consists of taking many photographs of his model, using a 35 mm camera. He photographs various angles of the profile of the model, working in much the same way as a fashion photographer. The photographs are enlarged to life-size and translated into cut-out plywood silhouettes. His first figures were matt black, but later works were painted in full colour. Recently he has used coloured plastics of varying thickness, with graduated tones at the contours of the figure to give it a vibrant edge.

Gallina uses a system of placing his figures that owes much to the cinema. They are positioned in gardens, or grouped in a room. The duality of his images is contradictory and demands double focus vision of the spectator. His technique is similar in many respects to the 'back-projection' process sometimes employed in feature films. A moving or static film shot out of doors is precisely synchronized with live-action film made in the studio. In early experiments (particularly in colour films) the fusion of images could be discerned from a slight vibrant haze at the contours of the figure.

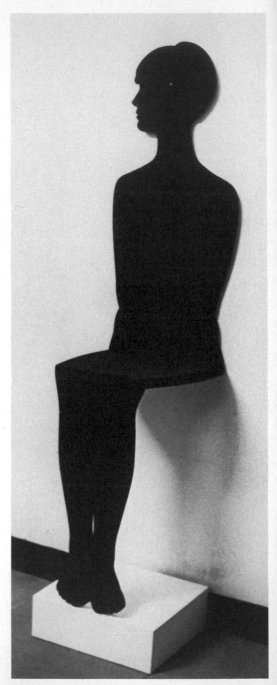

'Shadow of Seated Girl', 1966–7

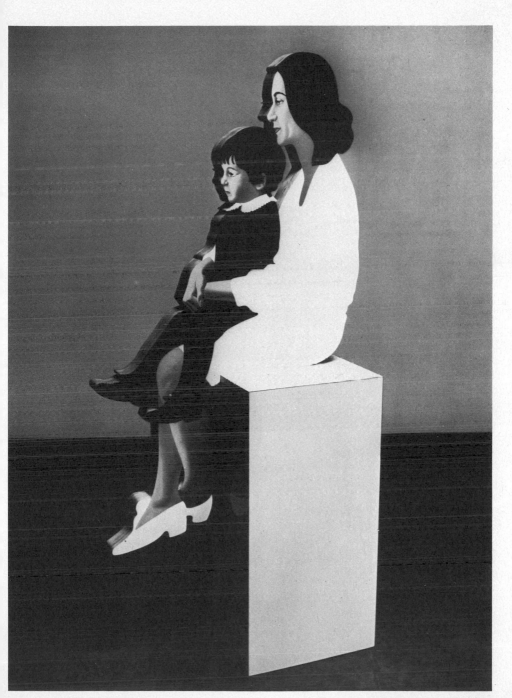

'Woman with Child', 1967

Frank Gallo

The smooth epoxy-resin figures
made by Gallo at first sight
seem to be related to the
waxworks dummy, or to the
department-store display
mannequin. Gallo's figures,
however, are not static, with a
blank, anonymous expression:
they are highly erotic and
sensuous (pouting mouth,
smooth crossed legs, breasts
tightly supported by a low-
slung brassière). Some figures
are posed like pin-up girls;
some are nervously poised on
the edges of seats with
expressions of expectancy. The
tactile quality of the material
used adds to the overall
illusion of soft, smooth skin.
The surface of the figure is
incised with darker lines in
order to give emphasis to the
main forms.

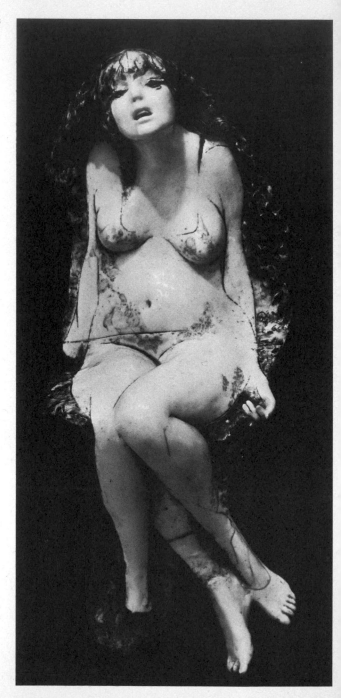

'Love Object' (life size)

Front and rear views of 'Beach
Figure', 1966

118

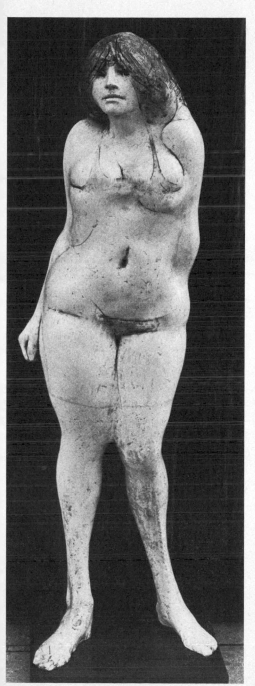 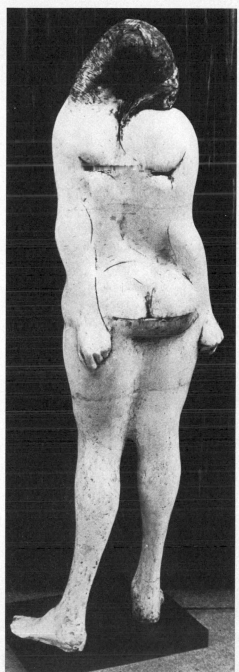

Winfred Gaul

'The Place of the Painting in a Technological Society'
'Our environment is a second-hand nature, "ready-made", prefabricated. It gives us a model, we must find the picture. In 1961 I began to turn my attention to a specific phenomenon of mobile society: traffic signs and signals. Traffic signs are contemporary and completely powerful, they are the real icons of the street; more than that, they are subversive, subliminal tabu-pictures, visual forms of an invisible norm. As art has primarily to do with this norm, even if it attacks or exposes it, traffic signs and signals seem to me to be especially suitable for an art which is concerned with communication. Whereas pop art and "happenings" are happy only to imitate reality, to mirror real situations and thus to expose their commercialization, I penetrate the waste landscapes of the barren cities. My "signals" are the hieroglyphs of a new urban art. They usurp the banality of the jargon of their originals to form a new language of a new, cool and unexploited beauty. Their aesthetic is a new dimension, of harsh colours and gigantic shapes, an art whose place is amongst skyscrapers and industrial buildings, on the intersections of motorways, flooded by traffic. Simultaneously inviting and forbidding, these huge signals stand in the landscape, at night illuminated by lamps, not painting, not sculpture, not a machine, without use, without a function — artificial objects, art objects.

'I have thus proved that in the future painting will not just be something for private houses and museum walls, not a decoration for banks and schools, but an independent expression of a coloured, sculptural form, a truly public affair.

'What has always been attributed to sculpture (that it works in front of, beside, inside and quite independently of architecture) will in future also apply to painting. Obviously this kind of "painting" cannot be an élite art form. My traffic signs and signals are neither a negation of technique, nor a romantic glamorization. Rather they are objects, which in their process of construction relate closely to technical progress and in their visual presence do not conceal the character of the manufactured object.'

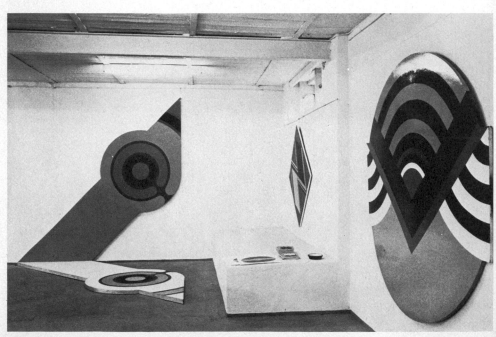

Detail from one-man exhibition, 1967

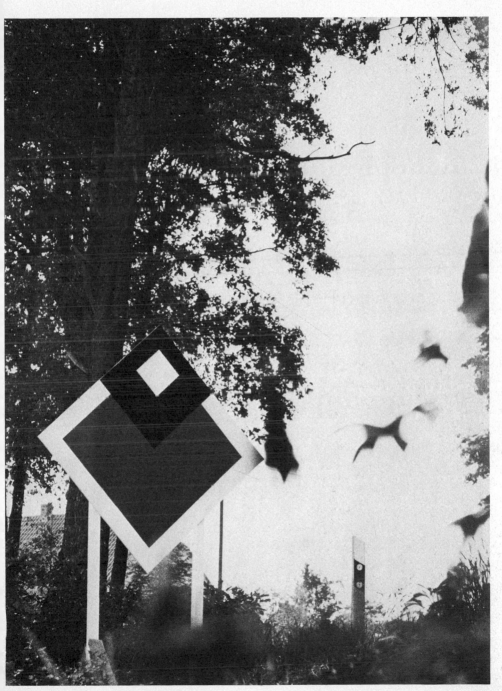

'Road Sign', 1967. *(See also frontispiece.)* 121

Juan Genoves

Painted Cinema
Genoves does not talk about his painting; all he asks is that we look with him through the viewfinder of a camera, or the telescopic sights of an automatic rifle, and focus on a crowd of frightened figures running for cover. Sometimes a single figure is isolated, slightly blurred as he tries to move out of range. There is the implication in Genoves' painting that, because of our impassive observation, we are somehow responsible for the events taking place. His source is the documentary newsreel film. We see single frames, or a sequence of frames, usually from a high viewpoint, distant, middle-distant and close-up. The figures defy close scrutiny because of their movement at the moment of flashpoint. The colours are predominantly grey, brown and black. One is reminded of fragments of newsreels of the Spanish Civil War, when machine-guns were mounted high in the bell towers of churches to fire down on to crowds in the square below. In recent paintings there are references to saturation bombing in Vietnam and the execution of hostages.

Genoves' work has inspired Stuart Cooper to make a film, *A Test of Violence*, in which live-action film of war and violence is punctuated by photographed stills of Genoves' paintings.

(See also page 11.)

'The Capture', 1969

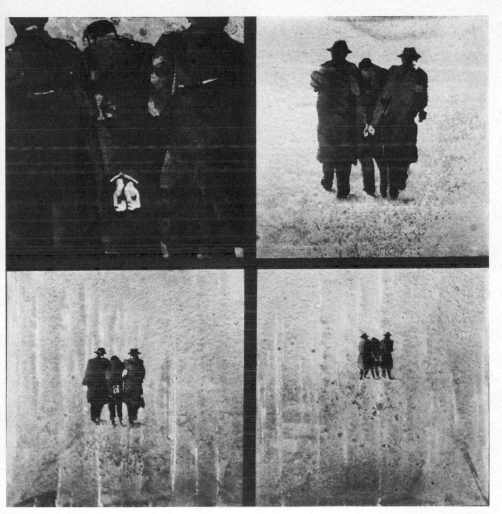

'The Arrest', 1967

Jean-Luc Godard

When James Joyce's *Ulysses* disrupted the idea of the narrative novel, it disturbed us because it also disturbed our view of life. In fact, *Ulysses*, with its use of fragmented time and memory, is more like life than is the conventional form of the novel. Similarly, Godard has disturbed our view of what a film should be like, and therefore of what life is like, by creating a new syntax from such devices as jump cuts, 360-degree pans, interminable tracking shots, documentary material and television interviewing techniques. Sometimes, by verbal reference, he reminds us that we are watching a film. He uses the typography of books, magazines and neon signs as images, isolated against stark walls. He uses silence, and dialogue which is obliterated or 'overprinted' by natural sounds or by music. He works between reality and abstraction, between documentary and fiction.

Godard has said that truth is in all things, even partly in error. This paradox is central to his philosophy and to his use of the medium. A consummate stylist and one of the most naturally gifted of film-makers, he wilfully uses a throw-away approach to film, denying its bourgeois associations.

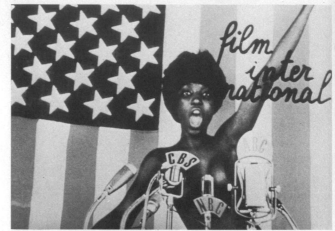

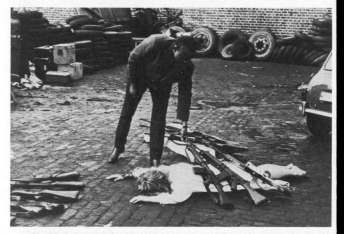

Still from *Le Gai Savoir*

Still from *One plus One*

Still from *Le Gai Savoir*

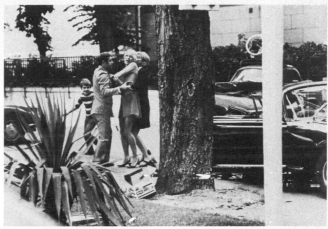

Still from *One plus One*

Still from *Weekend*

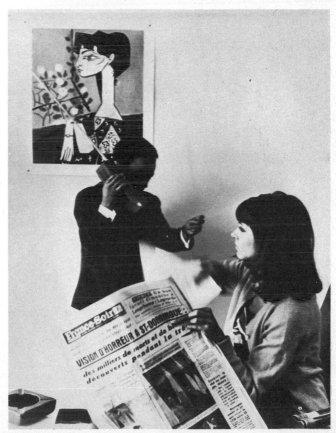

Still from *Pierrot le Fou*

Franco Grignani

'Communication is dynamic by nature, and eye and brain react more quickly to dynamic phenomena. This series of experiments began from geometrical drawings; when these were distorted, their inner relationship was not destroyed but became more vivid and more startling; when they were stretched, the tensions thus created were strong enough to produce an almost physical response in the observer. The laws which apply are the laws of optics, but because they are not those of the human eye, the effects gain in forcefulness. The basic themes of the experiments are dispersion from a centre, effects of hypnosis and illusion, graphic tensions, kinetics of the sign in a pattern without a centre of visual interest, and designs inspired by music (especially by syncopation).

'The primary function of graphic design is to create signs and symbols that hold the eye. Perhaps the schools should place less stress on teaching young artists to do, and more on teaching them to see.'

Grignani received a formal training as an architect before he became a graphic designer. He produced over twelve thousand experiments during the period 1950–70, comprising mainly photography, typography, painting and constructions. His most important work to date has been the development of photo-mechanical techniques used for the distortion of shapes and letter-forms. The work reproduced here is from a series of advertisements for the firm of type-founders Alfieri and Lacroix. The translated texts were written by Grignani.

'Bad printed matter is invariably doomed. In advertising an efficient idea and good artistic technique aren't enough. All these elements depend on the graphic design, because a bad design is irritating and un-arresting. An expert, powerful and up-to-date printing firm guarantees that fine result which will make your advertisement appreciated and remembered for its elegant typography and accurate colour.'

'Graphic art creates emotion. ''Impact, break, huge, debris, nightmare, collapse, black, stormy, heavy, ooh!, useless, wall, horrid, rumble, disaster, structure, escape, start, burden, rock, ruin.'' (These words were extracted from newspaper para-graphs.)'

'The image reaches its dynamic unity by various degrees of integration: tension, rhythm and harmony. An experiment is the outcome of a struggle between outer and inner forces, between dynamic forces and recurrent shapes. Also, quality in printing has a recurrency: Alfieri and Lacroix.'

'Now are we still artists? Creativity and technics have established themselves to modify the means, the probing and sensations.'

'A violent, torn typography. A typography for changes and protests. An aggressive typo-graphy. Visual, persuasive, symbolical typography. The typography of quality by Alfieri and Lacroix.'

LA GRAFICA CREA L'EMOZIONE

tavola offerta dall'Alfieri di Lacroix

tipografia
violenta
lacerata
tipografia
dei mutamenti
della protesta
tipografia
di aggressione
tipografia
visiva
persuasiva
segnica
tipografia
di qualità
Alfieri
Lacroix
tipolitozincografia
in Milano

tipografie

Richard Hamilton

'A ciné-camera films an event on a university campus in Ohio, USA. The scene filmed, almost by chance, in conditions not conducive to rational operation, happens at a pace hardly permitting accurate exposure or focus. The information recorded in the emulsion is urgent: it is processed and put into the hands of an American TV network or news agency which transforms the image in the film frames into electronic signals later beamed at an antenna on a satellite orbiting the earth. The satellite passes on the signals to a tracking station in the South of England and electrons are "piped" to a recorder which duly notes the facts on a magnetic tape.

'That evening, the message is re-transmitted as part of a BBC news broadcast to be detected by a TV receiver; information is decoded and divided among three guns in its cathode-ray tube. They spurt out streams of electrons which excite, to varying intensities, spots distributed evenly in triads over the surface of the tube. Red, blue and green dots blink as they are scanned.

'Staring at the screen is a still camera. Still, until with a sudden snap it gulps the moving picture (if it was 8 mm originally 16 frames per second scanned 25 times per second, a gulp equalled 2 frames scanned 3 times). What does the subject feel buried in a layer of gelatine in the darkness? "There is no known way to detect a latent image in a photographic emulsion except the process of development." Out of the

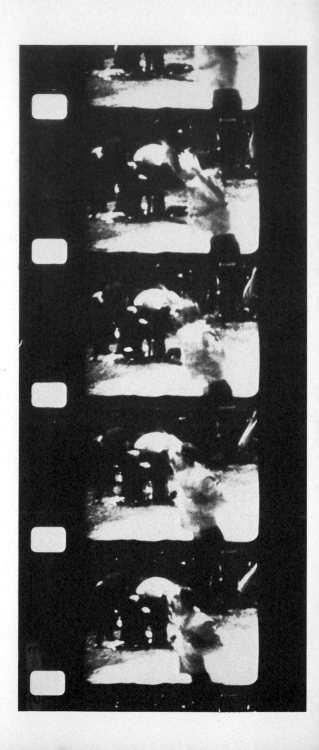

chemicals into the light another, this time random, mesh of coloured particles tells the story. The same message is there – the tone of voice is new, a different dialect, another syntax; but truly spoken.

'The two and a quarter square transparency now confronts a process camera to be sliced and layered. One slice carries no magenta, one no cyan, one no yellow, another slice holds in reverse the tonal values of all colours. Different times of exposure through these separation negatives produce different positives which when holding back varying amounts of light from an emulsion on a nylon screen make some areas of mesh open and leave others closed. Fifteen such layers of pigment; a tragic chorus monotonously chanting an oft repeated story. In one eye and out of the other.[1]'

[1] When a copy of the screenprint 'Kent State' was received from Hamilton, the print in turn was subjected to conversion back to a two and a quarter square colour transparency, which was separated by a process camera to make the four photo-lithographic plates needed to reproduce the image in this book (see p. 10).

Frames from student's 8-mm. film

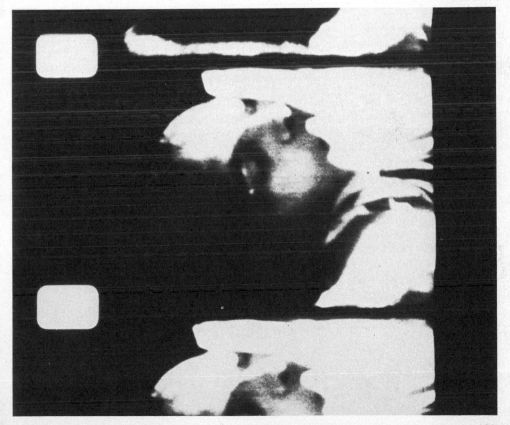

Dick Higgins

'Our astrologer friends tell us the world is now moving into the Aquarian age, and that the central image of Aquarius is of a carrier of water emptying his pitcher into a stream, that this symbolizes the return of energy to its source. Of course we needn't be interested in astrology to recognize this as a possible metaphor for our time, when many of the distinctions that characterized our compartmentalized, word-oriented approach to the world seem to be breaking down. Semanticists and physicists, artists and psychiatrists, anthropologists and sociologists all seem to be telling us that these distinctions have more reality inside our minds than in the external world. In fact we seem to be drawing closer to the acceptance of all things as being in a state of flux, and we begin to see the relationship of anything to its function as the prime determinate of its nature. We have come to see that if we find a way to use an object that was built as a table, it becomes essentially a table.

'Having known the author [Higgins is referring to himself] for the better part of the thirty years of his life, I'd like to say a few words about his work, and, while I'm at it, about him. I have met him on a variety of occasions, as composer, writer, speculator, dramatist, colleague, presence, etc. But there seems always to have been a common ground of research underlying his investigations in any field. He seems to approach things without the assumption of mastery over them, more with curiosity about them. As a result the distinctions among these fields apparently seem to him to be manifestations of man's fondness for "understanding" by putting labels on things, rather than by confronting them and seeing their similarities as well as their disparities. He is fond of saying that there are many similar mushrooms which are unaware that they are unrelated even though botanists have put them into separate phyla. This is why the book is structured as it is, into four separate columns, running simultaneously. To read everything in the book in sequence, the reader would have to read, say, all the left-hand columns, then all the next-to-left-hand columns, and so on. He would have to read through the book four times. And he would have missed the point—of confrontation at every turn with other elements of the same overall picture or situation. Hopefully the reader will get the point and read the four columns more or less together, keeping clear in his mind the correlations as well as the divergences which hazard has established. Maybe some of the longer poems — which have fairly involved structures — are some sort of partial exception to this, but the author has done no more than raise this as a possibility, so we shall presumably have to make up our own minds on the matter.'

From the preface to
FOEW & OMBWHNW.
(1969)

Two double-page spreads from his book *FOEW & OMBWHNW.* This is a grammar of the mind, a phenomenology of love and a science of the arts as seen by a stalker of the wild mushroom. For no reason, the book takes the form of a missal of the Roman Catholic Church.

ble, for example, for a performer to wait nine seconds, do a sound in his tenth second, wait a second, produce a sound in his second second, then wait eight seconds. Since this is intended as a piece with long and moderately long sounds, very short ones are avoided.

4. It is recommended that a pendulum with a flashlight affixed to it be used as a conductor by hanging it in such a way that it takes ten seconds to swing from side to side.

5. The performers continue to perform for about twenty minutes, after which they leave one by one or group by group until they are all gone.

New York
August 1965

tomas schmit

january 1966

New Song in an Old Style

(check one)
— speak
— dance
When I —— fall in love
— grow up
— grow old

(check one)
— I'm going to be
— it'll be with

(check one)
— an apple.
— a flower.
— a smile.
— you.

New York
11/27/67

THE GIRL (*Impressed*)
Me too

THE BOY
What do you mean, "me too"?

THE GIRL
Oh, nothing I guess.

THE BOY (*Staring past her*)
It would be nice to be famous. Oh well. (*He reads again. She wanders around the stage, almost dancing with her lightness. She looks up into the branches of the tree from time to time. Another breeze.*)

THE GIRL (*smiling*)
A bird's nest!

THE BOY (*not looking up*)
I know. (*She wanders around.*) Sure is hot. Isn't it. (*No reaction.*) Isn't it?

THE GIRL
Yes. I'm going to take my blouse off. (*No reaction. She takes her blouse off. She has nothing on under it. She throws her blouse on the ground beside him. He is staring off L. again.*) I'm cooler now. (*No reaction. She wanders around again.*) Aren't you hot?

THE BOY
I said I was.

THE GIRL
Take your shirt off, silly. (*He does, but*

Cowboy Play #2
Scene: The Fireplace.
$\log_{10}1 = $ I'm burning!
$\log_{10}2 = $ I'm burning!
$\log_{10}1, 2 = $ Rather not.
Curtain

Cowboy Play #3
Scene: Hugging, his hands in her slacks.
She: Is it me you're kissing? Or do I simply mean something to you?
Curtain

chickery

i skated over him
a little afraid

who wants to break the ice
and drown in what's underneath?

preface iv

i see nothing
i know nothing

but i describe everything
and my mouth is too big

old faithful's prayer

lord,

i
w i
s h i
h a d s
o m e o f
t h e s e r
e n i t y h
a t i a f f e c
t a t h a t p e o
p l e c o u n t o n
m e t o s u p p l y .

because they are simple or small, that is his eye and his taste. Somewhere I have a copy of the *Rubáiyát* of Omar Khayyám printed in microscopic type, and about ½ inch by ¾ inch in size: it has no implications that I can think of. So if George Brecht is the father of minimal art, then surely Yves Klein is the father of Bluism.

By Pop Art is usually meant is art which deliberately uses familiar images, styles and frames of reference from mass culture. Andy Warhol's Brillo Boxes, Claes Oldenburg's giant ice cream cone and Roy Lichtenstein's comic strips are generally accepted examples from what is considered the Pop Art movement. But Oldenburg is a fantasist, a magician. He takes the idea and transforms it, by altering its scale so massively, in the case of the ice cream cone, or by converting it into an art image that contrasts with its original function, as in the case of the soft baseball bat or the incredible, drooping soft toilet. It is typical of him to have done a series of proposed monuments, very few of which could be expected to be built, such as a gigantic teddy bear to tower over the New York skyline at Central Park, or the colossal pack of cigarettes for Piccadilly Circus in London. Whatever the debt that others who are generally considered Pop Artists

David Hockney

It is sometimes said that Yorkshire is a country within a country. Like many of his fellow Yorkshiremen, Hockney is dexterous and hard-working; he has steadily moved, in his taciturn way, from strength to strength. Underlying the wit and dry humour of his work, a dogged struggle with reality is being carried on. The realism of his recent paintings and etchings, indeed, indicates a certain affinity with the work of Morandi.

The paintings which emerged from Hockney's final year at the Royal College of Art were produced in the atmosphere of excitement and discovery which was especially prevalent among the students of the College at that time. For 1962 was a vintage year; Hockney and his contemporaries, all collectively described as 'pop' artists, left the College and their work began to appear in the London galleries. Hockney produced narrative works inspired by Blake, Whitman, Cavafy and the Brothers Grimm, as well as landscapes and portraits. In 1963 he visited California for the first time and began to paint what he called the 'physical look of the place'. On his travels he usually makes many drawings in pencil and crayon and takes photographs for later reference. There are recurring motifs in his work, and, like Adami, he is fascinated by the transitory confinement of hotel rooms. He has said that he uses painting as a means of personal expression, as a narrow form of art.

(See also pages 18–19.)

Study for Rumpelstilzchen, from ▶ Grimm's *Fairy Tales*

'A Grand Procession of Dignitaries in the Semi-Egyptian Style', 1961

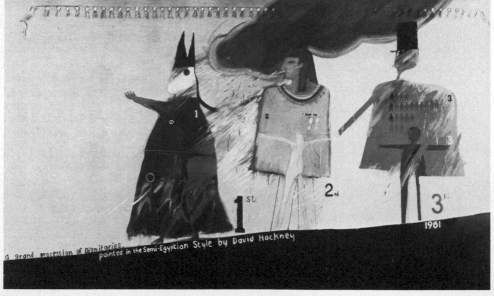

'Celia in Red', 1970. Wax crayon drawing

'View from the Miramar Hotel, Santa Monica', 1970. Wax crayon drawing

Dom Sylvester Houédard

architypestractures?
what is communication? —
what is visual communication?
— how and why communicate
visually? — does it even occur?
— what do i communicate
visually & otherwise? — i
wonder if the answer to this
last question is that i am
interested in communicating
questions more than asserting
answers? — if so then the
level at which i ask these
questions is not that at which
there are answers at all but
the level at which they are
mysteries to which the
appropriate response can never
be an 'answer' but has to be a

growth of awareness & awe —
gratitude depth & pleasure —
that is an awareness of the
questions as being essentially
those mysteria to which there
is no possibility of reply in
clear cartesian concepts —
those mysteria that lie behind &
even help to constitute those
parameters of what it means
to be human

 there is communication
between minds — between
artwork & mind — between
mind & environment — between
je & moi — between non & non-
non — & these communications
can co-unify if they are peace-
offerings love-tokens & human-

stimuli that improve our
human mental ecology — but
other communications can be
enforced injections —
transplants from some this into
some that — true fuzzplants of
an elitist & privileged ego (or
nos) that trap & erode
whatever is free human &
sacred in a Thou

 if i feel an achievement in a
typestract or a visual-poem it is
dependent on the degree to
which it succeeds in being
antieunochratic — but is there
anything that makes this
success more appropriate to a
visual than to an acoustic
communication? — or is it

134

merely inappropriate to largely verbal or lexical communications? — this to me is at least possible since i find an equation between these sorts of zen purity that are present both in visual-poetry & sound-poetry since in both of these in so far as they are abstract (& the 'concrete' is the totally abstract) i find a most satisfying possibility of evading the dictatorial & eunochratic
& yet the typewriter is only a slightly sophisticated improvement on gutenberg's moveable type — but on one level — to use it as a brush or as an instrument of visual music — it can become an illustration of marshall

mcluhans analysis — the shaman or nabi or spiritualist-as-medium is replaced by the medium-as-medium
the impossibility of this being achieved except at the sufi level of the imaginatrix does not detract from the validity of the direction now being taken by the sort of visual communication which i try to help make — lévi-strauss i find particularly persuasive when he sees myths as establishing mutually exclusive dualities & then creating links & hybrids as magic bridges & jacobs-ladders between them — ie pontificating (in its root sense) & helping the up-&-down

traffic of angels — & for myths read 'poems' — for poems read 'abstract poems' — visual or acoustic — i see my typostracts as icons depicting sacred questions — dual space-probes of inner & outer — at least that is the sort of way they work for me in the moments of making when they step by step control me & pose ultimate questions of their own identity dependence destiny & independence — they should probably be viewed like cloud-tracks & tide-ripples — bracken-patterns & gull-flights — or simply as horizons & spirit-levels

John Kaine

'*Sensation and escape*
Definition of the environment through personal and public taste. Redefinition of environment as mental environment, the consequence of the individual's escape from architectural harassment.

'*A chronological statement*
My earlier work was an élitist redefinition of the environment, not unlike selecting wall paper and changing unsatisfactory architectural planes. The pictures were flat; this has the advantage of changing the appearance of the environment without taking up any physical space. The paintings I did, using tubular metal, were linear definitions imposed within the environment, like electrical conduit which tends to run along edges and make horizontal and vertical movements, but always echoes the architectural planes.

'Any environmental interference on the part of the occupier must eventually lead to the thought, why am I doing this? And the answer must always fall in the general area: the information I am receiving from the environment is unsatisfactory, unsatisfactory in the sense that my mental environment is inadequately fed by the information or stimulation surrounding me. This, in my view, leads to the constant desire of human beings to change or interfere with the environment. The purpose of the interference is to produce a better mental state from the feed-back. Starting from this point, and believing that most art forms are at best feed-back systems, only partly effective from the outset, because they are

limited contributions to a total state, I have tried to design an art form with unlimited contribution potential. This is achieved by offering undirected stimulation. The limit then, if any, is the subsequent experience or imagination of the participant. A rough definition of this could be catalyst art, or perhaps intermediary art.

'As all incoming information is processed by previously held information, no two people will use information in quite the same way. This presupposes that we all have the opportunity to be individual and creative, but unfortunately the external manifestations of this state are clouded by public taste or

convention. This means that what contributes feed-back is modified to allow for the opinions of others and will again start to give unsatisfactory information, and leads me to the conclusion that if the stimulation is anonymous one's mental environment has the greatest chance of survival. As architects teach us to live in smaller and smaller spaces, to avoid architectural harassment the mind must escape. Because of this we all own escape sensation mechanisms, books, television sets, radios, gramophone records, motor cars, and so on. The advantage of escape mechanisms like those listed above is that in themselves

Flag painting, 1967

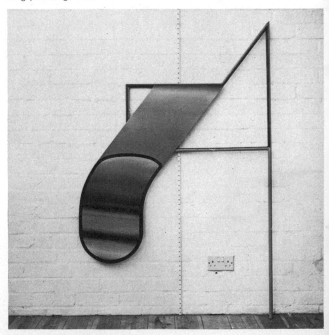

136

they are simply technical mechanisms when not in use and unlikely to cause adverse comment from others. This is important because criticism leads to public taste being imposed in an area that should be the property of the individual. Like all escape mechanisms they must be operated for the sensation they offer to be revealed. Books must be read, television watched, and so on. It is in this category that I would like my work to be considered. This work includes the "Progec" chairs Mks 1–11, including Mk 9 which operates by sound, all the others being touch stimulators, and the Mk I "Powergrope", which is intended for sexual fantasy.'

'Progec' chair, Mk II

Flag painting, 1967

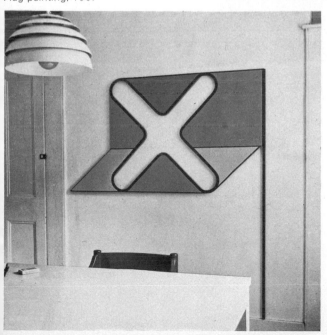

(See also page 15.)

William Klein

William Klein is an American who has lived in Paris since 1948. He has worked in a variety of media. As a painter he worked with Fernand Léger, and he has made numerous murals for French and Italian architects. He is probably best known, however, for his photographic, television and film work.

He has produced albums of photographs on New York, Rome, Tokyo and Moscow, but is equally well known as a fashion photographer. His photographic images are sharp, economical and incisive. He is often witty, sometimes funny, but never sentimental.

These characteristics are also evident in his film work. In the film *Qui êtes-vous, Polly Magoo?*, which he wrote and directed, Klein comments on the world of fashion and television in Paris. Beneath the humour and absurdity there is an underlying seriousness and irony. While entertaining us, he is also making keen observations. The same sort of wit and perception runs through most of his work.

(See also page 31.)

Design for the cover of the magazine *Domus*, 1960

Photograph from the series 'Moscow', 1961

Ferdinand Kriwet

Kriwet is among the most prolific members of the new school of experimental German artists. He has taken concrete poetry from the conventional 'private press' format to the scale of a full theatrical event. One has the feeling that he has, as yet, only begun to scratch the surface of his creative potential.

His method of work is as follows. He begins by composing brief basic texts, constructed from composite words. One has to decode the semantic implications of such compounds as 'incertimate' and 'youthornyouth'. Having collated a series of texts, he proceeds to channel them through any available medium: film (with animated letter-forms), tapes, books (using positive and negative images), embossed metal, or letter-forms silkscreened on to balloons or PVC cushions. Finally, all the elements are assembled in his 'textrooms', in which he creates a kind of 'think tank', with texts occupying the floor, the walls, the ceiling, and even free-standing objects. The basic text is repeated and repeated until, at saturation point, we begin to grasp its meaning. Kriwet's use of metaphor is skilful, and his work is imbued with a sense of humour.

The illustrations which have been selected are from his book about the American Apollo moon programme, which is a kind of documentation of all the information on this subject that he has assembled from various sources: newspapers, television, count-down numerals and so on.

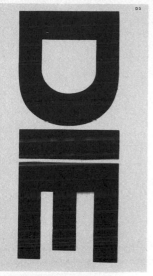

God
bless you
&
good
night
from
Apollo 11 "

KRIWET
Apollo Amerika

edition suhrkamp
SV

exchange · new york stock exchange — new york stock exchange · new york stock

THE · NEW · YORK · STOCK · EXCHANGE · SHARES · THE · WORLDS · JOY · AT · THE · SAFE · RETURN · OF
APOLLO 11 · FROM · THE · MOON · ASTRONAUTS · ARMSTRONG · ALDRIN · AND · COLLINS · SO · PROUDLY ·
WE · HAIL · YOU

.7 min. 46 sec. into descent burn

8 min. 46 sec. into descent burn

Cover and pages from *Apollo America*

Jan Lenica

Lenica has been called the angry young man of Polish graphic art. He began to draw cartoons in 1945, and contributed to the satirical Polish weekly *Szpilki* and other periodicals over a period of ten years. He began to widen his vocabulary of graphic techniques, experimenting with most of the processes of reproduction. His poster designs for the theatre and cinema were the result of close collaboration with lithographic printers. It was almost inevitable that he should become interested in film animation. 'I instinctively sense in the film a means of stepping up my imaginative powers; that is why I began to make films.' His wide experience of graphic techniques, together with his former training as a musician, provided the ideal background for making animated films.

His recent film *Adam 2* (1969) is his first full-length work in the medium (it runs for eighty minutes). It was written, designed and animated by Lenica himself, and is considered to be an important landmark in the history of the animated film. It expresses Lenica's ideological views on man and society, freedom and dictatorship, the individual and the crowd. Lenica traces the journey of Adam through a world of technological fantasy bringing into play a wide range of graphic devices: hand-coloured fragments of engravings, sections of machinery, letters and numerals all provide a background to the drawn figure of Adam. Lenica also experiments with a wide

variety of sounds to accompany each sequence: shrieking, howling, humming, sucking, knocking, grating, and crunching. It is in the film that Lenica reaches the apogee of his surrealist vision.

Stills from the film *Adam 2*

Design for a theatre poster

Sol Lewitt

'The idea is the machine that makes the art,' says Lewitt. He refers to his work as being conceptual; that is to say, the element of concept or idea in his work is *a priori*, in that it signifies first intentions. The resulting three-dimensional structures serve only to manifest his initial reasoning. His assistants work according to specification. Lewitt makes no attempt to alter the structures in any way; he cares nothing for 'taste', nor is he concerned with the physical appearance of his work. Lewitt is, indeed, an 'anti-labelist', in that he rejects the 'aristocratic pretentiousness' of titles. His works are identified by formulae or by specifications.

It is difficult to summarize all the elements in Lewitt's work. His drawings resemble typographic grid sheets, or the successive states in the scoring of a mezzotint ground. Using the cube as a basic artefact, he proceeds to work on a series of probable variations of placement and tone.

Lewitt's work appeals to the mind. His ideas are, in a sense, similar to the thinking of such a philosopher as Ockham, with his theories of causality, in which he attempts to ascertain whether A, B or C is the cause of D, or whether we have to accept a plurality of causes. Ockham suggested that the mind assents to the truth of a proposition as soon as it apprehends the meaning of

the terms. As a logician Lewitt makes his terms known to us, so that we may follow his propositions more clearly.

Wall drawing, 1969

Four sets, each containing four sections divided into four squares of different values

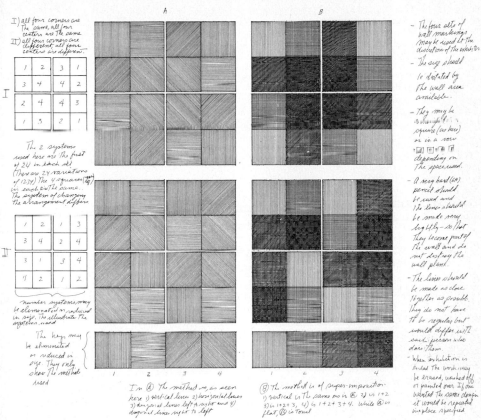

A B

I) all four corners are
the same, all four
centers are the same

II) all four corners are
different, all four
centers are different.

I

1	2	3	1
3	4	4	2
2	4	4	3
1	3	2	1

The 2 systems
used here are the first
of 24 in each set
(There are 24 variations
of 1234). The 4 squares
in each are the same.
The system of changing
the arrangement differs

II

1	2	1	3
3	4	2	4
3	1	3	4
4	2	1	2

number systems may
be eliminated or reduced
in size. They illustrate the
systems used.

The keys may
be eliminated
or reduced in
size. They only
show the method
used

1 2 3 4 1 2 3 4

In A the method is, as seen
here 1) vertical lines 2) horizontal lines
3) diagonal lines left to right and 4)
diagonal lines right to left

B The method is of super-imposition.
1) vertical is the same as in A 2) is 1+2
3) is 1+2+3, 4) is 1+2+3+4. While A is
flat, B is Tonal

- The four sets of
wall markings
may be used at the
discretion of the exhibitor.

- The size should
be dictated by
the wall area
available.

- They may be
in a simple
square (as here)
or in a row
depending on
the space used.

- A very hard (6H)
pencil should
be used and
the lines should
be made very
lightly - so that
they become part of
the wall and do
not destroy the
wall plane.

- The lines should
be made as close
together as possible.
They do not have
to be regular but
would differ with
each person who
does them

- When exhibition is
ended the work may
be erased, washed off
or painted over. If one
wanted the same design
it would be repeated
in place specified

Notes for wall markings

Romek Marber

There is no particular style to which one can attribute the work of Romek Marber, although in designing over two hundred cover designs for Penguin Books he has maintained a certain continuity of approach. He has a wide repertoire of graphic techniques and is a skilled photographer. He prefers to adapt his style and techniques to the requirements of a particular problem with which he is concerned, be it a corporate identity system for an industrial concern, a magazine illustration, or a series of credit titles for a film.

Marber began working in London at a time when design was essentially of a decorative and romantic nature. His own logical approach to design, both as a practitioner and as a teacher, has had a strong influence on many young English designers. He believes that there is always more than one solution to every design problem and, for this reason, he experiments a great deal before finally committing himself to a finished design. Much of the imagery that he uses is readily available; in the titles for the film *Passport* his own passport appears, gradually obliterated by a hand continually stamping out the photograph. In his titles for the film *The War Game* the typography is gradually animated so as to form a mushroom cloud, first rising and then disappearing.

Series of credit titles for the film *Passport*

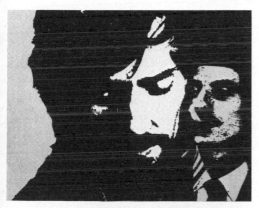

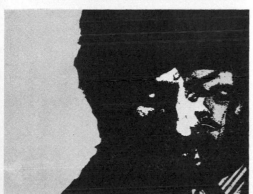

Robert Massin

Robert Massin inherited his love of letter-forms from his father, who was a sculptor and engraver. Although he has a comprehensive knowledge of letter-forms and their origins, he received no formal art training, but worked with the designer Pierre Faucheux. His interests range from early calligraphic scripts to neon signs and concrete poetry. He is now largely concerned with the letter-form as an independent entity, released from semantic associations.

In his work as a typographer and book designer, Robert Massin probably reached his apogee in the numerous books which he designed when art director for the French publisher Gallimard. His most important contribution as a book designer has been the way in which he has achieved a proper equation of word and image. In his design for Ionesco's play *La Cantatrice Chauve* each character is indicated not by name, but by a line image next to the speech which he is to utter. The shape of the words is distorted so as

to give emphasis to the sound of the speech. By using techniques which fall somewhere between those of the cinema and the comic strip, he ensures that, in the dialogue, the primary constituents of word and image are balanced in a way that heightens the meaning of the play.

Massin's knowledge of letter-forms enables him to make a judicious selection of type style in relation to the subject. In his design for the book *Conversation-Sinfonietta* the typefaces are 'orchestrated', from a light sans-serif for the soprano to a heavy condensed face for the bass. He has a preference for serifed faces such as Bodoni or Plantin, which he uses continually. But his inventive skill as a typographer is always based on his awareness of the history and range of typefaces.

Massin has also experimented with the bindings of books. In his volume of Raymond Queneau's sonnets, for instance, the binding is of particular importance; each line

of poetry is printed on a separate strip of paper, thus allowing the reader to choose whatever material he likes from ten different poems or, indeed, to readjust the structure of a poem by replacing certain lines with those from other sonnets.

At a time when most book design is either in the classical tradition, or is confined to a strict grid system, the work of Robert Massin is particularly refreshing.

Double-page spread (below) for the play *Delire à Deux*, by Eugene Ionesco (Gallimard, 1966)

Cover design for *La Cantatrice Chauve* ('The Bald Prima Donna'), by Eugene Ionesco (Gallimard, 1964). Typographical interpretation by Massin; photographs by Henry Cohen

Double-page spread from *The Bald Prima Donna*, by Eugene Ionesco (Calder and Boyars, 1966)

i✦nesc✦
LA CANTATRICE CHAUVE

suivie d'une scène *inédite*. Interprétations *typographique* de Massin et *photo-graphique* d'Henry Cohen Gallimard

it's not
that way
it's
over here

All together,
completely infuriated,
screaming in each others ears.
The light is extinguished.
In the darkness we hear,
in an increasingly rapid rhythm:

Hansjorg Mayer

Mayer enjoys an international reputation as a publisher of well-printed books, as a functional (but unorthodox) typographer, as a concrete poet and as a visiting teacher in West Germany and in England. While developing his own work, he has given equal attention to the publication of major experimental texts by writers in Europe and the United States. As a functional typographer he is concerned with the transmission of the text in the simplest possible terms. The content is not overpowered by typographical style. He uses the typeface called Futura, which is perhaps the least conspicuous of the sans-serif faces. He omits completely all capital letters and punctuation marks; pauses and sentence structure are denoted by additional spacing, and demi-bold characters of the same typeface are used for words that require particular emphasis. It is his intention to equate the optical structure of the printed word with the phonetic composition of speech.

Mayer also produces autonomous typography, usually in the form of limited editions printed in series. The series called *Alphabet*, produced in 1963, is a collection of twenty-six printed sheets; on each sheet a single letter is repeated and printed in close register so that it loses recognizability as an artefact of a language system. During the same year he produced a second folio under the title *Alphabetenquadratbuch*, which comprises thirteen pages. The first page is empty, the second contains a single letter, and

From the series 'Typoaktionen', 1967

there follows an accumulation of letter-forms which are finally cancelled out by overprinting.

Mayer's work is not restricted to the surface of the paper. He has used translucent plexiglass cylinders, with letter-forms printed on the periphery, as free-standing concrete poetry. In West Germany he has conducted experiments in

which he films letter-forms synchronized with a choir voicing the appropriate sounds and gradually working up to a climax.

Mayer has made his own intelligent interpretations of the experiments of Moholy-Nagy, Herbert Bayer, Joost Schmidt, Lissitzky, Zwart, Tschichold, and Schwitters. He has not

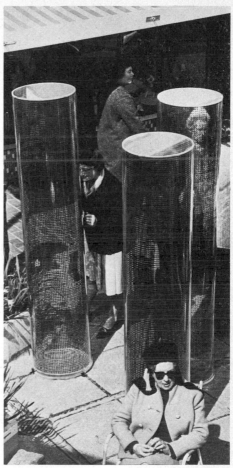

'Typosaulen', 1967

emulated their ideas to any
degree but has made his own
contribution to the 'new
typography'. In his efforts to
achieve a rationalization of his
work as a typographer, the
functional and autonomous
aspects have become largely
complementary.

Raymond Moore

Photography defies the role and treatment usually accorded to 'art'. Photographs are not usually framed and hung, they have no value as investment, the material itself has no unique or 'fetish' value. The photograph is never part of the photographer physiologically in the way that painting is (or can be) part of the painter. What, for instance, is the 'scale' of a photograph? Is it the dimensions of the negative, or is it determined by the dimensions of the developing dish?

The photographer's vision relates more to his pointing out or sharing an experience in life — fleeting, transitory, ambiguous images, seen and discarded at the same time — than it does to the aesthetics of painting. The strictures of 'art', however, persist in photography's struggle to find its own autonomy.

Part of the photograph's essential nature is to become raw material as it evolves in the hands of the photographer himself, other photographers, other image-makers, nostalgia-mongers and layout men. Eric De Maré says that Moore's work is pure photography, and, in attempting to describe his vision, reminds us of Rilke,

Everything beckons us to
perceive it,
Murmurs at every turn,
'Remember me'.

Moore, although an articulate man, feels that words dissipate the imagery.

When urged to supply a statement of his aims to publish in this book, Moore preferred to direct us to the following lines from the *Treatise on Faith in the Mind*, attributed to the seventh-century Chinese poet Seng-Ts'an:

Follow your nature and accord
with the Tao.
Saunter along and stop
worrying.
If your thoughts are tied you
spoil what is genuine.
Don't be antagonistic to the
world of the senses,
For when you are not
antagonistic to it,
It turns out to be the same as
complete Awakening.
The wise person does not
strive,
The ignorant man ties himself
up. . . .
If you work on your mind with
your mind
How can you avoid an
immense confusion?

(See also page 23.)

Pembrokeshire 1970

Pembrokeshire 1970

153

Josef Müller-Brockmann

English designers used to imagine that Swiss design represented the ultimate in the logical presentation of information. The ordered environment of the country, and the Swiss temperament, combined with the impeccable service given by printers and process engravers, seemed to create a design utopia. Swiss design still maintains its ice-cold attraction, and, after twenty years, English designers have managed to understand the concept of the grid. Emil Ruder says that 'the endeavour is simply to find a formally and functionally satisfactory answer to everyday requirements'. Nevertheless, a great deal of the aesthetic of the 'Swiss movement' can be seen to be highly organized, and not linked purely to everyday functional needs.

In the work of the Swiss designer Josef Müller-Brockmann, what once appeared to be an exclusively logical approach now admits poetry, and even a degree of irrationality. Müller-Brockmann has maintained a consistently undoctrinaire attitude towards design in a wide field of activity.

Series of seven roughs and completed poster for 'Musica Viva'

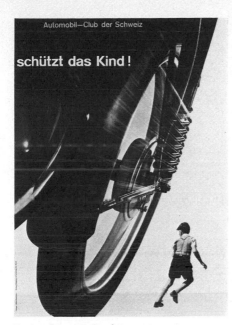

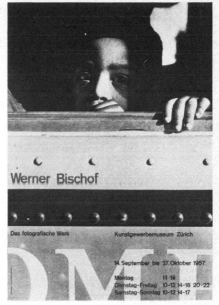

Design for a road safety poster

Poster for an exhibition of photographs by Werner Bischof at the Kunstgewerbe-museum, Zurich, 1957

Siegfried Odermatt and Rosemarie Tissi

Odermatt is self-taught, a very rare circumstance among Swiss designers. He is also almost exclusively a typographer. This is not to say that he does not use photography, but when he does he has a meticulous regard for the elements within the photograph. These elements are then treated actively with the typography. It is this that gives his work its peculiarly concentrated character. The client's problem is also an integral part of the total design problem; it is treated as an active constituent, and not as an irritant that has either to be ignored or allowed to predetermine the outcome. Because of Odermatt's heterogeneous background in design, his approach is undoctrinaire. At its worst, Swiss typography hovers on the edge of anaemia. But Odermatt can assimilate the most robust and diverse elements in his work, always passing them through the fine mesh of his intellect.

The work of Odermatt and his partner Rosemarie Tissi is always concerned with the meaning and purpose of the commission, and is never obscured by formalistic preconceptions. The scope and intensity of their achievement, within a seemingly limited formal range, is compelling.

Publicity design for Union Kassenfabrik AG, Zurich

Trademark for Reinhard

reinh a r d

Publicity design for Univac Remington Rand ▶

DLT Die Abkürzung steht für «Data Line Terminal» und bezeichnet ein Gerät, das bald in vielen modernen Unternehmen zu finden sein wird. Dank DLT können UNIVAC-Datenverarbeitungsanlagen nicht nur blitzgeschwind rechnen, sondern auch miteinander reden und Ergebnisse austauschen. Die PTT hat den Fortschritt, der darin liegt, erkannt; sie stellt das schweizerische Telefonleitungsnetz allen daran interessierten Benutzern von UNIVAC-Computern zu vorteilhaften Bedingungen zur Verfügung. In Zukunft übermitteln Sie während der üblichen 3-Minuten-Dauer ein Vielfaches an Information – gleich wohin. Die Sache funktioniert von St. Gallen nach Genf ebenso wie von Thayngen nach Stans absolut sicher und zuverlässig. Damit wird die Verwaltung von Filialen zwar nicht gerade zum Kinderspiel, auf alle Fälle aber braucht sie weniger Zeit bei obendrein reduzierten Kosten. Lohn, Arbeitsvorbereitung, Lagerkontrolle: keine der klassischen Tätigkeiten elektronischer Rechenanlagen ist länger an einen bestimmten Ort gebunden. Wenn man wollte, könnte man sagen, dass bei UNIVAC die fünfte Generation von Computern geboren wurde ... Und sie steht nicht auf dem Papier, nein, sie ist jetzt täglich von jedermann bei der praktischen Arbeit zu beobachten. Im Expojahr hat UNIVAC zunächst die beiden Städte Zürich und Lausanne auf revolutionäre Art miteinander verbunden. Dazu wurden zwei der bekannten Datenverarbeitungsanlagen vom Typ UNIVAC 1004 gewählt. Ihre guten Eigenschaften und ihr vernünftiger Preis sind speziell auf die vielen kleinen und mittleren Betriebe der Schweiz zugeschnitten. Jedes Standardmodell der UNIVAC 1004 kann innerhalb eines einzigen Tages mit wenigen zusätzlichen Schaltelementen beim Kunden selbst für die Datenfernübertragung ausgebaut werden. Über Demonstrationen, die UNIVAC für eine breitere Öffentlichkeit in Zürich und Lausanne laufend durchführt, gibt der Veranstaltungskalender der Tagespresse Auskunft.

Atelier
Odermatt
B. Trüb

Remington Rand **UNIVAC** Zürich, Basel, Bern, Lausanne, Genève

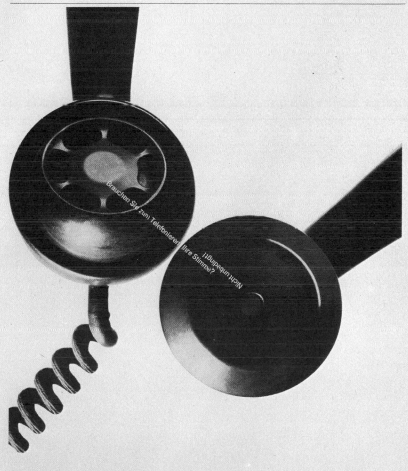

Brauchen Sie zum Telefonieren Ihre Stimme? Nicht unbedingt!

Ueber Raum, Zeit, Luzern und Union
L'espace, le temps, Lucerne et l'Union
Sullo spazio, sul tempo, Lucerna e l'Union

Union begrüsst Sie recht herzlich zur Bankiertagung in Luzern. Ein Tip: besuchen Sie zwischendurch einmal das neue Planetarium im Verkehrshaus. Das gibt Ihnen einen Eindruck von Weltraum, Welt, Raum und Zeit. Und lässt Sie zugleich ahnen, dass es jenseits der Gestirne Dinge gibt – den gekrümmten Raum zum Beispiel und die Antimaterie –, die faszinierend, grossartig und schwindelerregend sind.

Doch kommen wir zurück zur rauhen Wirklichkeit: Wenn es hier um die Sicherheit wertvoller Materie geht, wenden Sie sich nach wie vor an Union.

L'Union vous souhaite la bienvenue à la Journée Suisse des Banquiers à Lucerne. Permettez-nous de vous donner un petit conseil: Allez donc jeter un coup d'œil au nouveau planétarium du Musée des transports. Cette visite vous donnera un aperçu de l'espace interplanétaire, de l'univers, de l'espace et du temps. Elle vous fera aussi ressentir qu'il existe, au-delà des astres, des choses – telles que l'espace courbe et l'antimatière – qui sont fascinantes, sublimes et vertigineuses.

Mais revenons-en à la réalité de tous les jours: s'il s'agit d'espaces et de la sécurité des matières de haute valeur, sur notre terre – adressez-vous toujours à l'Union.

L'Union ha il piacere di darVi il benvenuto a questa Giornata dei Banchieri a Lucerna. Un consiglio: approfittate di un momento libero per visitare il Planetario nel «Verkehrshaus». Ciò Vi darà un'idea dello spazio interplanetario, del cosmo, del mondo e del tempo. In più Vi farà intuire che oltre i pianeti ci sono cose – per esempio lo spazio curvo e l'antimateria – che sono affascinanti, meravigliose e vertiginose.

Ma torniamo alla realtà: se si tratta di spazio e della sicurezza di materie preziose, rivolgeteVi, come sempre all'Union.

Union – im Bewahren von Werten bewährt
Union – Passé maître dans la sauvegarde des valeurs
L'Union – cimentata nella custodia di valori

UNION

Union-Kassenfabrik AG
Albisriederstrasse 257, 8047 Zürich. Postfach
Telefon 051/52 17 58

Publicity designs (opposite and
below) for Union Kassenfabrik
AG, Zurich

Calendar for Mettler and Com-
pany

Symbol for Mettler and Com-
pany

Claes Oldenburg

'I am always seeing something I want to do, to re-do, to have done.'

'My art shows the following:

'The source. For example, a pie or hamburger. Dish-washing got me used to sensual effects I later wanted to re-live. I preferred touching the food to eating it.'

'Exaggeration of the elements I desired to re-experience. Like caricature, a simplification and intensification of only certain effects appealing to my specific appetites. But not caricature.

'Rationalization of the result. A confessed exhibitor, I cannot hide the outcome of my pleasure. I must explain.

'Beastly desire precedes beauty. Beauty is weak without its origin in beastly desire. How can I explain this satisfying result to others? Guilt leads to reasoning.'

'In 1952 I declared that I was going to be an artist, but this seemed at the time a disguise. It gave me greater freedom than declaring I would be a newspaper man. In a way, a newspaper man is more what I really am.

'My real role, as I imagine it, is that of a communicator. Art to me is a technique of communication. I prefer it to writing, probably because I am better at making images than at writing. For me, the image is the most complete technique of communication.

'Some things I am attracted to, do not seem to be liked enough. By choosing to re-make them, I may help them. I wish the best for all things. In a situation that offers little (like living in Chicago), I try to make the best of what there is; I work too hard at this perhaps.'

From 'Items towards an Introduction' (*Tate Gallery exhibition, 1970*)

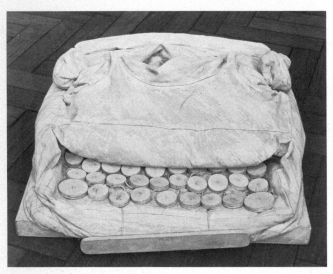

'Soft Typewriter', ghost version

'Soft Manhattan' 1 (postal zones), 1966

'I don't mix knowing with doing. If I did, the results would be highly unnatural. As it is, nothing *necessarily* means anything, which is the way with nature.

'Only when someone looks at nature does it mean something. Because my work is naturally non-meaningful, the meaning found in it will remain doubtful and inconsistent — which is the way it should be. All that I care about is that, like any startling piece of nature, it should be capable of stimulating meaning.'

(See also pages 26–27.)

'Small Monument for a London Street — Fallen Hat (for Adlai Stevenson), 1967'

'Soft Popsicles'

Giovanni Pintori

For three decades Giovanni Pintori has been associated with Olivetti, the Italian company which manufactures business machines and whose products and advertising are an epitome of good design in Italy. During this period, Pintori has been closely concerned with a graphic analysis of the products for which he has been commissioned to design advertisements and exhibitions. His designs have been inspired by the various artefacts that are used in the manufacture of typewriters, adding machines and table-top computers. By selecting significant shapes from these machines, he builds up a visual description of their functions.

The typewriter is a versatile tool of communication. It has been used, for instance, to make notes for this book, and it is also the means by which Dom Sylvester Houedard produces his imagery. The component numerals and letter-forms sometimes dominate Pintori's designs; his best known poster depicts a large 'O' in which each letter outlines the next, to make the word 'Olivetti'.

Pintori has accepted the limitations of his brief — that is, to produce a means of promoting the products of Olivetti. But he has used the brief also as a vehicle for probing experimental techniques and concepts, just as Franco Grignani has done under the sponsorship of Alfieri and Lacroix.

In recent years Pintori's work has become more fluid and dependent on primary colour. Since 1967 he has worked as a freelance designer in Milan.

LA MACCHINA ARITMETICA IL CALCOLO ELETTRONICO

Vi occorre una Olivetti da calcolo: dai conti più elementari alle più complesse sequenze di matematica spaziale c'è sempre una Olivetti che può risolvervi il problema, darvi un risultato sicuro, aggiungere all'attivo dell'ufficio tutto il valore del tempo che vi farà risparmiare. Olivetti produce una linea di macchine da calcolo che non ha eguali nel mondo: macchine a due, a tre, a quattro operazioni (come le famose Divisumma); macchine universali e macchine specializzate; manuali, elettriche, elettroniche (come il sorprendente computer da tavolo PROGRAMMA 101); e tutte macchine che, oltre a svolgere l'operazione richiesta, ve ne consegnano anche il documento scritto. Olivetti è la piccola addizionatrice manuale, Olivetti è la calcolatrice automatica, Olivetti è la macchina contabile, Olivetti è la fatturatrice elettronica. Non c'è problema di cifre che non abbia già pronta la sua soluzione nei meccanismi di una macchina Olivetti.

Publicity design for Olivetti calculating machines

162

Design for a poster advertising the Elettrosumma 22 calculating machine

Michelangelo Pistoletto

'Communication becomes very easy without the structures of language, since it's easy to understand who everybody is and what he's like. For communication and understanding, we will finally be able to develop all of the possibilities of the mechanism of perception.'

Pistoletto has moved in a number of new creative directions since he produced his first 'mirror' paintings in 1962, but it is that phase of his work which is perhaps most characteristic of his approach to painting. In common with a number of other painters working in Turin and Milan, Pistoletto is interested in relationships between the real and the unreal, and in the time and space between images. He is anxious that his work should not be subjected to a poetic interpretation.

Pistoletto used life-size photographs, taken by himself, as a starting-point for his paintings. The photographs were mainly of figures in arrested movement — a man, tying a shoelace, reading a newspaper, or sweeping a floor. The figures were traced on to a thin onion-skin paper, cut out at the contours of the drawing, and pasted flat on to a thin sheet of polished steel. The painting was then completed in a range of sombre, neutral colours, and the steel sheet was placed carefully in a room so that the painted figure was carefully registered with the reflection of the spectator in the surrounding area of the steel sheet. The main point of interest lies in the relationship between these two images. Neither can cancel the other out: one image is static; the other, reflected image is dynamic. Pistoletto has stated that he was interested in the uncrossable space between the edge of the painted figure and the reflection itself. He was

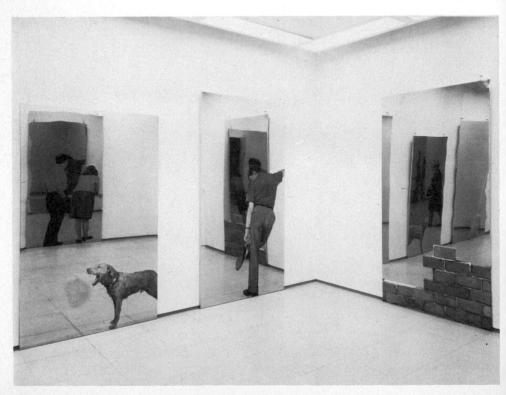

concerned with the creation of a system dealing with two levels of perception: the receptive mirror-like surface with a continually changing reflection, and the imposition of the static painted figure. The spectator is involved in the affinity between his own reflected image and the painted figure on the surface of the steel. In later works the mirrors did not bear painted figures and took the form of reflective wells.

Pistoletto has also experimented with film, and more recently with spontaneous dance movements.

General views of one-man exhibition at Galeria Ileana Sonnabend, Paris, 1968

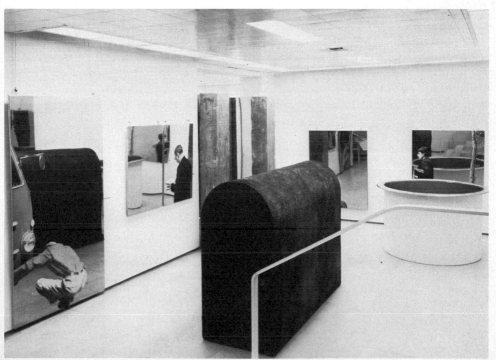

Paul Rand

'Graphic design —
which fulfils aesthetic needs,
complies with the laws of form
and the exigencies of two-
 dimensional space;
which speaks in semiotics,
 sans-serifs,
and geometrics;
which abstracts, transforms,
 translates,
rotates, dilates, repeats, mirrors,
groups and regroups —
is not good design
if it is irrelevant.

'Graphic design —
which evokes the symmetria of
 Vitruvius,
the dynamic symmetry of
 Hambidge,
the asymmetry of Mondrian;
which is a good gestalt;
which is generated by
 intuition or by computer,
by invention or by a system of
 co-ordinates —
is not good design
if it does not co-operate
as an instrument
in the service of
 communication.'
 From 'Thoughts on Design'
 (revised edition, 1970).

When Paul Rand's book
Thoughts on Design was first
published in 1947, it very soon
became a standard work for the
guidance of designers in the
United States and in Europe.
The aphoristic statements
which Rand wrote at that time
have a timeless validity — so
much so, that a revised edition
of the book was recently
published and is used by the
present generation of student-
designers. Rand's work ranges
from complex design systems
for companies such as I B M
and Westinghouse to
illustrations (which he
produces with his wife) for

Symbol for Westinghouse

Symbol for IBM

elementary books for children.
In all his work, however, his
personal hallmark is
unmistakable; there are few
designers who are able to
select, juxtapose and combine
graphic imagery with quite the
same skill. Rand has always
been concerned that all

aspects of visual
communication should
embody form and function —
that there should be an
integration of the beautiful and
the useful. 'Like a juggler, the
designer demonstrates his
skills by manipulating these
ingredients in a given space.'

Illustration from *Little 1*, 1962

166

123456789101112 13
1415161718192021 22
232425262728 2930
313233343536 3738
3940414243444546
47484 525354
55565 596061
62636 676869
707172 767778
7980818283848586
8788899091929394
959697989 9100

**Westinghouse
x-ray system... can reduce
radiation exposure
100 times**

A new Westinghouse X-ray television system gives the physician "instant replay." On pushbutton command, he can "freeze" a single frame of a continuing fluoroscopic study on a TV screen. This enables him to study the internal body in detail.

While the stored image is on, no X-ray exposure is needed to keep it displayed. Thus the patient's total exposure can be reduced by 10, 20 or as much as 100 times. The system can also "tune out" bone structure and other images to give the physician the clearest possible TV picture of the internal organs.

Helping sick people get better is a major activity at Westinghouse. Making life brighter, cleaner and easier takes up the rest of our time. You can be sure . . . if it's Westinghouse.

Full-page advertisement for Westinghouse X-ray television systems

Robert Rauschenberg

Rauschenberg has, in a sense, pioneered the art of the last twenty years. His work has embraced minimalism, light and sound, earthworks and dance. Since 1964, when he won first prize at the Venice Biennale exhibition, he has explored the possibilities of audience participation. His techniques often parallel those of film (flashbacks and tracking shots) or of magazine production (bleeds, fragments, tri-colour separations). He uses all the artefacts of today and includes references to the whole history of art during the twentieth century. He uses, without sentimentality, anything and everything to hand.

'It has never bothered me a bit when people say that what I'm doing is not art. I don't think of myself as making art. I do what I do because I want to, because painting is the best way I've found to get along with myself. And it's always the moment of doing it that counts. When a painting is finished it's already something I've done, no longer something I'm doing, and it's not so interesting any more. I think I can keep on playing this game indefinitely. And it *is* a game — everything I do seems to have some of that in it. The point is, I just paint in order to learn something new about painting, and everything I learn always resolves itself into two or three pictures.'

'Tilt'

'Horn'

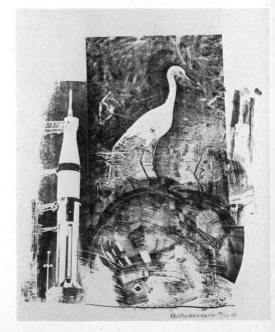

Series of lithographs, 1969

'Banner'

'Arena II'

'Trust Zone'

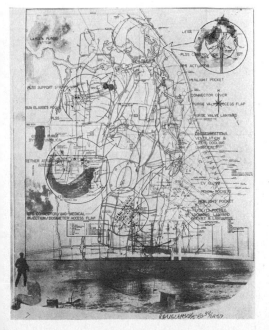

'Earth Tie'

Roger Raveel

Raveel is purposefully intent on making real everyday landscape an integral part of his art. Rather than impose his painted structures on a landscape, he prefers to incorporate real life by using mirrors and cut-out shapes which contain that which is immediately beyond the painting. The form and colour in their natural state contrast sharply with the gestural marks of the painting. The landscape is considered as a primary constituent of his work that must be fully integrated in it. The spectator is lured into looking through the apertures in his paintings to the real life beyond, where grass moves in the wind or a bird pecks at bread.

Raveel calls his 'new vision' an attempt to bridge the gap between art and real life. In the work of Gallina the background is of secondary importance, but Raveel makes the figures appear as a negative which contains the primary shapes of real life. His paintings do not have the photographic realism achieved by other painters working in this field, the drawing is lucid, and perhaps more sensitive in application. Some of his work consists of groupings of a number of figures together with structures containing mirrors which in turn reflect fragments of both figures and landscape, often distorting the perspective.

'Illusion', 1966. Wood and mirrors. Raveel says, 'This is a play on reality and space. By the effect of mirrors and voids one becomes aware of the space in which one finds oneself.'

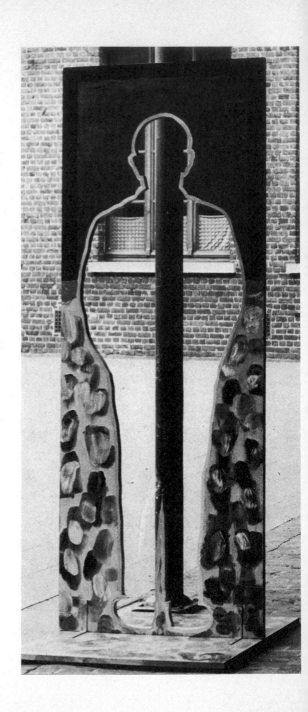

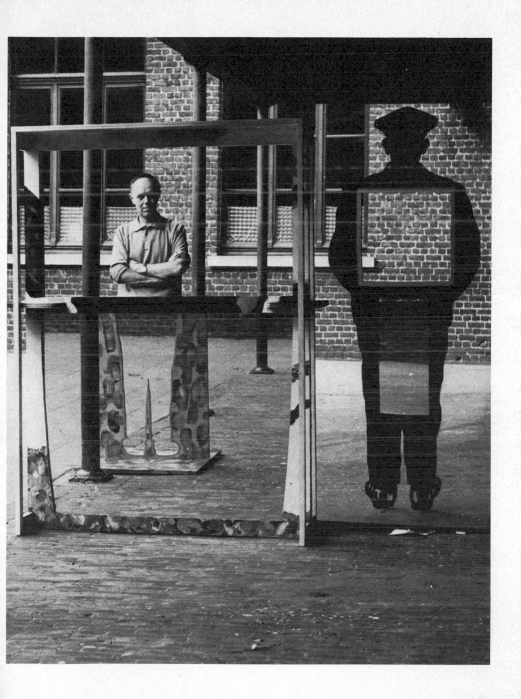

Alain Robbe-Grillet

'To see or to perish is the very condition laid upon everything that makes up the universe, by reason of the mysterious gift of existence. And this, in superior measure, is man's condition.'

Pierre Teilhard de Chardin

No doubt the nature of Robbe-Grillet's work as an agricultural scientist has partly contributed to his intense power of perception, in his written work and in his work for the cinema. The treatment of his subject-matter, however, goes beyond a mere preoccupation with objectivity, or impersonal documentation; by giving *presence* to gestures and objects, he comes nearer to a reality which hitherto has largely been avoided by novelists. The precision of his observation has made us more aware of the element of time, and the reality of our total situation. Robbe-Grillet's texts reveal to us what *is*, without the use of emotional adjectives that one normally accepts in a work of fiction; the '*calm* sea' tells us little about the atmospheric qualities of that sea, the '*subdued* landscape' rules out any further description.

A number of French literary critics have given his work various labels, such as 'The Objective Novel', or 'The School of Observation'. Robbe-Grillet himself uses the term 'new novel', but he does not propose that it should be a label for a new movement or for a school of new writers.

In the film *Last Year in Marienbad* (in which he collaborated with Alain Resnais) the detailing and visualization of the script have been perfectly balanced. Robbe-Grillet's work as a

Still from *Trans-Europe Express*

scriptwriter has been complementary to his work as a novelist; he has remarked that when a novel is translated into film we experience much more than the transposition of a story into pictures. The original details which support the plot in the book are lost, because in the film we see the reality of every facet and detail, the juxtaposition of objects,

shapes and movements. The fragments of reality recorded by the camera go beyond the human capacity for verbal description. By sitting in a darkened cinema, we are able to concentrate on this reproductive reality without distraction, and the details which the film cannot avoid offering us make a lasting impression on our memory.

Still from the film *Last Year in Marienbad* (directed by Alain Resnais)

Diter Rot

Diter Rot's work encompasses graphic design, furniture design, commercial typography, painting, textile design, print-making, poetry, film-making and book design. He moves continually through workshops and art centres in Europe and the United States, occasionally 'going into retreat' at his home near Reykjavik where he can work in isolation or, if need be, telephone instructions to printers in Holland, England or Germany.

One of the projects which he set his students at Watford School of Art was based on the following recipe. Print until you can't stand it any more or you don't want to any more; take away for binding, for instance, the sheets which the machine cannot take any more (torn, wrinkled, or beautiful according to someone's taste); don't throw anything away. As soon as you can't stand this any more, have another recipe; if you can't stand anything any more, give it up; if you don't want to give it up, go on until you can't stand it any more.

When we were visiting Richard Hamilton to select some work for this book, Diter Rot arrived for a short visit. Richard Hamilton suggested that we might include his recent print of the Kent State University shooting, and Rot told us that when he had received a copy of this print he had decided that he would overprint a Swiss landscape. His explanation of this was that one sometimes goes for a walk in the country to forget bad news, and that, in the same way, the incident at Kent State University could be 'cancelled out' by overprinting a pleasanter scene.

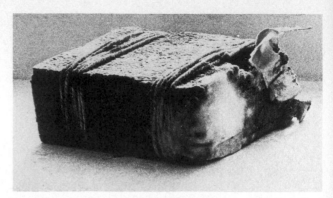

Bound bread with interleaved messages (gift to G.W., 1968)

'Little Tentative Recipe' (for collective project), 1968

little tentative recipe: PRINT until you can't stand it anymore or " you don't want anymore, take away, for binding for instance, the sheets which the machine cannot take anymore (torn, wrinkled, or beautiful according to someone's taste), don't throw anything away.

as soon as you can't stand this anymore, have another recipe, if you can't stand anything anymore, give it up, if you don't want to give it up, go on until you can't stand it anymore.

D. R.

Hans Schleger

'We are truly living in a fabulous time — even if it is accompanied by anxiety which, in turn, produces the desire to hug material success. This, all too often, brings negative feelings of helplessness, cynicism, fear and rebellion.

'The archives of scientific institutions and industrial organizations are overflowing with data of experiments and achievements. There is a great need for the trained and intelligent designer to help with the communication of these facts. Through his intuitive link with universal forms, the artist-designer has always been in touch — even with the world which we do not see.'

From *Graphics RCA*, a publication which documented the exhibition, so entitled, which was held at the Royal College of Art, London, in 1963.

Schleger's own work demonstrates the 'intuitive link' to which he refers.

Symbol (1953) for Finmar Ltd, the furniture company. A fusion of a tree and an initial F, it is shown on this page in three weights, the equivalents of 'light', 'medium' and 'bold' in typography. The illustrations at the top of the opposite page show the symbol used organically in three ways: in metal (for door handles), and incorporated in fluid and rigid forms in two posters.

steel and china

an exhibition
by Finmar Hotelware Ltd

FINMAR FAIR

Mac Fish

Logotype (above) and symbol
for Mac Fisheries Ltd. The logo-
type, based on the characteristic
chalk-on-slate lettering em-
ployed by fishmongers, is an
early example (1950) of demotic
lettering used as a feature of a
house style.

Peter Schmidt

'Finding oneself in the time and place that one does, and being the person one is, one faces the question of what one should do. The difficulties inside and the difficulties outside are possibly the same. One's faith in this possibility is undermined by the conflict between the deep-seated knowledge that all could be well inside and the insistence by nearly everyone else that there is little hope of things being well outside, but it is still the only working hypothesis. So one works for things to be well inside and expects the outside consequences to be mildly good as a result. Content with the possibility of such a tiny bit of good against the gigantic opposition (to try for more, being the person one is, is useless), one finds ways and means to employ the abilities one has. The faculties must not fight against each other. A faculty will fight if it is not well employed.'

'One continues to make pictures, aware that at any moment a better possibility may occur. The pictures are gifts, inside gifts one receives and outside gifts that one can give to other people. When one gives a present that is more than a symbol of the intention to give a present (chocolates) the present embodies qualities common to the giver and the receiver. If pictures are presents for people one doesn't know, they must first of all be accepted. If accepted they must not be found disappointing later, like a beautiful box with no chocolates inside. They must both seduce and shock (one of the shocks of a seduction may be that it is not just a seduction). They must not be esoteric, making sense only to people who already know what one is talking about.'

Monoprint-collage from a series of 120 made in 1969. The prints are a combination of collage, using old work and other autobiographical material, and printing in transparent colours through an open silk screen. Each print is a sandwich consisting of about three layers of collage and three layers of printing.

Drawings from the book *In the Head*. Limited edition produced and published by the author. The book contains eighty-six pages of drawings and a few lines of text.

178

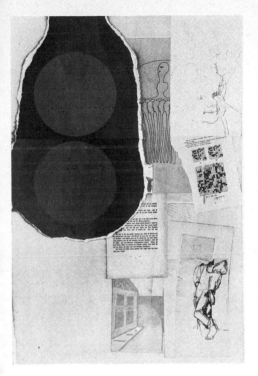

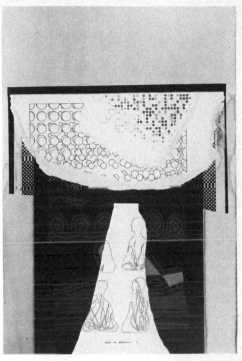

Richard Smith

One's work can either be designed to communicate, or else it can be concerned with the process of communication.

'I paint about communication. The communication media are a large part of my landscape. My interest is not in the message so much as in the method. There is a multiplicity of messages (smoke these, vote this, ban that), fewer methods. Can how something is communicated be divorced from what is being communicated, and can it be divorced from who it is being communicated to? We tend to look at primitive art this way because we are unaware of the object's orientation socially and spiritually.

'The degree of contact in my painting depends in part on the spectator's knowledge of the original function of the forms used. In annexing forms available to the spectator through the mass media there is a shared world of references. Contact may be made on a number of levels. These levels are not calibrations of merit on a "popular-fine art thermometer" (aesthetes look at this, social scientists note that) but of one aspect seen in terms of another. In writing about painting aspects tend to get separated; within the paintings there is less punctuation.'

From notes to a film made by Smith in collaboration with Robert Freeman (fashion photographer turned film-maker) in 1962

Elsewhere Smith has talked about his obsession with boxes.

'The carton is an incessant theme in present-day civilization. . . . You don't buy visible goods, you don't buy cigarettes — only cartons. The box is your image of the product.' Smith's three-dimensional paintings of boxes are not replicas (like those of Warhol). Unlike those artists who re-create, Smith says that he tries to keep close to the sensibility, the 'ethos' almost, of objects and themes in everyday life.

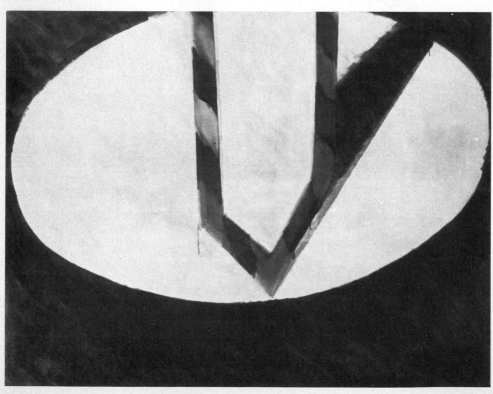

'Western Stile'. 1968

'Pack 1962'

(See also page 34.)

Stefan and Franciszka Themerson

'This, of course, creates a typographical problem: the method itself was simple: to replace some of the key-words of a poem by their definitions. But how to do it typographically? How to replace one atomic element by the long ribbon of its spectrum? In short: how to print five, ten, fifteen words in place of one, and so that they would hold together as one entity? Well, yes, but Typographical Topography of a printed page is two-dimensional, is it not? You scan it not only from left to right but also from top to bottom. Therefore, if I have a number of words that form one entity, a bouquet of names by which a rose may be called, why shouldn't I write them as I would write the notes of a musical chord: one under another, instead of one after another? Internal Vertical Justification is the answer to our problem: how to set Semantic Poetry Translations. I.V.J. for S.P.T. Yes, I know, printers will not like it. But "learning hath gained most by those books by which the printers have lost".' From Stefan Themerson, *Bayamus*, 1946. See Anthony Froshaug's version of Themerson's Semantic Sonata No. 2 on page 113

Below and opposite, below: two pages from *Semantic Divertissements*, 1962

After studying architecture for many years, Stefan Themerson abandoned it to become one of Poland's first avant-garde film-makers. Only a few stills survive from *Europa*, made in 1930-31.

Stefania Zahorska wrote in *Literary News* in 1932:

'*Europa* is a film poem. It is not an abstract film, for it contains objects, people, fragments of action, but all these elements of realism are liberated from their immediate application — the relationship between them exists only on the level of ideology, at the threshold of symbolism. And it is on this level that, placed side by side, are the crusty, rough surface of a cut loaf awaiting the mouth and teeth, and the purposeful, not at all mysterious hips of a woman, and at once — photographically multiplied, the gestures of arms and lips, the chewing at pre-selected bits of food — in short cuts, in a kind of sharp, oblique lighting, on this level it is materially and tangibly shown that Europe

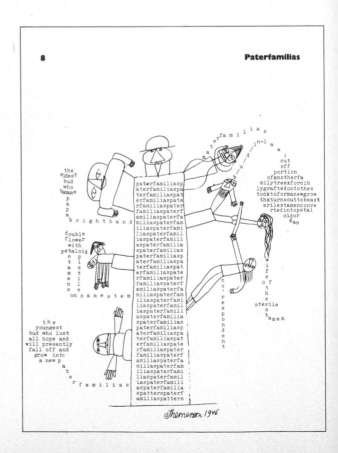

Word game

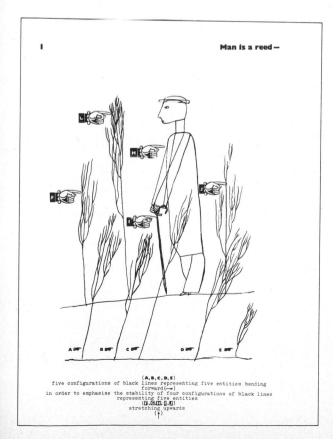

I Man is a reed —

(A, B, C, D, E)
five configurations of black lines representing five entities bending
forward (→)
in order to emphasise the stability of four configurations of black lines
representing five entities
(F, G, H, I, J)
stretching upwards
(↑)

Cover, title-page and two humanized initial letters (the book contains over a hundred), designed by Stefan Themerson, from the English edition of Raymond Queneau's *Exercises in Style* (1958), translated by Barbara Wright. In this book Queneau tells the story, in ninety-nine different versions, of a minor brawl in a Paris bus, thus exploring the resources of language.

eats, Europe reproduces, Europe functions the normal cycle – and continually gives birth – to machine gun fodder.'

At that time Themerson was also editing and producing the first Polish magazine devoted to experimental films, making collages and photograms, and beginning to write novels.

Poland in the 1930s had strong traditions of experiment and contact between artistic and scientific activities, but the Themersons in 1937 moved to Paris, on account of its artistically stimulating and less socially repressive environment.

Franciszka Themerson came to London in 1940, and Stefan, who was by then in the Polish army, also escaped (via Spain and Portugal) in 1942 to England, where he made two abstract films for the Polish Ministry of Information.

Anthony Froshaug has described his first meeting with Themerson at about that time:

'At the top of the house was a curious room, filled with books (apparently mostly dictionaries), piled one above the other as though in a second-hand bookshop, paintings and objects by Schwitters and Potworowski, primitive furniture, and a wall covered from end to end with a wide strip of paper, divided horizontally into rough categories of subject (painting and sculpture, scientific discovery, literature, political events, architecture, and so forth).

'Vertically, the paper strip was divided chronologically; but the time scale was intentionally logarithmic, giving little space before Christ, much more after; less before Copernicus than after; less before Cervantes than after; in fact, about the same before, say, Faraday, as from the 1820s to the present day. On this grid were arranged, by subject and date, hand-written annotations of events, illustrations cut from booksellers' catalogues, postcard prints of paintings and buildings: a synoptic collage of human artefacts.'

In 1948 Stefan and Franciszka Themerson founded the Gaberbocchus Press (Gaberbocchus is a supposed Latin translation of Jabberwock). Their publishing credo was summed up in a letter to the book trade in 1955: 'We are not interested in producing best-sellers. On the contrary, we would be rather embarrassed if we received orders for twenty thousand copies. When we design a book what we aim at is a best-looker, not a best-seller. You may think it odd, but that is sound economic policy for a publisher of our size.' The directions in which Gaberbocchus has pointed during the last two decades have been totally ignored by other publishers and art schools (where a bogus professionalism has replaced real enquiry) alike. Gaberbocchus remains an isolated case of genius in low-budget book production.

At the age of fourteen (in 1924) Themerson built himself

St Francis and the Wolf of Gubbio (or Brother Francis' Lambchops). An opera in two acts, text and music by Stefan Themerson. This is a scenic demonstration of the ethical theory, proposed in his 'factor T' (1955, now out of print), where T stands for Tragic discrepancy between our dislike of killing and the necessity of doing so.

a wireless set. He was more impressed by the musical possibilities of the 'divine interference whistling' than by hearing a girl's singing voice (perhaps he was anticipating Cage?). Four years later, in an article which he wrote for the Polish fortnightly journal *Wiek XX*, he accurately visualized the forms that radio, cinema ('Might not such a fusion . . . of sight and sound . . . become the ultimate form of the theatre, at least for our age?') and even television would take. This was before the advent of the 'talkies'. Even some years later Eisenstein, René Clair and Chaplin, among others, were condemning 'talking film'.
Anthony Froshaug describes

the period when he was helping Themerson with the English translation of his satirical novel *Cardinal Pölätüo*[1]: 'During all this time, I was impressed by the universality of interests of this person . . . a man capable of all the combinatories of symmetry theory translated into literature: reflecting the image, like the medieval philosophers; relating and then reflecting, Carroll-like; enlarging or reducing, like Rabelais or Swift.'
Although Themerson would refuse the title of precursor, his work as a collagist and maker of photograms in the 1930s, his seminal film *Europa* (first full-frontal nude?), his philosophical-satirical writing,

with its intimations of concrete poetry (*Bayamus*, 1946), and his concern for the structures and meaning of language, with all its typographical implications, contained the promise of much that we now take for granted. He is unable to write or draw a line without implying kaleidoscopic possibilities. As a critic writing in *Tribune* remarked, reviewing *Bayamus*, Themerson shows 'an extremity of alertness – like a sudden new angle of light'.

[1] Froshaug said that Themerson made a virtue of the constraint of having been given a typewriter with the letters, ä, ö, ü – which, by their presence, demanded to be used.

Jan Tschichold

The vital contributions to modern typographical design made by Jan Tschichold precede the time span of this survey (1950–70) by more than twenty years; his book *Die Neue Typographie* was first published in 1928. The ideas which he propagated then are still valid today, and indeed influenced the training of many of the younger designers whose work is represented in this book.

Tschichold was aware of the interdependence of all forms of visual communication and, in particular, of the relationship between abstract painting and modern typography. 'The new vision is most purely embodied in abstract painting, which is both the foundation and summit of modern design.' He was enthusiastic about the work of Albers, El Lissitsky and Moholy-Nagy, and about their experiments in painting and photography. Typography in the 1920s and 1930s was concerned with style. It was illogical, often irrational and, as a result, often boring. Tschichold, working with a sense of historical detail, evolved a new dogma, abandoning the practice of 'centred' typography for a new asymmetrical approach, giving careful consideration to weight, scale, colour, space and contrast as design elements.

In 1946 he came to England and was asked to redesign the entire typographical structure of Penguin Books. He has designed and written many books since then and has received awards from numerous countries in recognition of his work. He now lives in Switzerland as a practising designer, working mainly in the style of classical typography.

The title-page of *Die Neue Typographie*

Im VERLAG DES BILDUNGSVERBANDES der Deutschen Buchdrucker,
Berlin SW 61, Dreibundstr. 5, erscheint demnächst:

JAN TSCHICHOLD
Lehrer an der Meisterschule für Deutschlands Buchdrucker in München

DIE NEUE TYPOGRAPHIE

**Handbuch für die gesamte Fachwelt
und die drucksachenverbrauchenden Kreise**

Das Problem der neuen gestaltenden Typographie hat eine lebhafte
Diskussion bei allen Beteiligten hervorgerufen. Wir glauben dem Bedürf-
nis, die aufgeworfenen Fragen ausführlich behandelt zu sehen, zu ent-
sprechen, wenn wir jetzt ein Handbuch der **NEUEN TYPOGRAPHIE**
herausbringen.

Es kam dem Verfasser, einem ihrer bekanntesten Vertreter, in diesem
Buche zunächst darauf an, den engen Zusammenhang der neuen
Typographie mit dem **Gesamtkomplex heutigen Lebens** aufzuzei-
gen und zu beweisen, daß die neue Typographie ein ebenso notwendi-
ger Ausdruck einer neuen Gesinnung ist wie die neue Baukunst und
alles Neue, das mit unserer Zeit anbricht. Diese geschichtliche Notwen-
digkeit der neuen Typographie belegt weiterhin eine kritische Dar-
stellung der **alten Typographie.** Die Entwicklung der **neuen Male-
rei,** die für alles Neue unserer Zeit geistig bahnbrechend gewesen ist,
wird in einem reich illustrierten Aufsatz des Buches leicht faßlich dar-
gestellt. Ein kurzer Abschnitt „**Zur Geschichte der neuen Typogra-
phie**" leitet zu dem wichtigsten Teile des Buches, den **Grundbegriffen
der neuen Typographie** über. Diese werden klar herausgeschält,
richtige und falsche Beispiele einander gegenübergestellt. Zwei wei-
tere Artikel behandeln „**Photographie und Typographie**" und
„**Neue Typographie und Normung**".

Der Hauptwert des Buches für den Praktiker besteht in dem zweiten
Teil „**Typographische Hauptformen**" (siehe das nebenstehende
Inhaltsverzeichnis). Es fehlte bisher an einem Werke, das wie dieses Buch
die schon bei einfachen Satzaufgaben auftauchenden gestalterischen
Fragen in gebührender Ausführlichkeit behandelte. Jeder Teilabschnitt
enthält neben **allgemeinen typographischen Regeln** vor allem die
Abbildungen aller in Betracht kommenden **Normblätter** des Deutschen
Normenausschusses, alle andern (z. B. postalischen) **Vorschriften** und
zahlreiche Beispiele, Gegenbeispiele und Schemen.

Für jeden Buchdrucker, insbesondere jeden Akzidenzsetzer, wird „Die
neue Typographie" ein **unentbehrliches Handbuch** sein. Von nicht
geringerer Bedeutung ist es für Reklamefachleute, Gebrauchsgraphiker,
Kaufleute, Photographen, Architekten, Ingenieure und Schriftsteller,
also für alle, die mit dem Buchdruck in Berührung kommen.

typ. tschichold

Das Buch enthält über **125 Abbildungen,** von
denen etwa ein Viertel **zweifarbig** gedruckt ist,
und umfaßt gegen **200** Seiten auf gutem Kunst-
druckpapier. Es erscheint im Format DIN A5 (148×
210 mm) und ist biegsam in Ganzleinen gebunden.

Preis bei Vorbestellung bis 1. Juni 1928: **5.00** RM
durch den Buchhandel nur zum Preise von **6.50** RM

Bestellschein umstehend

Stan Vanderbeek

Stan Vanderbeek began his career as a traditional painter. He studied painting and graphics at the Cooper Union Art School, New York, but soon began to realize the limitations of the museum-based 'object' tradition. Vanderbeek feels that it is essential for the artist to make use of the increasingly sophisticated technology of communication, and also for technology to make use of the artist. It is clear, he thinks, that entirely new visual techniques, symbols and media must be employed, now that we are re-ordering our visual semantics.

The methods of transmitting, storing and retrieving data have now become so efficient, fast and complex that we must reappraise our whole outlook. It is now practicable to bring a variety of disciplines to bear upon a single problem. In fact, technology is changing so rapidly that it is imperative that the ideas and interests of all sorts of people are co-ordinated in using the new tools. Vanderbeek recognizes this, and has worked with musicians, mathematicians, choreographers and engineers. He even envisages systems by which there could be a mass response from, say, a television audience. He says it is very important that art and life interact.

Vanderbeek has been involved in a multiplicity of projects. He constructed what he calls a 'movie drome' in Stony Point, New York. This is a sort of audio-visual laboratory for the simultaneous projection of dance, magic theatre, sound and film. He has also experimented with computer-graphics, animation, projection

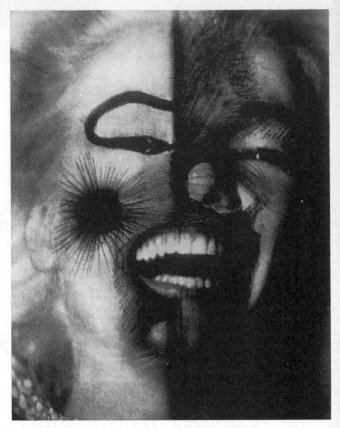

Still from film

systems, movie murals and multi-media concepts. Much of his recent work has been concerned with video experiments and computer-generated films. With the aid of a computer, he can produce in an hour an experimental film which would otherwise have taken several weeks to complete. He is looking forward to the introduction of computer/laser imagery, which he says will be so breathtaking that even the artist will be shocked.

Stan Vanderbeek has always been concerned with

education. He has held posts at various American universities, and is at present Artist Fellow in the Centre for Advanced Visual Research at the Massachusetts Institute of Technology.

'Panels for the Walls of the World', phase 1, 1970. Telephone mural transmitted from the Center for Visual Studies, Massachusetts Institute of Technology, to the Walker Art Center, Minneapolis, over a period of two weeks by means of a telecopier and telephone.

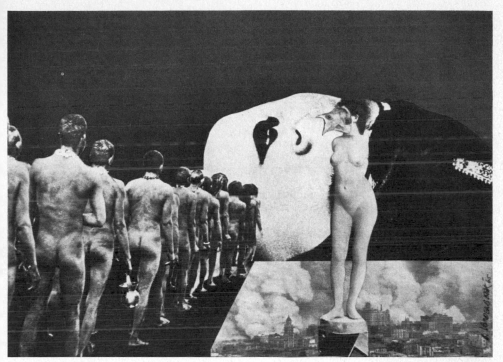

Still from film

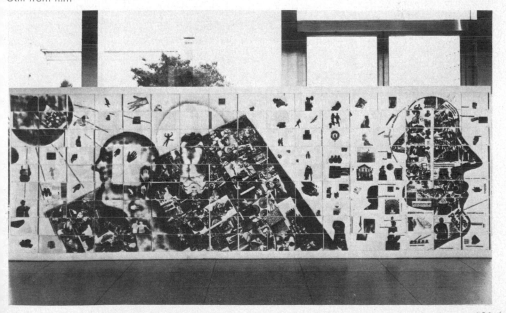

Tom Wesselmann

Tom Wesselmann was brought up in Cincinnati, Ohio. While he was in the army he began to draw cartoons. And it was this interest which led him, eventually, to enrol at the Cooper Union Art School, New York. While he was there he started making the kind of collages which were to constitute much of his early post-student work. He has used objects found in the street, photographs, advertisements, reproductions of works of art and even, recently, a live woman's breast.

Much of his work seems to be simple, open and direct. But this simplicity is often deceptive. His 'Colour Study for Seascape 1966', for instance, shows a landscape with a large leg in the foreground. The whole work is reduced to the simplest flat shapes. He has taken what is virtually a cliché and imposed upon it a new vision.

His nudes look as if they could be the creation of an advertising agency. They are deodorized, streamlined, devoid of all unnecessary detail and constructed from plastic. Within the smooth contours only the necessary sexual features remain: the mouth, the nipples and the genitals. All their characteristics seem to confirm the analogy between these plexiglass models and modern manufactured products. Even the tactile quality of the surfaces evokes that of the refrigerator or car.

Wesselmann says himself that all he does is to make his paintings and collages within the context of painting and art.

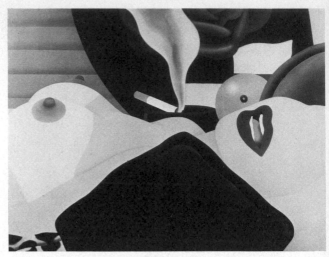

'C.A.N. H 99', 1968

'Landscape 5', 1965

'Bedroom Tit Box' (with live tit), 1968–70. When this was exhibited in London in March 1971 speculation as to how it might be made permanent (Robert Melville, writing in the *Architectural Review*, hinted at taxidermy), and the private life of the young lady contributor, was probably more interesting than the box without its live component. The legend on the wall, 'The live breast will be on view on Saturday mornings between 9.30 and 1 p.m.', contributed to what might be called a 'happening of the mind'. The box, when fully operative – with its overtones of Victorian dioramas and fairgrounds ('tip the lady out of bed'), together with erotic speculation and fantasizing – evoked an undeniable *frisson*.

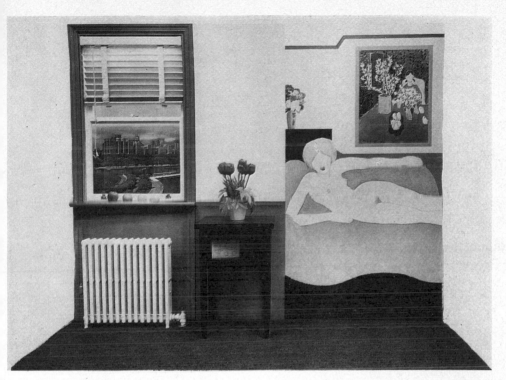

'Great American Nude 48', 1963

Kurt Wirth

Sometimes the ordering of typographical space, based on the meaning of language, is forgotten and we are left with the stylistic shell. The Swiss must be particularly susceptible to this problem, having three official languages. Certainly they were ready to acclaim the rationalism in typography which resulted from the work of the Bauhaus.

Kurt Wirth is an exponent of the 'Swiss style' in typography. He believes, however, that a designer should be versatile and should engage in a wide range of activities. Deploring the fashionable tendency for graphic designers and picture-makers to tighten up their boundaries, he thinks that the graphic designer should not be condemned as lacking in personality merely because he has a command of several techniques.

Wirth thinks that people who are engaged in designing for industry should execute as much of their own free work as possible, and that the experience which they gather from this will enrich the work which they do for fixed commissions. He sees drawing as an indispensable part of the designer's activity. 'Drawing,' he says, 'is like writing, like speaking, like walking.' It is an extremely flexible medium, which allows instantly all sorts of distortions, selections and juxtapositions of the various pictorial elements. No other technique of design enables one to express oneself more personally.

Design for a poster

Broadsheet for A.G.I.

'Avenida.' Painting, 1967

AGI congress

Invitation
to the AGI Congress
Friday, 14th June
to Sunday, 16th June 1968
in Rigi-Kaltbad Hostelry
Switzerland

Invitation
à l'assemblée de l'AGI
du vendredi 14 juin
au dimanche 16 juin 1968
à l'Hostellerie
Rigi-Kaltbad
Suisse

Einladung
zur AGI-Tagung
Freitag, 14. Juni
bis Sonntag, 16. Juni 1968
in der Hostellerie
Rigi-Kaltbad
Schweiz

In the loveliest month of the year Switzerland and the Rigi appear in their most attractive garb. We AGI members therefore plan to rest on the above dates in the now famous Rigi Hostelry, a pleasant and comfortable house with a magnificent view. All our problems will be discussed there in an informal atmosphere but with a little unobtrusive guidance. We shall make new acquaintances and refurbish old contacts. Our wives and families will share the pleasures of our stay. The particulars of our programme are as follows:

Friday, 14th June
By 12.00 noon Arrival of all participants on the Rigi
1.00 p.m. Get-together luncheon (optional)
2.30 p.m. Commencement of Congress
a Address of welcome by the President of the AGI, Germano Facetti
b New members introduce themselves and their principal works in ten transparencies each
c Ensuing discussion
The poster competition organized by the AGI on the subject of the International Festival of Music in Lucerne, will be submitted to critical study (see special invitation)
6.00 p.m. Close of proceedings
7.00 p.m. Apéritif (optional)
8.00 p.m. Dinner à la carte
The whole evening is free.

Films will be shown. We shall also be able to judge the posters entered for the competition. Naturally, groups will also form to talk shop, to exchange jokes and generally to have fun together.

Saturday, 15th June
10.00 a.m. Commencement of a Round Table Conference on the subject of «The Graphic Designer Today and Tomorrow»
Sub-headings:
1 In what light do I see myself as a designer? How do I conceive of my professional function, what is my place in society and in the economy? What ideals have I over and above my practical approach?
2 Future prospects. Where are today a rapidly changing styles leading, is any valid expression of visual communication beginning to take shape?
3 What are we to do about the younger generation? Are we taking the right course as teachers and example-setters? Are we training our young people so that they will be equal to the ever more exacting demands of practice without becoming simply servants of advertising?
A person with no appointed to lead the discussions on each of these topics, which will be translated simultaneously, and he will see to it that everyone has a chance to make a useful contribution. Unnecessary prolixity will if possible be avoided. We hope

to maintain a high standard of discussion and expect our talks to be fruitful. Controversial sentiments will be invited, for instance the uneasiness felt at present on the advisory or otherwise of the numbers of designers going to older companies adapting their relations between the traditional designer and the advertising agency. We believe that the three subjects mentioned above will provide matter for very interesting discussions. An opportunity to collect information and to contribute to the study of urgent problems on an international plane has not been offered in this form before. For the matters there will be a ready-made and rigidly apodictic speeches, but a lively exchange of views.
12.00 noon Close of the first series of discussions, followed by luncheon together or individually.
2.30 p.m. Resumption of the Round Table Conference.
4.00 p.m. Tea or coffee break
4.15 p.m. Resumption of discussions
4.15 p.m. Close of discussions
7.30 p.m. Apéritif

Sunday, 16th June, «Swiss Sight Seeing» Departure 10.00 a.m. over Lucerne to Engelberg. With telepherique over snowfields and glaciers to the 3200 m high Titlis.
About 16.30 p.m. farewell drink in Trübsee Hotel. Back in Lucerne about 20.00 p.m. Overcost, about 30 frs.

We Design a Poster

We want the Congress to be a visual manifestation for our guests as well as for ourselves. We are therefore planning an especial invitation on the Rigi. All AGI members are invited to join in a poster design competition on the subject of the International Festival of Music in Lucerne.

This Festival is today well-known to musicians and music-lovers all over the world. Since our Congress will take place in the vicinity of Lucerne, the subject seems to suggest itself for our open competition, and we believe that it will be a fascinating challenge to all participants.

Size: 50% × 35% in
Colours: No restrictions
Technique: The design should be made on waterproof colours on paper (paper (Takens acrylic colours, LUKAs CRYL, sixteen colours).
Copy: International Festival of Music, Lucerne 1969
14th August–6th September 1969. We shall mail all members who enter for this competition a white poster sheet in a board cylinder with a return address label.

The finished poster can be returned in the cylinder to the address indicated. Closing date: see special programme. All the designs will be returned on special stands.

Public relations will be mobilized for this poster competition, which will be brought to the attention of press, radio and television. All designs submitted will be returned.

It is probable that the management of the International Festival of Music in Lucerne will buy one of these posters, naturally for the usual fee. The subject is an inviting one. The treatment may be abstract or may refer to musical instruments, and any technique may be used including photography.

It will unfortunately not be possible to return the posters. We shall place the mounted posters at the disposal of the Collection of the Museum of Applied Art in Zurich immediately after the end of the exhibitions. We shall then leave it entirely to the results of this AGI competition.

Day ticket for the AGI Congress: SFr. 60.–; (including wife) SFr 60.–; for 3 days (Friday–Sunday) SFr 110.– (excluding hotel and overnight expenses).
Worst cases will be modest: approx. SFr. 25.– per night per head.

Juin est sans doute le plus beau mois de l'année, en Suisse en général et sur le Rigi en particulier. C'est pourquoi nous avons choisi la date si-dessus indiquée pour nous retrouver à l'hostellerie du Rigi qui a déjà acquis une véritable renommée. Et elle le mérite en fait. La ville au aussi hospitalière que magnifiquement située.

Nous y discuterons des problèmes qui nous préoccupent, ferons connaissance et retrouverons des amis. Nos femmes et nos enfants prendront part au programme de nos plaisirs et de l'agrément de ces journées est resté.

Vendredi 14 juin jusqu'à
12.00 h arrivée des participants au Rigi
13.00 h repas en commun
14.30 h ouverture de l'assemblée
a discours de bienvenue du président de l'AGI, M. Germano Facetti
b présentation des membres nouvellement admis qui nous montreront chacun 10 diapositives de leurs travaux principaux
c étude critique du concours d'affiche organisé par l'AGI sur le thème des Semaines musicales internationales de Lucerne (voir invitation spéciale)
18.00 h fin de la séance officielle
19.00 h apéritif (pour les amateurs)
20.00 h dîner à la carte
Toute la soirée est libre.
Des films seront présentés. Si le cœur nous en dit nous pourrons encore jouir du jury du concours d'affiches.
Nous ne doutons pas que des groupes se formeront spontanément, on discourra femme, dira les calembours pour bon train, que les temps

se restregojnos idées si rien la figure fictive y régnera

Samedi 15 juin
10.00 h début d'une table ronde sur le thème «Le graphiste d'aujourd'hui et celui de demain».
Sous-titres:
1 Comment est-ce que je me vois moi-même? Comment conçois-je mes obligations professionnelles, comment est-ce qu'il m'appartient sur le plan économique? Quel est aujourd'hui, vis à part son attitude et la pratique?
2 Perspectives d'avenir.
Où mènent les rapides changements de styles actuels, quelle forme d'expression valable se dessine déjà sur le plan des communications visuelles?
3 Que faisons-nous vis-à-vis de la jeunesse? Agissons-nous correctement en tant que chefs ou professeurs? Donnons-nous aux jeunes la formation nécessaire pour qu'ils puissent satisfaire aux exigences toujours plus grandes dans la pratique sans devenir des esclaves de la publicité?
Ces conversations seront traduites simultanément et la discussion sera menée par un responsable qui s'efforcera de donner la parole à quiconque à quelque chose d'essentiel à dire. Les polémiques devraient pouvoir être évités. Nous voulons garder un niveau élevé et arriver à de féconde conclusions. Les mêmes épineux ne seront pas évités, nous parlerons du malaise née par la situation de nos collègues âgés, par exemple et des relations entre les graphistes indépendants et les agences de publicité.

à mentre a high standard de...

Carte manifestation est destinée tant pour nos hôtes que pour nous-mêmes. Nous préparons une exposition en plein air et tous les membres de l'AGI sont cordialement invités à y participer.

Nous réalisons une affiche

Suisse autorités au jus de l'importance d'une manifestation visuelle, tant pour nous-mêmes que pour nos hôtes. Nous préparons une exposition en plein air et tous les membres de l'AGI sont cordialement invités à y participer.

Nous autorisons échanger des points de vue et non pas faire des discours apodictiques.
12.00 h fin du premier cycle de discussions suivi du déjeuner en commun ou individuel.
14.45 h reprise de la discussion
16.00 h pause café ou thé
16.15 h reprise
17.30 h close
20.00 h banquet officiel de l'AGI
(et l'autonne exigeront qu'on à la tenue vestimentaire)

Dimanche, 16 juin, «Swiss Sight Seeing» Départ, 10 heures vie Lucerne pour Engelberg. En téléphérique, au-dessus des champs de neige et glaciers jusqu'au Titlis (3200 m). Environ 16.30, le vin de l'amitié à l'Hôtel Trübsee.
De retour à Lucerne, env. 20.00 heures. Frais supplémentaires, env. 30 frs.

Carte manifestation est destinée tant pour nos hôtes que pour nous-mêmes. Nous préparons une exposition en plein air et tous les membres de l'AGI sont cordialement invités à y participer.

Nous assistons le tirant à proximité de Lucerne, nous avons délibéré sur un concours d'art de circonstance et il a passionnément les participants.
Format de l'affiche:
format normal 90.5/128 cm
Couleurs: à volonté
Technique: l'esquisse devrait être réalisée en couleurs indélébiles sur du papier à dessin (takens acrylic colours, LUKAs CRYL, couleurs de sérigraphie inscription: semaines musicales internationales de Lucerne 1969 du 14 août au 6 septembre 1969

Tous les participants qui s'inscrivent recevront une feuille d'affiche blanche sur un carton à part, le rouleau d'emballage muni d'une étiquette de Lucerne; nous avons ajouté rien de l'adresse adéquate pourra être utilisé pour l'envoi de l'affiche.
Délai de l'envoi: voir invitation spéciale. Tous les travaux seront collés sur panneaux et montés comme il se doit. Cette exposition sera exploitée sur le plan des relations publiques, la presse, la radio et la télévision seront informées. Tous les travaux reçus seront photographiés.

Il est probable que la direction des semaines musicales internationales fasse acquisition d'une de ces affiches, au tarif habituel, cela va de soi. Le thème donné prête matière à de nombreuses interprétations, abstraires instrumentales, si usuels les techniques peuvent être employées

Carte journalière de l'assemblée de l'AGI: 60 francs par jour (épouse comprise)
110 francs pour 3 jours (vendredi au dimanche) sans les frais de voyage et d'hôtel.

Im schönsten Monat des Jahres zeigt die Schweiz und der Rigi das verlockendste Kleid an. Deshalb wollen wir AGI-Freunde uns an oben genannten Tagen in der schon berühmt gewordenen Hostellerie treffen. Ein bequemes, gastliches Haus mit wunderbarer Fernsicht. Alle unsere Probleme werden dort in ungezwungener, doch leicht gelenkter Form diskutiert. Wir werden einander kennen oder frischen alte Kontakte wieder auf. Unsere Frauen und Kinder sollen teilhaben an den Freuden mit uns. Was im einzelnen geboten wird, sollen Sie jetzt erfahren:

Freitag, 14. Juni,
12.00 Ankunft aller Teilnehmer auf der Rigi
13.00 nach Wunsch gemeinsames Mittagessen
14.30 Tagungsbeginn
a Begrüssung durch den AGI-Präsidenten Germano Facetti.
b Die neu aufgenommenen Mitglieder stellen sich selbst durch je 10 Dias mit ihren wesentlichsten Arbeiten vor.
c Wir studieren kritisch die von der AGI organisierte
Plakat-Wettbewerbs-Aktion mit dem Thema «Internationale Musikfestwochen Luzern»
18.00 Schluss
19.00 Apero, wer Lust dazu hat
20.00 Nachtessen à la carte.
Der ganze Abend ist frei. Es werden noch Filme vorgeführt.

Wir können Ihnen empfehlen, zum Jury für die Plakataktion spielen. Natürlich werden sich Gruppen bilden, es wird fleissig fachgesimpelt, gekalauert, gelacht, je nach Lust und Laune.

Samstag, 15. Juni
10.00 Beginn eines Round-Table-Gesprächs mit dem Thema «Der Grafiker in Gegenwart und Zukunft».
Untertitel:
1 Wie sehe ich mich als Grafiker? Wie fasse ich meine berufliche Aufgabe auf, wie fühle ich mich in der menschlichen Gesellschaft, in der Wirtschaft? Welche Ideale habe ich, neben meiner praxisnahen Einstellung?
2 Ausblicke in die Zukunft.
Wohin führen die heute rasch wechselnden Stile, wie beginnt sich eine gültige Ausdrucksform der visuellen Kommunikation abzuzeichnen?
3 Was machen wir mit der Jugend? Tun wir als Lehrmeister und Lehrer das Richtige? Schulen wir unsern jungen Leute so, dass sie den stets wachsenden Anforderungen der Praxis gewachsen sind und doch keine blossen Werbediener werden?
Für diese Themenreihe, deren Gespräche fortlaufend übersetzt werden, wird je ein Diskussionsleiter angesetzt, der dafür besorgt ist, dass jedermann etwas wesentliches beitragen kann. Es soll vermieden werden, das unnötige Polemiken entstehen. Wir wollen

ein hohes Niveau einhalten und erwarten fruchtbare Auseinandersetzungen. Es soll nicht an heissen Eisen vorbeigeredet werden
z.B. das Malaise ünberug auf die rückläufigen Beschäftigungsgrad älterer Kollegen betreffen die Verhältnis zwischen freiem Grafiker und Werbeagentur. Glauben Sie nicht auch, dass die genannten drei Themata genügend Stoff für sehr anregende Gespräche abgeben? Uns gibt die Gelegenheit, auch an informieren und einen Beitrag zur Lösung dringender Fragen auf internationaler Ebene zu leisten hat sich bisher noch nie in dieser Form geboten.
Aus diesem Grund keine fertigen apodiktischen Referate von apodiktischer Starrheit, sondern brodende Meinungsbildung.
12.00 Schluss der ersten Diskussionsreihe. Anschliessend gemeinsames oder separates Mittagessen.
14.30 Wiederbeginn des Round-Table-Gesprächs
16.00 Kaffee- oder Teepause
16.15 Wiederbeginn der Diskussionen
18.15 Schluss
19.30 Apero
20.00 Beginn des festlichen AGI-Banketts mit Tanz (kein Toilettenzwang)

Sonntag, 16.Juni, «Swiss Sight Seeing», Abfahrt um 10 Uhr via Luzern nach Engelberg, mit der Schwebebahn über die Schneefelder und Gletscher auf den 3200 m hohen Titlis.

16.30 Abschiedsdrink im Hotel Trübsee Zürich in Luzern ca. 20 Uhr. Extrakosten ca. 30 Franken.

Wir malen ein Plakat

Die Tagung soll auch eine visuelle Manifestation werden, nicht nur für uns, auch für unsere Gäste. Geplant ist eine Freiluftausstellung auf der Rigi. Alle AGI-Mitglieder sind herzlich zur Teilnahme eingeladen.
Wir malen ein Plakat mit dem Thema: Internationale Musikfestwochen Luzern. Dieser Veranstaltung ist heute ein Weltbegriff im Kalender der Interpreten und Konzertpublikums. Unsere Tagung findet in unmittelbarer Nähe von Luzern statt, deshalb scheint uns das Thema für einen freien Wettbewerb sinnvoll und für alle Teilnehmer eine packende Aufgabe.
Format: Weltformat 90,5/128 cm
Farben unbeschränkt
Technik: Der Entwurf sollte auf Zeichenpapier in wasserfester Farbe ausgeführt werden (Takens acrylic colours, LUKAs CRYL, Siografie Farben). Inschrift: Internationale Musikfestwochen Luzern 1969
14. August–6. September 1969
Allen schon angemeldeten Teilnehmern wird gesandt: Ein weisses Plakatbogen in Kartonrolle und Rückzentadresse zugeben. Das fertige Plakat kann in der Rolle an die angegebene Adresse zurückgeschickt werden.

Termin: siehe Spezialeinladung
Alle Entwürfe werden von uns auf Hartplatten aufgezogen und auf Spezialständer montiert. Für diese Plakataktion werden die Mittel das PR mobgesetzt, Presse, Radio TV werden sich mit ihr befassen. Sämtliche eingereichten Entwürfe werden fotografiert.
Es besteht die Möglichkeit, dass die Leitung der Internationalen Musikfestwochen eines dieser Plakate erwirbt, selbstverständlich gegen das übliche Honorar.
Das gegebene Thema ist gar dankbar. Es können instrumentbezogene oder abstrakte Lösungen gewählt werden, in jeder beliebigen – auch Foto-Technik. Eine Rücksendung der Plakate ist leider nicht möglich. Wir werden die aufgezogenen Affichen der Sammlung des Kunstgewerbemuseums Zürich zur Verfügung stellen, sobald der Ausstellungsturnus abgelaufen ist. Wir sind gespannt auf die mutmasslichen Resultate dieses AGI-Wettbewerbs.

Tageskarte der AGI-Tagung
20.00 Franken pro Tag (Frau inbegriffen) Fr. 60.–
für 3 Tage (Freitag–Samstag) Fr. 110.– ohne Hotel und Nacht.
Die Hotelkosten sind nicht niedrig, ca. Fr. 25.– pro Nacht und Person.

Henry Wolf

Describing the methods of composition of Stockhausen and John Cage, Dick Higgins has said, 'The artist defines the scope of the work of art; what happens in between is "the piece".' This seems to be an apt description of the nature of magazine art direction, which during the 1950s and 1960s gradually evolved as a specific activity. And, although dependent on artists, photographers and writers, the art director himself does not necessarily possess the same talents. In extreme cases art direction could be called the Diaghilev syndrome.

Henry Wolf, though a painter, draughtsman and photographer of rare gifts, has chosen to devote most of his time to the self-effacing role of art director. Rebelling against the slick, conforming, specialized attitudes prevalent in American magazine design, when he took over the art directorship of *Esquire* in 1952 one of his first acts was to commission artists such as Lindner, Shahn and Baskin, and several photographers, for work in which they had not previously specialized. No one whose work is unconnected with commercial design can fully appreciate the significance of this iconoclastic action performed in a society committed to conformism.

Regretting the passing of magazines which once made fashions, made architecture, and made taste, instead of merely reflecting them, Henry Wolf said at the Design Conference of the Art Directors Club of New York in 1963, 'I think there is room for a free-wheeling, out-on-a-limb sort of editing that doesn't always have to win or always have to sell and that even can afford to be gloriously wrong once in a while.'

Cover design for the magazine *Esquire* (1955)

Full-page illustration from an advertisement for the Ogden Corporation

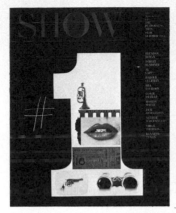

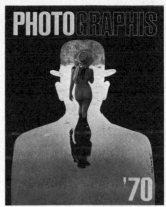

Cover design for the magazine
Harper's Bazaar (1958)

Cover design for the magazine
Show (1961)

Cover design for the magazine
Photographis '70

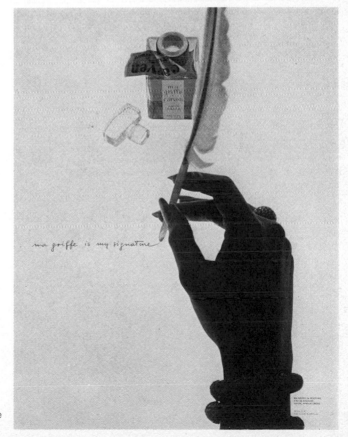

Full-page advertisement for the
scent 'Ma Griffe'

Edward Wright

Designer of environmental graphics, architect, painter, constructivist-typographer, concrete poet, interpreter of other concrete poets, sculptor, designer of alphabets, ad-man, art historian of the modern movement, furniture-maker, teacher — this description of Wright is accurate, but the minute one attempts to put a name to a particular activity, one moves away from the truth. Wright works in a wide field of media of necessity, because only by exploiting contradictory elements in the world and in his own nature can he fully realize his essential vision.

Communication is very much his concern, and lexical structures probably lie at the core of his interests. In 1952 he planned and supervised a course, entitled 'Experimental Typography', at the Central School of Arts and Crafts, London, launching out into the unknown with only a hand press and some wooden type. Although, after nearly twenty years, the stylistic qualities which were developed during this course have become part of the common currency of graphic design, very few of Wright's enquiries into language, and into the possibilities of lexical structure,

have been followed up. Many of the experiments conducted in that class might now be called 'concrete poetry', a term which had not yet been coined in the early 1950s, although Gomringer in Germany, and Augusto and Haraldo Campos in Brazil, were already working in the direction of concrete poetry.

In a paper read at a symposium at Downside, Wright spoke of the 'Painter's Task' and the 'Painter's Play'. He said, 'During the ice-age both painter's task and painter's play were sacred. The task included a given theme, site and materials. The

Mural on scaffolding planks on a temporary building (architect, Theo Crosby) constructed on the South Bank, London, for the Congress of the International Union of Architects, 1961. An interpretation in four languages of the words 'architecture of technology'.

interpretation of the theme, the use of materials and above all the use of the site, were vitalized by the instinct of play. Nowadays the painter is not given a theme nor is he asked to create visual symbols for his society. In spite of this the will to make images survives. In a curiously oblique way people are still ready to look at new images and even to absorb them because they are still needed.'

(See also page 22.)

Poem folded

Collage, 1969

Collage, 1969

Biographies

Acknowledgments

Biographies

Valerio Adami
Born in Bologna, 1935. Lives and works at Arona, Italy. Executed illustrations for *Derrière le Miroir* (Maeght Editeur, 1970). One-man exhibitions in Milan, Rome, Venice, London, Brussels and Ulm.

Michelangelo Antonioni
Born in Ferrara, 1912. Studied at the University of Bologna. Became film critic for *Cinema* in Rome, 1939. Entered the Experimental Centre, a school for training film technicians. Assistant director to Marcel Carné in France for *Visitors of the Night*. Worked as translator and film critic until the end of the war. Directed eight documentaries between 1943 and 1955. First feature film, *Cronaca di un Amore*, 1950. Later films: *I Vinti*, 1952; *La Signora senza Camelie*, 1953; 'Tenato Suicido', an episode in *L'Amore in Città*, 1953; *Le Amiche*, 1955; *Il Grido*, 1957; *L'Avventura*, 1960; *La Notte*, 1960; *L'Eclisse*, 1961; *Il Deserto Rosso*, 1964; *Blow-up*, 1967; *Zabriskie Point*, 1968.

Dennis Bailey
Born in 1931. Studied at the West Sussex College of Art and the Royal College of Art until 1953. Travelled to Sicily in 1954 on a scholarship from the Royal College of Art; produced paintings and drawings. Worked as freelance illustrator 1954–56, working for publishers and magazines; produced two murals. In 1956 became Assistant Editor of the magazine *Graphis* in Zurich. Worked on experimental film project in Paris; travelled in Greece, drawing and painting. Established a practice as a designer in London in 1959 and began teaching. Art Director of the magazine *Town*, 1964. Went to India on photographic assignment for *Town*. Since 1966 has worked as a freelance designer/illustrator.

Saul Bass
Born in New York, 1921. Studied at the Art Students' League, and at Brooklyn College with Gyorgy Kepes. Freelance designer until 1946. Became Art Director for Buchanan and Company. Joined Foote, Cone and Belding, Los Angeles, 1950. In 1952 established his own design office, working as a consultant to industry and to advertising agencies. His work has been shown regularly at the Art Directors Club since 1949. He is perhaps best known for the credit titles that he has designed for many films, including *West Side Story*, *Anatomy of a Murder*, *Exodus*, *Bonjour Tristesse* and *Walk on the Wild Side*. Voted Art Director of the Year, 1957. Member of the Alliance Graphique Internationale.

Lester Beall
Born in Kansas City, 1903. Studied at Lane Technical School, Chicago. Received Ph.B. in the History of Art from the University of Chicago, 1926. Worked as freelance designer in Chicago 1927–35. Produced two murals for the Chicago World Fair, 1933–34. In 1935 moved to New York, where he remained for sixteen years. Transferred his business to his home in Dumbarton farm, Connecticut, where he remained until his death in 1969. Participated in over a hundred exhibitions, including one-man exhibitions at the Museum of Modern Art, New York (1937), and in Paris and London. Exhibited watercolours at the Art Institute of Chicago. As a teacher, lectured in the United States and Canada. Is perhaps best known for his research into corporate identity systems.

Max Bill
Born in Winterthur, Switzerland, 1908. A lecture by Le Corbusier, which he attended in Paris, led him to take up architecture. Studied in Zurich, and (1927–29) at the Bauhaus, Dessau. Head of the Hochschule für Gestaltung, Ulm, 1951–56. His work in architecture, painting/sculpture and graphic design has been widely exhibited. As an exhibition designer, was responsible for the Swiss Pavilion at the Milan Triennale exhibition, 1951; the exhibition pavilion, 'Ulm', Stuttgart, 1955; the exhibition 'The Unknown Present', Zurich, 1957; and the section, 'Education and Creation', at the Swiss National Exhibition, Lausanne, 1964. Designed approximately fifty posters, 1950–70. Lives in Zurich. Awarded National Prize for Sculpture, São Paulo Bienal exhibition, 1951; Grand Prix, Milan Triennale exhibition, 1936 and 1951.

Derek Birdsall

Born 1934. Studied at Wakefield College of Arts and Crafts, Yorkshire. Studied design at the Central School of Arts and Crafts, London, until 1955. After two years' military service established himself as a freelance designer in 1957. Lecturer in Typography and Design at the London College of Printing, 1958–60. Participated in an exhibition of work by the Association of Graphic Designers, London, 1960. Founder member of the design partnership Birdsall, Daulby, Mayhew, Wildbur. Consultant designer to Balding and Mansell Printers and to BBC Television. Founder member of the design group OMNIFIC. Member of the Alliance Graphique Internationale. Visiting Lecturer, Central School of Arts and Crafts. Examining Assessor for the National Diploma in Art and Design.

Jan Bons

Born in Rotterdam, 1918. Studied graphic design and exhibition design at the Hague and in Amsterdam. Produced a large mural for a Dutch exhibition in Mexico. Worked with Willem Sandberg, and the architect Gerrit Rietveld. Consultant designer to Van Ommeran and the Studio Theatre Group. Member of the Alliance Graphique Internationale. Awarded the H. N. Werkman Prize of the Municipality of Amsterdam, 1969. Books designed by him were included in the exhibition of Dutch books printed clandestinely during the Nazi occupation of Holland, British Museum, 1970.

Walerian Borowczyk

Born in Kwilcz, Poland, 1923. Studied painting at the Académie des Beaux Arts, Cracow, 1946–51. Worked as a painter/lithographer, and began drawing for animation, 1951–56. Has been awarded many prizes for his animated films in Europe and the United States. His best known films are *Dom*, 1958; *Renaissance*, 1963; *Les Jeux des Anges*, 1964; *Le Théâtre de Monsieur et Madame Kabal*, 1967 (awarded the Prix Max Ernst); *Goto, L'Ile d'Amour*, 1968. During 1970 he worked on the film *Blanche*.

Mark Boyle

Born in Glasgow, 1934. Studied law at Glasgow University, 1955–56. Taught at the School of Art, Watford College of Technology, 1966–67. One-man exhibitions: Woodstock Gallery, London; Arts Council, Edinburgh; Arts Council, Glasgow; Indica Gallery, London, 1966; Arts Centre, Bristol, 1967. Organizer of events and happenings. Founder member of the Institute of Contemporary Archaeology.

Bill Brandt

Born in London, 1904. Student of Man Ray in Paris, 1929. Has worked as a freelance photographer in London since 1931 for English, French and American magazines. During the war worked as a photographer for the Ministry of Information and National Buildings Record. Is the author of several books. One-man exhibitions in New York (Museum of Modern Art, 1969) and London (Arts Council, 1970).

Robert Brownjohn

Born in Newark, New Jersey, 1925. Studied painting and design under L. Moholy-Nagy at the Art Institute of Chicago. Studied architecture under Serge Chermayeff at the Institute of Design, Illinois. Founder member of the design group Brownjohn, Chermayeff (q.v.) and Geismar (q.v.) in New York, 1957. Faculty member of the Cooper Union Art School and the Pratt Institute, New York. Came to London in 1961 and was appointed Art Director at the McCann Erickson advertising agency. Produced titles for the films *Goldfinger* and *From Russia with Love*, also a number of cinema advertisements using animated letter-forms. Died in London, 1970.

Alberto Burri

Born in Perugia, 1915. Studied medicine and surgery. Prisoner of war in Texas, where he began painting in 1944. Began to paint continuously in Rome, 1946. First major exhibition, Galleria la Margherita di Roma, 1947. First sack paintings, 1952. Awarded first prize, Venice Biennale exhibition, 1952. Began to use plastics, 1958.

Pol Bury

Born in Haine-Saint-Pierre, Belgium, 1922. Studied art and design at the Académie des Beaux-Arts, Mons, 1938. In

1939 joined the Rupture group (engaged in surrealist research); was influenced by Magritte and Tanguy. Exhibited at the International Exhibition of Surrealism, Brussels, 1945. Abandoned painting, 1953. Exhibited his multiplans and used electricity in his work for the first time, 1957. First one-man exhibition, Paris, 1962. Member of the Zero group. Exhibited at the Venice Biennale exhibition, 1964; awarded prize in the Marzotto selection. Illustrated Stendhal's *Piccola Guida Allouso di un viaggiatore in Italia*, 1967. Became interested in magnets, 1968.
Retrospective exhibition, University of California Museum, Berkeley, 1970.

Mel Calman
Born in London, 1931. Studied illustration at St Martin's School of Art, London. Worked as a cartoonist for the *Daily Express*, *Observer*, *Sunday Telegraph* and *Sunday Times*. Now freelance cartoonist for publishing houses and advertising agencies. Books include *Through the Telephone Directory*, *Bed-sit*, *Boxes*, *Calman and Woman* and *The Penguin Mel Calman*. Recently opened a gallery in London, selling original cartoon drawings and prints.

Antonio Carena
Born in Italy, 1925. Studied at the Accademia Albertina, Turin. Is a teacher at the Liceo Artistico di Cuneo. One-man exhibitions in Turin, Rome, Milan and Venice. Group exhibitions mainly in Italy.

Eugenio Carmi
Born in Genoa, 1920. Became Art Director of Italsider/Italian Steel Works. Exhibited sculpture in Spoleto, 1962. Lectured in the United States, 1965. Produced a series of lithographed tin plates, 1964–65. Electronic work exhibited at the Venice Biennale exhibition, 1966, and in the exhibition, 'Cybernetic Serendipity', at the Institute of Contemporary Arts, London, 1968. Founder member of the Gruppo Cooperativo di Boccadesse, Genoa. Plexiglass and stainless-steel sculpture commissioned by Pirelli for 'Expo 70', Osaka. Experimental work produced for Italian Television. One-man exhibition at the Museum of Modern Art, Paris, 1971.

Mario Ceroli
Born in Castel Frenato, Italy, 1938. Lives in Rome. One-man exhibitions in Italy, Germany and the United States. Group exhibitions include Premio Gubbio, 1958; Quadriennale Nazionale, Rome, 1965; 'Art Actuel en Italie' (exhibitions in Germany, Norway, Ireland, Scotland, 1965–66); Troisième exposition internationale de sculpture, Paris, 1966; Venice Biennale, 1966; Premio Spoleto, 1966; Italy New Tendencies, New York, 1966; Pittsburgh International exhibition of painting and sculpture, 1967; São Paulo Bienal, 1967; Paris Biénnale, 1967; 'Italian Art', National Museum of Modern Art, Tokyo, 1967; Eurodomus 2, Italy, 1968; Venice Biennale, 1968. In 1968 he designed sets for Shakespeare's *Richard III*, performed in Venice.

Ivan Chermayeff
Studied at Harvard University and the Institute of Design, Chicago. Became assistant to Alvin Lustig and Assistant Art Director at Columbia Records. Founder member of the design group Brownjohn (q.v.), Chermayeff and Geismar (q.v.), in New York, 1957. Instructor in design at Brooklyn College, 1956–57, and at the School of Visual Arts, 1959–65. Author and illustrator of *Blind Mice and Other Numbers*. Illustrator of *The Thinking Book*, *Keep it like a Secret* and *The New Nutcracker Suite*. Active Director and President of the American Institute of Graphic Art. Member of the International Center for Typographic Arts, the Royal Society of Arts, the Industrial Design Society of America. Benjamin Franklin Fellow. Has received awards from the Type Directors Club, the American Institute of Graphic Arts, the Society of Illustrators and Art Directors Club of New York, and the American Institute of Architects (Industrial Arts Medal, 1967).

Christo
Born Christo Javacheff in Gabrovo, Bulgaria, 1935. Studied at the Academy of Fine Arts, Sofia, 1951–56. Work-study at the Burian Theatre, Prague, 1956. Studied for one term at the Academy of Fine Arts, Vienna. Moved to Paris, 1958. First packages and wrapped objects. First project for the packaging of a public building, 1961. Wall of oil drums, 'Iron Curtain', set up in Rue Visconti, Paris, 1962. Moved to New York, 1964.

First air package, Stedelijk van Abbemuseum, Eindhoven, Holland; packed tree, 33 feet long, 1966. Packed fountain and medieval tower, Spoleto, 1968. Museum of Contemporary Art, Chicago, packed, 1969. Wrapped coast, Little Bay, Australia (one million square feet), 1969. 1,249,000 stacked oil drums (project), Houston, Texas, 1969.

Chryssa
Born in Athens, 1933. Studied at the Académie de la Grande Chaumier, Paris, 1953–54, and at the California School of Fine Arts, San Francisco, 1954–55. Lives and works in New York City. Her work has been exhibited widely throughout the United States, and in Paris, Cologne, São Paulo, Buenos Aires, Eindhoven, Kassel and London. Her work is represented in the Museum of Modern Art, the Guggenheim Museum and the Whitney Museum of American Art, in New York, and in the Tate Gallery, London.

Roman Cieslewicz
Born in Lvov, Poland, 1930. Studied art at Cracow. Worked in Warsaw, producing 220 posters for cultural activities, 1956–63. Settled in Paris, 1963, and worked there for various publishers. Art Director of *Elle*, 1966–69. Art Director of *Opus International*. Joined the agency Mafia as an art director, 1969. Member of the Alliance Graphique Internationale.

Giulio Cittato
Born in Venice, 1936. Structural and visual designer at the department store La Rinascente/Upim, Milan, 1963–64. Assistant Design Director, Unimark International, Chicago, working on corporate identity, packaging, books and other publications, transportation and interiors, 1965–66. Became senior designer and project director at the Center for Advanced Research in Design, Chicago, 1966. In 1968 became senior designer for structural and visual design at the Container Corporation of America. Exhibitions: posters, Museum of Modern Art, New York, 1967–68; packaging, Smithsonian Institution, Washington, and Museum of Science and Industry, Chicago, 1968, 1969–70.

Bob Cobbing
Born in Enfield, England, 1920. First monotypes produced with typewriter and duplicator, 1942. First poems produced with emphasis on sound, 1954. Published *Massacre of the Innocents* with John Rowan, 1963. Twenty-six 'Sound Poems' produced, 1965. Recording of 'Sound Poems' made with Ernst Jandl, 1965. Co-editor/publisher for Writers Forum Poets. Lives and works in London. Group exhibitions of concrete poetry: 'Britain, Canada, USA', Stuttgart, 1965; 'Experimentalni Poezie', Prague, 1968; 'Once Again', New York, 1968; 'Mostra di poesia concreta', Venice Biennale, 1969; 'The Word as Image', London, 1970; 'Mindplay', London, 1970.

Theo Crosby
Born in South Africa, 1925. In 1965, with Alan Fletcher (q.v.) and Colin Forbes (q.v.), founded the design group Crosby, Fletcher, Forbes. Member of the council of the Institute of Contemporary Arts, of the Alliance Graphique Internationale, and of the Preservation Policy Group for the Ministry of Housing and Local Government. Won a Gran Premio for the design of the British Section, Milan Triennale exhibition, 1964. Has worked on large-scale environmental planning: the reconstruction of Euston Station, 1962–64; the Fulham Study, 1963; the town centre, Hereford. Is the author of *Architecture: City Sense*.

Wim Crouwel
Born in Groningen, Holland, 1928. Trained at the Academy of Arts and Crafts, Groningen, and at the Institute of Arts and Crafts, Amsterdam. Began career as a freelance designer, 1954. Awarded the H. N. Werkman Prize of the Municipality of Amsterdam, for graphic design, 1958. Became a partner-director of the design association Total Design in Amsterdam, 1963. Became responsible for the design of the catalogues of the Municipal Museums of Amsterdam in the same year. Awarded the Duwaer Prize of the Municipality of Amsterdam for his graphic and typographical work, 1966. In 1967 was commissioned by the Dutch government to be one of the four members of a team entrusted with the task of designing the Dutch pavilion at

'Expo 70', Osaka, Japan. Is a teacher in the industrial design department of the Technical High School, Delft. Former secretary of the International Council of Graphic Design Associations.

Allan D'Arcangelo

Born in Buffalo, New York, 1930. Studied for BA degree in history, University of Buffalo, 1953. Worked on graduate studies in Mexico, 1957–60. His work has been widely exhibited and is included in many collections, including the Museum of Modern Art, New York; the Gemeentemuseum, The Hague; the Museum of Modern Art, Skopje, Yugoslavia; the Museum of Contemporary Art, Nagoaka, Japan; and the Stadtische Kunstausstellung, Gelsenkirchen, Germany. Produced an exterior mural for the Transportation and Travel Pavilion, New York World's Fair, 1963. Executed an exterior wall painting (measuring approximately 60×45 feet) on a tenement building, Manhattan, New York, as a gift to the community, 1967. Awarded List Art Poster Commission for the Lincoln Center Festival of the Arts, 1968. Visiting critic at Cornell University, Ithaca, February–May 1968.

Rudolph De Harak

Born in California, 1924. Originally more interested in music than in art. In 1942 began to work as a painter, with some freelance work as a designer/illustrator. Since 1960 has worked as a freelance designer and eventually formed the partnership Corchia-De Harak. Continues to work as a painter/photographer in addition to his work as a graphic designer/exhibition designer.

Eric De Maré

Born in Enfield, England, 1910. Trained at the Architectural Association, London. Practised as an architect until the outbreak of the Second World War. Edited the *Architects' Journal*. Has worked as freelance photographer for the *Architectural Review*, *Harper's Bazaar*, the *Penrose Annual*, *Building*, the *Architects' Journal*, the *Daily Telegraph Magazine* and other publications. Is the author of a number of books, including *Photography*, *Colour Photography*, *The Canals of England* and *The Bridges of Britain*, and has illustrated many other books. Recently he has completed a social/architectural history of Victorian England, and has prepared an exhibition for the Arts Council on 'The Functional Tradition'.

Walter De Maria

Born in Albany, California, 1935. Studied at the University of California, Berkeley (BA History, MA Art, 1969). Awarded Guggenheim Fellowship, 1969. One-man exhibitions in the United States and in Germany. Numerous group exhibitions, including 'For Eyes and Ears', Cordier and Ekstrom Gallery, New York, 1964; 'Language To Be Looked At And/Or Things To Be Read', Dwan Gallery, New York, 1967; Documenta, Kassel, 1968; 'Earthworks', Dwan Gallery, New York, 1968; 'When Attitudes Become Form', Kunsthalle, Berne, 1969; 'Op Losse Schroevan', Stedelijk Museum, Amsterdam, 1969; 'Evidence of the Flight of Six Fugitives', Museum of Contemporary Art, Chicago, 1970. Work represented in the Museum of Modern Art, New York, and other collections in the United States.

Federico Fellini

Born 1920. Worked as a cartoonist in Rome before becoming an assistant scriptwriter to Rossellini. Collaborated on scripts for *Documento Z3*, 1941; *Quarta Pagina*, 1942; *Apparizione*, 1943; *Roma, Città Aperta*, 1945, and many other films. The films which he has directed include *Luci del Varieta*, 1950; *I Vitelloni*, 1953; *La Strada*, 1954; *Il Bidone*, 1955; *La Dolce Vita*, 1960; *Boccaccio '70*, 1962; *8½*, 1963; *Giulietta degli Spiriti*, 1965; and *Fellini Satyricon*, 1970.

Alan Fletcher

Born 1931. Studied at the Royal College of Art and at the School of Design and Architecture, Yale University. Has worked in the United States and in Italy. In 1965, with Theo Crosby (q.v.) and Colin Forbes (q.v.) founded the design group Crosby, Fletcher, Forbes. Has lectured at many art schools, including the Royal College of Art and the Central School of Arts and Crafts, London. Co-author, with Colin Forbes, of *Visual Comparisons*. Member of the Designers and Art Directors Association and of the Alliance Graphique Internationale.

Jean-Michel Folon

Born in Brussels, 1934. Abandoned his studies in architecture to take up design and illustration. Illustrations appeared in numerous magazines, including *Holiday*, *Fortune*, *Graphis* and *The New Yorker*. Awarded the Grand Prix, 'Triennale of Humour in Art', Italy, 1965. Awarded the Certificate of Merit by the Art Directors Club, New York, 1966. Worked with William Klein on the design of the Paris Biennale exhibition and also on the film *Qui êtes-vous, Polly Magoo?* 1967. Has made several animated films, including *Le Message* for the Olivetti Company. Worked with Klein on a sequence in the film *Mister Freedom*, 1968. At the Milan Triennale exhibition, 1968, created an illuminated arrangement of his paintings. His work was represented at the Venice Biennale exhibition, 1970.

Lucio Fontana

Born of Italian parentage in Rosario, Argentina, 1899. Travelled to Italy, 1905. Served in the Italian Army, 1917–18. Returned to Argentina, 1921; worked in father's stone-mason's shop. Studied at the Brera Academy, Milan, 1927–29; became interested in Futurism. First one-man exhibition, Galleria del Milione, Milan, 1930. Worked as a designer of ceramic sculpture in Paris, 1936; met Mirò and Tristan Tzara. Returned to Argentina for the duration of the Second World War. Established a private art school in Buenos Aires; published *Manifesto Blanco* with ten of his students. Began applying spatialist ideas to sculpture, 1947. Issued first *Spatialist Manifesto*, 1948. Further manifestos issued, 1949, 1950, 1951, 1952. Work displayed in special room at Venice Biennale exhibitions, 1954–58. First 'Atesse', or slit canvases, 1958. Awarded first prize for painting, Venice Biennale exhibition, 1966. One-man exhibitions throughout the world. Died in Comabbio (Varese), 1968.

Colin Forbes

Born 1928. Worked in publishing and advertising before being appointed head of the graphic design department of the Central School of Arts and Crafts, London. In 1965, with Theo Crosby (q.v.) and Alan Fletcher (q.v.), founded the design group Crosby, Fletcher, Forbes. Has served on panels of jurors for exhibitions mounted by the Council of Industrial Design, the Royal Society of Arts, and the Designers and Art Directors Association. Diploma assessor for the Royal College of Art. Member of the Designers and Art Directors Association, the Alliance Graphique Internationale and the Royal Society of Arts. Co-author, with Alan Fletcher, of *Visual Comparisons*.

André Francois

Born in Timisoara, Rumania, 1915. Pupil of A. M. Cassandre in Paris, 1935–36. Began to work in publicity design, and to execute humorous drawings, 1944. His illustrations became well known in French and English periodicals. Illustrated several children's books, and contributed to *Punch*. Designed a set of playing cards for Simpsons, Piccadilly, London. Designed décor for ballets by Roland Petit, 1956, Peter Hall, 1958, Jean Babilée, 1959, and Gene Kelly, 1960. Designed a series of Christmas cards for UNICEF, 1960. Awarded a medal by the Art Directors Club, New York. One-man exhibitions, including an exhibition at the Club du Meilleur Livre, Paris, 1958, coinciding with the appearance of his drawings for Alfred Jarry's play *Ubu Roi*.

Anthony Froshaug

Born in London, 1920. Trained in drawing and wood-engraving at Central School of Arts and Crafts, 1937–39 (five terms). Never allowed into typography room. Freelance designer and typographer from 1941, believing that mechanical composition could do as well as hand. Work regarded as 'backwash of the continental movement of the 1920s', therefore unacceptable or minimally paid. Fell in love with printing: from love and economic stress and difficulties in having accurate layouts carried out at second-hand, bought £25-worth of minimal equipment (type, l.c. only, spaces, strip leads, tweezers, galley, Adana H/S No. 2. Found old rusty stick and some survival type and cases in Cornwall; had screwdriver, cotton-wool, spanners, paper, ingenuity). Customers prepared to leave typographer alone, if end-product printed. Immense interest in emotional and structural meaning of text.

Desire to find visual form matching verbal. Never thought could teach, but approached by Jesse Collins (1947) to do a day a week at Central, 'because you have authority'. Flabbergasted, but the teaching seemed to work. Driven back to minimal living, moved to Cornwall (5s. per week rent), doing 130 jobs a year. Earned £4 per week. Returned to London on appointment as Senior Lecturer in Typography at Central (1952–53). Appointment not confirmed, since place needed for trade appointee, in order to help extension of school being built to house apprentices. (Apprentices not forthcoming.) First understood that teaching not a matter of educating potentially superb students, but rat-race. Disgusted, resolved never to teach again. Re-established press, Cornwall (6s. per week rent). Tempted by anarchist dream of Hochschule für Gestaltung, Ulm, to learn German and take up Professorship in Graphic Design and Visual Communication (1957–61); also established typography workshop in the college. Appointed to Royal College of Art as first-year tutor in Graphic Design (1961–64), teaching 'stars', trying to help them to become human. Huge disagreement with organization, behaved most disagreeably. (As R. Sandford said, some years later, 'Here comes Anthony, pretending to be a human being.') Senior Lecturer and first Director of Visual Communication Course, School of Art, Watford College of Technology. Had one good student, helped a few others. Used-up by teaching, left to

study architecture at Architectural Association School (1967–69). Part-time tutor, Coventry College of Art and Design (1969–70), at present visiting lecturer, Central School of Art and Design (1970–). With great encouragement from friends (=ex-students), printing workshop re-established, London, 1971.

Geoffrey Gale
Born in London, 1929. Trained at Camberwell School of Art, London. Conscripted into the Army and served in Singapore. Completed training in the department of industrial design, Central School of Arts and Crafts, London. During this period came into contact with Nigel Henderson and, through him, became interested in photography as a profession. Practised as an industrial and exhibition designer and then took up photography. Now practises as a freelance photographer, working mainly for magazines and television; teaches at Hornsey College of Art, and the Central School of Art and Design, in London.

Pietro Gallina
Born in Turin, 1937. Worked for a number of years as a designer in an advertising agency before taking up experimental three-dimensional work and painting. One-man exhibitions in Turin, Milan, Genoa and Verona. Group exhibitions in Italy, Germany, Spain, France and Czechoslovakia. Lives and works in Turin.

Frank Gallo
Born in Toledo, Ohio, 1933. Educated at the Toledo Museum of Art (BFA), 1954; Cranbrook Academy of Art, 1955; State University of Iowa (MFA), 1959. Exhibitions include Toledo Museum of Art, 1955; Pennsylvania Academy of Fine Arts, 1958, 1960; Des Moines Art Centre, Iowa, 1959 (first prize for sculpture); Interior Valley Competition, Cincinnati, Ohio, 1961 (first prize for sculpture), the Art Institute of Chicago, Gilman Galleries, Chicago, Graham Gallery, New York City, 1964; University of Illinois, Biennial Exhibition of Contemporary Painting and Sculpture, 1965, 1967; the Whitney Museum of American Art, New York, 1965, 1966, 1967; the National Institute of Arts and Letters, 1966; the Toronto International Sculpture Symposium, 1967; the Venice Biennale, 1968. Awarded Guggenheim Foundation Fellowship, 1966. His work is represented in the Whitney Museum of American Art and the Museum of Modern Art, New York, the Montreal Museum of Fine Arts, the Helsinki Museum, and many other collections.

Winfred Gaul
Born in Düsseldorf, 1928. Studied at the Kunstakademie, Stuttgart, under Baumeister, 1950–53. Exhibited at the Documenta exhibition, Kassel, 1959. Lecturer at the Kunstschule, Bremen, 1964–65. Visiting lecturer, Bath Academy, 1965. Visiting lecturer, Regional College of Arts, Hull, 1966. First 'signal'

paintings exhibited, 1962. His work has been widely exhibited in Europe and in the United States. Lives and works in Neuss, West Germany.

Thomas H. Geismar

Studied at Brown University and Yale University (MFA, Graphic Design). Became freelance exhibition designer and graphic designer. Founder member of the design group Brownjohn (q.v.), Chermayeff (q.v.) and Geismar in New York, 1957. Became a partner in Cambridge Seven Associates Inc., Cambridge, Massachusetts. Member of the American Institute of Graphic Art, Industrial Designers Society of America. Has received awards from the American Institute of Graphic Arts ('50 Books of the Year' and 'Design and Printing for Commerce') and the Container Corporation of America. His work has been exhibited throughout the United States and in England, France, Germany, Russia and Japan.

Juan Genoves

Born in Valencia, 1936. Studied at the Escuela Superior de Bellas Artes, Valencia. Paintings represented at the Venice Biennale exhibition and at the São Paulo Bienal exhibition (Gold Medal), 1967. Lives and works in Madrid.

Jean-Luc Godard

Born 1930. Was a film critic and an actor before becoming involved in the production of films. Acted in the film *Quadrille*, 1950, directed by Jacques Rivette. Founded the journal *Gazette du Cinéma* with

Jacques Rivette, 1950, and contributed articles under the pseudonym Hans Lucas; only five issues appeared. Wrote articles regularly for the journals *Cahiers du Cinéma* and *Arts* until 1959. As an actor has appeared in the films *Le Coup du Berger*, 1956; *Le Signe du Lion*, 1959; and *Cleo de 5 à 7*, 1962. The films which he has directed include *Operation Beton*, 1955; *Tous les Garçons s'Appellent Patrick*, 1957; *Une Histoire d'Eau* (with Truffaut), 1958; *Charlotte et son Jules*, 1959; *A Bout de Souffle*, 1959; *Le Petit Soldat*, 1960; *Une Femme est une Femme*, 1961; 'La Paresse' (episode in *Les Sept Péchés Capitaux*), 1961; *Vivre sa Vie*, 1962; *Les Carabiniers*, 1963; *Bande à Part*, 1964; *Une Femme Mariée*, 1964; *Alphaville*, 1965; *Pierrot le Fou*, 1965; *Masculin-Féminin*, 1965; *Made in USA*, 1966; *La Chinoise*, 1967; *Weekend*, 1968; *Le Gai Savoir*, 1968; *One Plus One*, 1968.

Franco Grignani

Born in Pieve Porto Morone, Pavia, 1908. His studies and research have embraced architecture, photography, optics, graphic design and painting. Has produced twelve thousand experiments in the field of visual communication since 1949. In 1950 made a special study of optical dynamics. His graphic work and painting have been exhibited at the Museum of Modern Art, New York, the Stedelijk Museum, Amsterdam, and in the Documenta exhibition, Kassel, 1964. Lives and works in Milan.

Richard Hamilton

Born in London, 1922. Studied at the Royal Academy Schools, 1938–40. Undertook a course as engineering draughtsman for nine months before becoming a jig and tool draughtsman at Design Unit and EMI. Resumed studies at the Royal Academy Schools, 1946. Attended the Slade School of Fine Art, London. Devised the exhibition 'Growth and Form' for the Institute of Contemporary Arts, London, 1951. Taught at the Central School of Arts and Crafts, London, 1952. Appointed lecturer in the fine art department, King's College, University of Durham, 1953. Devised the exhibition 'Man, Machine and Motion', Newcastle-upon-Tyne, 1955. With John McHale and John Voelcker, devised an environmental section of the exhibition 'This is Tomorrow', Whitechapel Art Gallery, London, 1956. Awarded the prize of the William and Noma Copley Foundation for painting, 1960. Designed and published typographical version of Marcel Duchamp's 'Green Box'. Film of his work made in collaboration with James Scott for the Arts Council of Great Britain, 1969. Retrospective exhibition, Tate Gallery, London, 1970.

Dick Higgins

Born of American parents in Cambridge, England, 1938. Composed first music at six, and wrote first plays at nine. Studied at Yale University, then moved to New York, where he has lived ever since. Studied composition with John Cage

and Henry Cowell. Graduated from Columbia University, 1960, with BS in English. Studied at the Manhattan School of Printing, 1961. Active in 'happenings' from 1958 onwards. Co-founder of the Fluxus group, 1961. European tour with Fluxus group, 1962–63. Founded the Something Else Press, 1964. Teacher at the California Institute of the Arts, 1970. Publications include *What are Legends*, 1960; *Jefferson's Birthday/Postface*, 1964; *FOEW & OMBWHNW*, 1969; *A Book About Love & War & Death, Cantos Two and Three*, 1969; *Computers for the Arts*, 1969.

David Hockney
Born in Bradford, England, 1937. Studied at Bradford College of Art, 1953–57. Worked as a conscientious objector in a hospital as an alternative to doing military service, 1957–59. Studied at the Royal College of Art, 1959–62. First visit to New York, 1961. First visit to Berlin, and taught at Maidstone College of Art, 1962. Travelled to Egypt to make an illustration for *The Sunday Times*, and first visit to Los Angeles, 1963. Visiting lecturer, University of Iowa, 1964. Visiting lecturer, University of Colorado, 1965. Travelled through Italy, France and Cornwall, and visiting lecturer at the University of California (UCLA), 1966. Visited France and Italy, and taught at University of California, Berkeley, for twelve weeks, 1967. Since 1968 has travelled widely in the United States, Germany, France, Ireland, Holland and Austria. Won Junior section prize, John Moores Exhibition, Liverpool, 1961. Awarded Gold Medal by the Royal College of Art, 1962. Awarded prize for graphic work at the Paris Biénnale exhibition and special mention at the fifth International Graphic Exhibition, Ljubljana, 1964. Received first prize at the eighth International Exhibition of Drawings and Engravings, Lugano, 1964. Awarded first prize, sixth John Moores Exhibition, 1967.

Dom Sylvester Houédard
Born in Guernsey, 1924. Educated at Elizabeth College, Guernsey. First poems, *Blue-Blame* and *Cincma*, 1928. Fascinated by Tibetan music and other interests until the outbreak of the Second World War. At Oxford, 1942, wrote poems aiming at new form (*pierronades, pierranelles*; mostly in French in opposition to the thoughtfreeze of English literature during the 1940s); worked with Peter Fison (d. 1969). At Prinknash, 1949, wrote poems grouped as *jeux théologiques*. Studied at Sant'Anselmo University, Rome, 1951. Became honorary member of the international centre for sindonological studies, 1955. Became honorary member of La Société des Etudes Napoléoniennes, 1959. Became Literary Editor of the Jerusalem Bible, also wrote article on concrete poetry (the first in England) for *Typographica 8*, 1961. Gave lecture on concrete poetry at the Institute of Contemporary Arts and at the Royal College of Art, London, 1964. Began work on anthology (unpublished) of concrete poetry, 1964. Became member of the National Liturgical Commission and corresponding member of the international committee for English in the Liturgy, 1966. Formed Glostershire Ode Construction Company Ltd, 1967. Became member of Creative Taps (technicians and projects), 1968. Retrospective exhibition, Victoria and Albert Museum, London, 1971. Group exhibitions: 'First International Expo of Concrete/Kinetic', Cambridge, 1964; 'Between Poetry and Painting', Institute of Contemporary Arts, London, 1965; 'Poesia concreta internacional', Galeria Universitaria, Mexico City, 1966; 'Expo internacional de novissima poesia', Buenos Aires, 1969.

John Kaine
Born in London, 1935. Apprenticed to Waterlow and Sons as lithographic artist, 1951–56. Studied at the London College of Printing and the Royal College of Art, 1956–60. Studied at the Akademie der Bildenden Künste, Munich, 1961–62. Has taught at the London School of Printing and Hornsey College of Art. Now teaches at Maidstone College of Art. Exhibitions at the New Vision Centre, Institute of Contemporary Arts and Hayward Gallery in London; at the Museum of Modern Art, Oxford, and at other galleries in London and the provinces.

William Klein

Born in New York, 1928. Has lived in Paris since 1948. Painter, photographer and film director. Worked with Fernand Léger in Paris. Author of photographic books on New York (Prix Nadar, 1957), Rome, Moscow and Tokyo. Voted by the international jury at the Photokina Exhibition, 1963, as one of the thirty most important photographers in the history of photography. As a film-maker, was responsible for the photographic style of *Zazie dans le Métro*. Directed the films *Broadway by Light*, *How to Kill a Cadillac*, *The Big Store* and *Cassius the Great*. In 1966, wrote and directed the film *Qui êtes-vous, Polly Magoo?* (Prix Jean Vigo, 1967). Recent films include *Loin du Vietnam* (with Resnais, Godard, Marker and others), *Mister Freedom* (1968, scenario by Klein), a three-hour documentary on the revolution in Paris of May 1968, *Panafrican Festival of Culture* and *Eldridge Cleaver Black Panther* (1970). Retrospective exhibition at the Stedelijk Museum, Amsterdam, 1967.

Ferdinand Kriwet

Born in Düsseldorf, 1942. Self-taught. Has written poems and experimental texts since 1957. Publications include *Rotor* (1961), *10 Sehtexte* (1962) and *Leserattenfaenge-Sehtextekommentare* (1965). For the theatre he has produced a number of texts, including *Offen* (for five solo vocalists, 1962) and *Aspektakel* (a piece for mobile theatre). One-man exhibitions in Düsseldorf, Berlin, Stuttgart, Ulm and Paris. Group exhibitions include the International Exhibition of Concrete Poetry, Cambridge, 1965; 'Between Poetry and Painting', Institute of Contemporary Arts, London, 1965, and 'Schrift und Bild', Amsterdam, Baden Baden and Basle, 1963.

Jan Lenica

Born in Poznan, Poland, 1928. Studied at the Conservatory, Poznan, and at the Department of Architecture, Polytechnical University, Warsaw. Since 1945 has been a satirical cartoonist, animator and graphic designer. For his film-posters, awarded first prize at the International Biennial Exhibition of Posters, Warsaw, 1966. His animated films include *The House*, *Monsieur Tête*, *Labyrinth* and *Rhinoceros and A*. First full-length animated film, *Adam 2*, 1969. Designed the sets for the opera buffa *Yolimba*, by W. Killmayer, staged at Wiesbaden Opera.

Sol Lewitt

Born 1928. Studied at Syracuse University (BFA, 1949). One-man exhibitions: Dwan Gallery, New York, 1966; Dwan Gallery, Los Angeles, 1967; Galerie Bischofberger, Zurich, 1968; Heiner Friedrich Gallery, Munich, 1968; L'Attico, Rome, 1969; 'Art and Project', Amsterdam, 1969; Galerie Yvon Lambert, Paris, 1970; Gemeentemuseum, The Hague, 1970, and many others. His work is represented in the Museum of Modern Art, New York, and in many other collections in the United States and Europe. Group exhibitions include: Documenta, Kassel, 1968; 'Abstract Artists Invitational', Riverside Museum, New York, 1966; 'Minimal Art', Kunsthalle, Düsseldorf, 1969; 'When Attitudes Become Form', Kunsthalle, Berne, 1969; 'The Art of the Real', Tate Gallery, London, 1969; 'Art by Telephone', Museum of Contemporary Art, Chicago, 1969; 'Art from Plans', Kunsthalle, Berne, 1969; Tokyo Biennale, 1970.

Romek Marber

Studied at St Martin's School of Art and the Royal College of Art, London; graduated in 1956. Redesigned the covers for the crime series published by Penguin Books, and also the publicity and packaging of Penguin Books. Participated in launching the *Observer Colour Magazine* in 1964; Art Director of the magazine 1964–65; consultant to the *Observer* 1965–66. Has a design studio in London; is design consultant to a number of industrial and publishing companies. Since 1967 has been consultant head of the department of graphic design, Hornsey College of Art.

Robert Massin

Born in France, 1925. Learned the crafts of letter-cutting, sculpture and engraving from his father, a sculptor and engraver. Learned the rudiments of typographical design from Pierre Faucheux. Art Director of the Club du Meilleur Livre for eight years, during which time he experimented in typography. Now Art Director for the French publisher Gallimard. His book *The Letter and the Image*, published in France by

Gallimard and in England by Studio Vista, is the result of many years' research. As an experimental typographer he is best known for his work on the following books, all published by Gallimard: *Cent Mille Milliards de poèmes*, by Raymond Queneau, 1961; *Exercices de Style*, also by Raymond Queneau, 1963; and *Conversation Sinfoniotta*, by Jean Tardeau, 1966.

Hansjorg Mayer
Born in Germany, 1943. Works as typographer, printer, publisher and teacher. His time and work are divided between Stuttgart and England. Lectures in typography at Bath Academy of Art and at the School of Art, Watford College of Technology. Under the imprint Editions Hansjorg Mayer has published anthologies of concrete poetry, broadsheets and monographs. His work has been included in most exhibitions of concrete poetry in recent years. His most important published works are *Alphabet 1963*; *Alphabetenquadratbuch*, 1965; and *Typoaktionen*, 1967.

Raymond Moore
Born in Wallasey, England, 1920. Studied at Wallasey College of Art, 1937–40, and the Royal College of Art, 1947–50. Though originally a painter, has gradually changed to photography as a more suitable medium for his work. Now teaches creative photography at Watford School of Art. Worked with Minor White at the Massachusetts Institute of Technology, 1970. Two one-man exhibitions in London, 1959 and 1962. One-

man touring exhibition organized by the Welsh Arts Council, 1968. Other one-man exhibitions: George Eastman House, Rochester, New York, 1970; Chicago Institute of Art, 1971; Carl Siembab Gallery, Boston, 1971. Work included in the exhibition 'Modfot I', R.W.S. Gallery, London, later shown extensively in West Germany, 1967. Works published in *A Concise History of Photography*, by Helmut and Alison Gernsheim; the Penguin *Colour Photography*, by Eric De Maré, and the *Penrose Annual*, 1971. Works in public and private collections, including the Gernsheim Collection, Austin, Texas.

Josef Müller-Brockmann
Born in Rapperswil, Switzerland, 1914. After two years' apprenticeship with a graphic designer in Zurich and two years' attendance at the School of Applied Arts, Zurich, became freelance graphic designer in Zurich. Designed the Pavilion of Honour of the Swiss Universities at the National Exhibition, Zurich, 1939. Since then has designed many exhibitions in Switzerland and other countries. Has lectured at the School of Applied Arts, Zurich, the Nippon Design School, Tokyo, Naniwa College, Osaka, and the Hochschule für Gestaltung, Ulm. Is the author of several books on design, including *The History of Visual Communications* (1970). Is a former President of the Association of Swiss Graphic Designers and co-founder of the progressive magazine *New Graphic Design*. Has been a speaker at

numerous international conferences on design, including the International Design Conference, Aspen, 1956, and 'Vision 65', Carbondale, 1965, in the United States, and the Icograda Conference, Bled, Yugoslavia, 1966. Organized and owns the Gallery 58 in Rapperswil.

Siegfried Odermatt
Born in Neuheim, Switzerland, 1926. Initially intended to become a photographer, but after several years' practice in a photographic studio ventured into advertising and taught himself design and typography. Worked in various advertising agencies before establishing his own design studio in 1950. Now works in partnership with the designer Rosemarie Tissi.

Claes Oldenburg
Born in Stockholm, 1929. Spent childhood in Chicago. Studied at Yale University and at the Art Institute of Chicago. Work represented at the Venice Biennale Exhibition, 1964. Retrospective exhibition, Tate Gallery, London, 1970. Lives in New York.

Giovanni Pintori
Born in Sardinia, 1912. Studied at the Istituto Superiore per le Industrie Artistiche, Monza, 1930–36. Designer for the Olivetti company, 1936–67. Now a freelance designer whose work is based in Milan. Is the author of many articles on graphic design. His work has been represented in exhibitions in New York, Tokyo, London, Paris and Milan. Member of the Alliance Graphique Internationale.

Michelangelo Pistoletto
Born in Biella, Italy, 1933.
Studied in Turin. Worked as an
assistant to his father as a
restorer of paintings until
1957. One-man exhibitions at
the Galleria Sperone, Turin, the
Galerie Sonnabend, Paris, and
elsewhere. Has recently taken
up experimental dance with a
group in Italy.

Paul Rand
Born in Brooklyn, New York,
1914. Studied at the Pratt
Institute and the Art Students'
League (with George Grosz).
Became design consultant to
IBM, Westinghouse and other
corporations. Is a professor of
design at Yale University, an
honorary professor at Tama
University, Tokyo, and adviser
on art education to New York
University. Is the author of
many books on design,
including *Thoughts on Design*
and *Design and the Play
Instinct*. Has illustrated a series
of children's books. Awards
include the Gold Medal of the
American Institute of Graphic
Arts, 1966. Member of the
Alliance Graphique
Internationale, the Industrial
Designers Society of America,
and the Royal Society of Arts.
Has served on the jury of the
Fulbright Scholarship.

Robert Rauschenberg
Born at Port Arthur, Texas,
1925. Studied at Kansas City
Art Institute; Académie Julien,
Paris; Black Mountain College,
North Carolina, with Josef
Albers; Art Students' League,
New York, with Vytacil and
Kantor. Travelled in Italy and
North Africa, 1952–53.

Designed and executed stage
sets and costumes for the
Merce Cunningham Dance
Company and also served as a
technical director for the
group. One-man exhibitions in
Europe and the United States.
Drawings and paintings
exhibited at the Galeria La
Tartuga, Rome, 1959, and at
the Galerie 22, Düsseldorf,
1959. Series of prints
illustrating Dante's *Inferno*
exhibited at the Leo Castelli
Gallery, New York, 1960.
Series of lithographs, 'Stoned
Moon', exhibited at the Mayfair
Gallery, London, 1970.
Awarded first prize at the Fifth
International Exhibition of
Prints, Ljubljana, 1963, first
prize at the Venice Biennale
exhibition, 1964, first prize at
the Corcoran Biennal
exhibition, Corcoran Art
Museum, Washington DC,
1965.

Roger Raveel
Born in Machelen-à-Leie,
Belgium, 1921. Studied at the
academies of Deinze and
Ghent. One-man exhibitions in
Belgium, Italy, France,
Switzerland and Holland.
Group exhibitions include
International Art Exhibition,
Tokyo, 1965; 'Nouvelles
Recherches flamandes',
Geneva, 1965; Documenta,
Kassel, 1968; and the Venice
Biennale, 1968. In 1966 he led
a group of four Belgian and
Dutch artists who created in
the cellars of Beervelde
Castle, near Ghent, a
permanent artistic environment.
In 1969 he and his colleagues
created a similar artistic
environment in the Dulcia
factories in Zottegem, Belgium.

Alain Robbe-Grillet
Born in Brest, France, 1922.
Worked as an agricultural
expert for the French National
Institute of Statistics in the
West Indies and Africa. Was
Literary Director of the
publishing company Les
Editions de Minuit. Founder
member of the French literary
group New Novelists. Wrote
the script for the film *Last Year
in Marienbad*. Directed the
film *Trans-Europe Express*.
Published a series of short
texts under the title *Snapshots*,
1961.

Diter Rot
Born in Hanover, 1930. Lived
in Switzerland, 1943–55;
Denmark, 1955–57; Iceland,
1957–64, and the United
States, 1964. Since 1960 has
worked in different countries,
combining teaching with his
graphic work and returning to
his home in Iceland for more
prolonged periods of work.
One-man exhibition at the
Institute of Contemporary
Arts, London, 1971; other
exhibitions in Germany, the
United States and England.
Awarded the prize of the
William and Noma Copley
Foundation, 1960. Has recently
been producing collective
prints with Richard Hamilton.

Hans Schleger
Studied in Europe before
working for a period of five
years in New York. For the
past thirty-five years has lived
in London. His work has
been mainly concerned
with organic graphic design
systems and trademarks. Has
held educational appointments
and his work has been

published in year books and periodicals, and exhibited in many countries. Was a delegate and speaker at the World Design Conference, Tokyo, 1960. His clients include the British Sugar Corporation, Mac Fisheries, Finmar, the John Lewis Partnership, Shell-Mex and BP Limited, London Transport and British Rail.

Peter Schmidt
Born in Berlin, 1931. Emigrated to England, 1938. Studied at Goldsmith's College of Art and the Slade School of Fine Art, London, 1951–57. Developed techniques of allowing pictures to grow without being able to envisage the results. Later, started working with electronic sound and film. Published the personal booklet *In the Head*, 1969. Used some of his previous work in a series of 120 monoprint/collages, 1969. Used the rest in making 100 sets of *The Thoughts behind the Thoughts*, each set consisting of 55 pieces of old work overprinted with sentences. Continued to make pictures.

Richard Smith
Born in Letchworth, England, 1931. Studied at Luton School of Art, 1948–50. Served in the Royal Air Force, 1950–52. Continued studies at St Albans School of Art and at the Royal College of Art until 1957. Awarded scholarship for travel in Italy, 1957. Taught painting in London until 1961. Lived and worked in New York, 1961–63. Received an award at the Venice Biennale exhibition, 1966. Awarded the

Grand Prix at the São Paolo Bienal exhibition, 1967. Lives in Wiltshire. His works are represented in many collections, including the Tate Gallery and the Arts Council, London; the Walker Art Center, Minneapolis; and the Museum of Modern Art, Rome. His paintings have been exhibited widely in Europe and the United States.

Stefan Themerson
Born in Plock, Poland, 1910. Studied natural science and architecture, 1931–37. With his wife Franciszka made several short films in Warsaw, including *Europa* (based on a futurist poem) and *Fuse*. Left Poland for Paris in 1938 and later settled in London, where he now lives, working mainly as a writer and publisher in connection with the Gaberbocchus Press.

Jan Tschichold
Born in Leipzig, 1902. Studied at the Leipzig Academy of Book Design, where he later became a lecturer on lettering. Lectured on typography and lettering at the school for German printers in Munich, 1926–33. Moved to Basle when the Nazis came to power in 1933. Has designed over fifty books, including translations into five languages. Gave lasting impetus to the rise of asymmetrical typography with the publication of his book *Die Neue Typographie* in 1928. In 1946 came to England to re-design the internal and external form of Penguin Books. Awards include the gold medal of the American Institute of Graphic Arts, the Gutenberg Prize, and

the honorary title of Royal Designer for Industry 'for outstanding contributions as a typographer and book designer', 1965. Member of the Société Typographique de France.

Stan Vanderbeek
Born in New York, 1930. Studied painting and graphic design at the Cooper Union Art School, New York, and at Black Mountain College, North Carolina, until 1953. Received a Ford Foundation grant for experimental films, 1963–64, and a Rockefeller grant for experimental films and studies in non-verbal communication, 1967–68. Associate Professor at Columbia University, 1963–65, and at New York State University, 1967–68. Held fellowship at the Center for Advanced Visual Studies, Massachusetts Institute of Technology, 1969–70. Projects include the construction of the 'Movie-Drome', Stony Park, New York. Awarded bronze medal for the films *Mankinda* and *What, Who, How* at the Brussels International Experimental Film competition, 1958. Participated in the Venice Film Festival, 1964. Since 1970, Artist-Fellow at the Center for Advanced Visual Studies, Massachusetts Institute of Technology, working on computer-generated films, video experiments and multi-media.

Tom Wesselmann
Born in Cincinnati, Ohio, 1931. Studied at the University of Cincinnati, the Art Academy of Cincinnati and the Cooper Union Art School, New York. Lives and works in New York.

Kurt Wirth

Born in Berne, 1917. Served a three-year apprenticeship as a graphic designer, 1933–36. Attended the Gewerbeschule, Berne. Established his own design studio, 1938. Travelled in France, Italy, Greece, Spain and Algeria for the purpose of private research. Spent some time in Paris, drawing and painting. Has always balanced his work as a designer with periods spent painting and drawing. Contributed to the International Exhibition of Graphic Art, Los Angeles, 1949. Awarded first prize at the International Poster Exhibition, Tokyo, 1956.

Henry Wolf

Born in Vienna, 1925. Studied in France before going to New York to take courses in design and photography at the School of Industrial Arts. Studied painting with Stuart Davis. Designer in an art studio, 1945–47. Art director in an advertising agency, 1947–51. Art Director for the United States State Department, 1952. Art Director of *Esquire* (whose format he redesigned), 1952–58. Became Art Director of *Harper's Bazaar* and continued to work as a freelance designer. Became Art Director of *Show*, 1961. Has lectured on design at the Cooper Union Art School, New York. Awards for his work include gold medals from the Art Directors Club, New York.

Edward Wright

Born in Liverpool, 1912, son of Eduardo Wright Aguirre, Consul of Ecuador. Educated at Stonyhurst College and the Bartlett School of Architecture. Lived in Ecuador and Chile, 1937–42. Returned to the United Kingdom as a volunteer for military service; became a British subject. Worked in Paris, designing graphics for a documentary film unit, 1946. First one-man show at the Mayor Gallery, London. Worked with Theo Crosby on the design of the exhibition 'This is Tomorrow' at the Whitechapel Gallery, 1956; executed a mural on a temporary building designed by Crosby for the Congress of the International Union of Architects on the South Bank, London, 1961. Tutor in the school of graphic design at the Royal College of Art, 1956–59. Visiting teacher at the Central School of Arts and Crafts, London; the London College of Printing; and the School of Architecture, Cambridge University. Now head of the department of graphic design, Chelsea School of Art, London.

Acknowledgments

Grateful acknowledgments are expressed to the following, for providing the photographs, and relevant information, which relate to the sections on the artists indicated

Arturo Schwarz, Galleria Schwarz, Milan. *Valerio Adami*.
Metro-Goldwyn-Mayer Pictures Ltd, London. *Michelangelo Antonioni*.
John Halas, Halas and Batchelor Animators Ltd, London. *Saul Bass*.
Mrs Lester Beall. *Lester Beall*.
Gordon Fraser Postcards. *Eric De Maré*.
Bob Gill. *Robert Brownjohn*.
Collection Luciano Pistoi. *Alberto Burri* ('The Bag').
Kasmin Ltd, London. *Pol Bury, David Hockney, Richard Smith*.
Galleria D'Arte del Naviglio, Milan. *Mario Ceroli*.
Vowinckel Collection, Cologne. *Christo* (packed tree).
Lund Humphries Ltd (*Typographica 15*). *Crosby, Fletcher, Forbes*.
Marlborough Gerson Gallery, New York. *Allan D'Archangelo*.
Dwan Gallery, New York.
Walter De Maria, Sol Lewitt.
United Artists Corporation Ltd, London. *Federico Fellini*.
Aldo Passoni, Museo Civico, Turin, and Marlborough Gallery, Rome. *Lucio Fontana*.
Gilman Gallery, Chicago. *Frank Gallo*.
Marlborough Gallery, London. *Juan Genoves*.
British Film Institute, Connoisseur Films Ltd, London, and Gala Film Distributors, Ltd, London. *Jean-Luc Godard*.
Lisson Gallery, London. *Dom Sylvester Houédard*.
Editions Gallimard. *Robert Massin*.
Arts Council of Great Britain. *Claes Oldenburg*.
Galerie Ileana Sonnabend, Paris. *Michelangelo Pistoletto*.
Mayfair Gallery, London. *Robert Rauschenberg*.
Connoisseur Films Ltd, London, and Contemporary Films Ltd, London. *Alain Robbe-Grillet*.
Gaberbocchus Press, London. *Stefan and Franciszka Themerson*.
Culture Intercom. *Stan Vanderbeek*.
Sidney Janis Gallery, New York. *Tom Wesselmann*.

Grateful acknowledgments are expressed to the following, for permission to quote extracts in the sections on the artists indicated

Hamish Hamilton Ltd (Saul Steinberg, *The Passport*). *Introduction*, page 33.
Michelangelo Antonioni, 'Entretien', *Cahiers du Cinéma*, October 1960. *Michelangelo Antonioni*.
British Film Institute (Philip Strick, article in *Sight and Sound*, Autumn 1969, vol. 38, no. 4). *Walerian Borowczyk*.
Lund Humphries Ltd (Gene Federico, statement quoted in *Typographica 2*). *Chermayeff and Geismar*.
William Collins and Company Ltd (Pierre Teilhard de Chardin, *The Phenomenon of Man*). *Alain Robbe-Grillet*.
Anthony Froshaug (extracts from an unpublished essay; copyright © Anthony Froshaug). *Stefan and Franciszka Themerson*.
Niggli (Kurt Wirth, extract, 'drawing is like writing, like speaking, like walking', from *Drawing When How*). *Kurt Wirth*.
Studio Vista Ltd (Paul Rand, *Thoughts on Design*). *Paul Rand*.
Vertigo Publications (Bob Cobbing, *The Wild Game of Sight*). *Bob Cobbing*.